# Venice and the Grand Tour

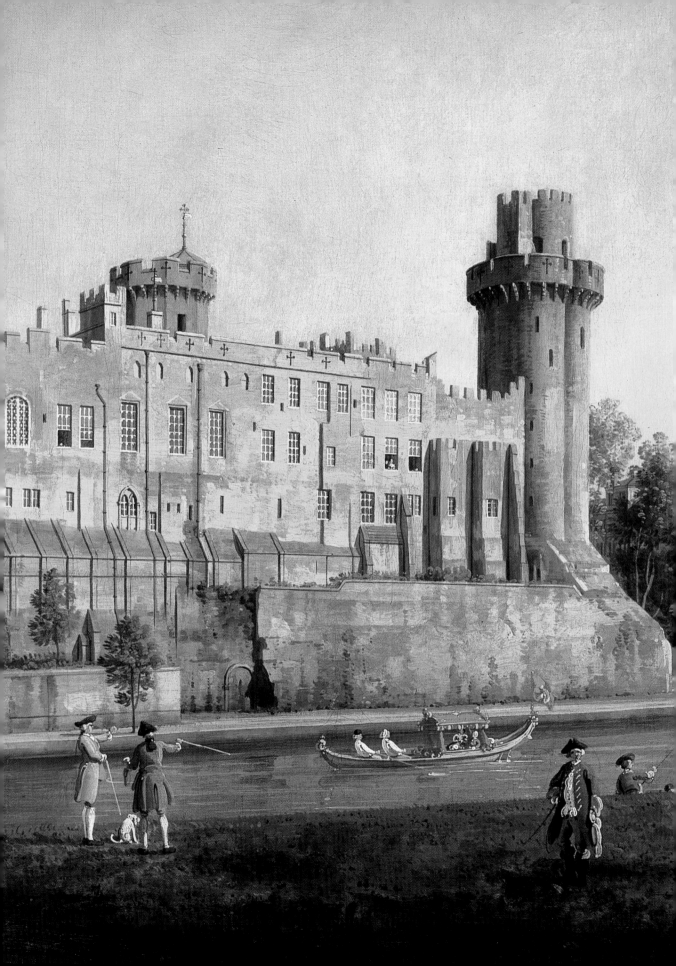

# Venice & the Grand Tour

BRUCE REDFORD

YALE UNIVERSITY PRESS
NEW HAVEN AND LONDON
1996

For Margaret Bent and Eric Southworth

FRONTISPIECE: *Warwick Castle, the South Front*
(detail of Plate 27)
by Canaletto. Holkham Hall, Norfolk.

Designed by Faith Brabenec Hart
Printed in Hong Kong

**Library of Congress Cataloging-in-Publication Data**

Redford, Bruce.
Venice & the grand tour / Bruce Redford.
p. cm.
Includes index.
ISBN 0-300-06911-1 (hardcover ; alk. paper)
1. Venice (Italy)—Description and travel. 2. Travelers—Great
Britain—History. 3. Travelers' writings, English—History and
criticism. I. Title.
DG673.R43 1996
914.5′31047′08921—dc20 96-26616
CIP

# CONTENTS

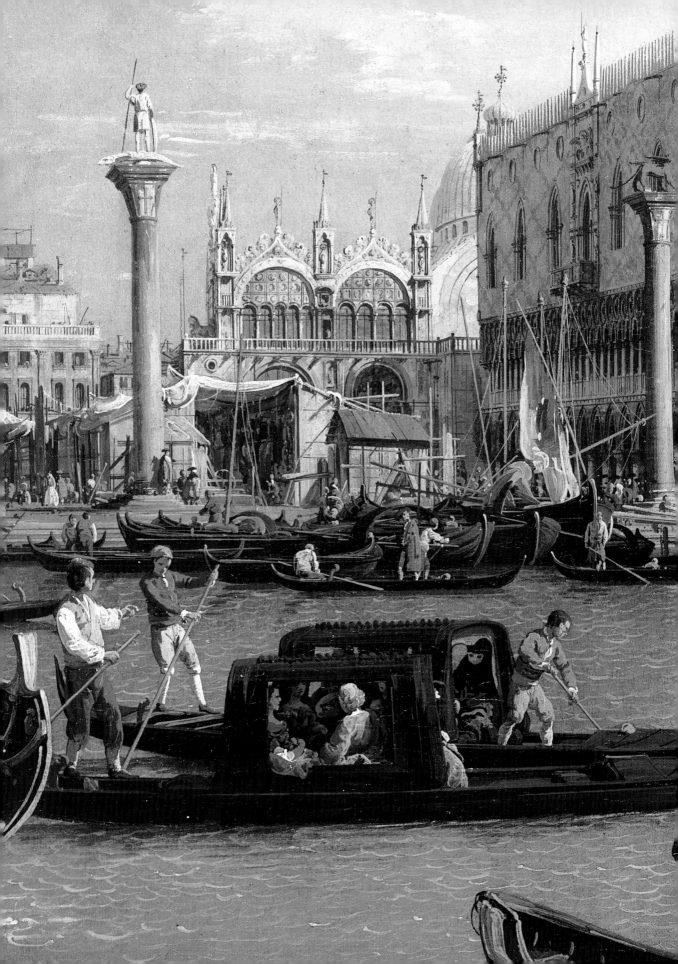

# PREFACE

With Oxford, Lausanne, and the Hampshire Militia behind him, Edward Gibbon sets out at the age of twenty-six on "the pilgrimage of Italy."* Gibbon's version of the Grand Tour is anomalous in several important respects: he is not making his first trip across the Channel *in statu pupillari*, but rather "revisiting the Continent on a larger and more liberal plan"; furthermore, he travels as a precocious, self-directed historian (p. 124). Nevertheless, Gibbon's account of his trip highlights both the aspiration and the ambivalence that characterize the Tour and make it for students of eighteenth-century Great Britain a fascinating cultural puzzle. How could an institution have been so prized yet so reviled, so durable yet so riddled with internal contradictions?

Gibbon begins his account with a concise statement of the orthodox justification for making the Tour: "According to the law of custom, and perhaps of reason, foreign travel completes the education of an English gentleman." This poised generalization works like the opening sentence of *Pride and Prejudice:* "It is a truth universally acknowledged, that a single man in possession of a good fortune, must be in want of a wife." On close inspection, both propositions cast an ironic shadow over their own certitude, interrogating the very social imperatives they urbanely impart. In Gibbon's case, the qualifying "perhaps" and the juxtaposition of adjectives begin to suggest a central paradox: that gentlemen-in-the-making should engage in the dubiously rational enterprise of perfecting their Englishness by immersing themselves in the foreign.

Rome is for Gibbon, as for all Grand Tourists, "the great object" of the exercise, and it does not disappoint him. Elsewhere, however, he finds "pride," "vice," "slavery," "poverty," and "sad solitude." Praise is continuously undercut by censure, as Gibbon organizes his narrative around a sequence of "buts": "The architecture and government of Turin presented the same aspect of tame and tiresome uniformity: but the Court was regulated with decent and splendid œconomy. . . . The size and populousness of Milan could not surprise an inhabitant of London: the Dome or Cathedral is an unfinished monument of Gothic superstition and wealth: but the fancy is amused by a visit to the Boromean islands" (p. 133). On his return journey through northern Italy, the oscilla-

---

* *Memoirs of My Life*, ed. Georges A. Bonnard (New York, 1966), p. 124. All subsequent quotations are taken from this edition.

1

tion between poles of rapture and recoil intensifies: "The spectacle of Venice afforded some hours of astonishment and some days of disgust" (p. 135).

In his edition of the *Memoirs*, Lord Sheffield moderates the sentiment by deleting the last five words. Yet the uncensored sentence prepares for the final stage of the narrative, which endows the Continent with a powerful sexual magnetism that the traveler must resist if he is to become the "English gentleman." Italy and France, figured as the torrid female South, give way to the claims of northern domestic responsibility: "Rome and Italy had satiated my curious appetite, and the excessive heat of the weather decided the sage resolution of turning my face to the north, and seeking the peaceful retreat of my family and books. After an happy fortnight, I tore myself from the embraces of Paris" (p. 137). Safe at home, he hints at the danger from a position of achieved superiority. The Tour has made him, Gibbon asserts, "a better Englishman than I went out. Tho' I have seen more elegant manners and more refined arts I have perceived so many real evils mixed with these tinsel advantages, that they have only served to make the plain honesty and blunt freedom of my own country appear still more valuable to me."[*]

Although Gibbon's record is unusually precise and eloquent, it typifies the reactions of those who remembered, analyzed, perpetuated, and attacked the phenomenon that had "completed" them. These reactions, which include visual as well as literary evidence, allow us to grasp the essential form and function of the Tour. My purpose in the following pages might well be described as an attempt to tease out the implications of "tinsel advantages," to probe the relationship between "astonishment" and "disgust." *Venice and the Grand Tour* approaches the British experience of Venice—where "refined arts" reigned supreme—as evidence and as epitome of the Tour's larger significance. The book is designed to function both horizontally and vertically: horizontally as a narrative that spans what historians call "the long eighteenth century"; vertically as a cluster of analytical approaches to the Tour and to the place of Venice within it. The first chapter, "Perspectives," borrows from a variety of disciplines as it investigates the pedagogical, social, and sexual dimensions of the topic. Chapter 2, "Narratives," focuses on three categories of guidebook (the political, the literary, and the artistic) and then turns its attention to texts that repudiate the Tour. Chapter 3 investigates the mythic identities—fleshed out at first hand and adapted for domestic consumption—that shape British representations of Venice. The fourth chapter looks at contrasting but complementary styles of portraiture, a form of visual record that helped alumni of the Tour to display its indelible effects. The book ends by charting the final phases of the Tour, and the corresponding transformation of Venice into mere spectacle, through the careers of William Beckford and Lord Byron.

*Venice and the Grand Tour* would not have been possible without the generosity of the John Simon Guggenheim Memorial Foundation. It took decisive shape at All Souls College, Oxford; I am most grateful to the Warden and Fellows for the privilege of spending a year in their midst. In Venice I would like to thank Mr. Peter Lauritzen, Lady Rose Lauritzen, and the staff of the Marciana Library. Warmest

---

[*] *The Letters of Edward Gibbon*, ed. J. E. Norton, 3 vols. (London, 1956), i.197-98.

thanks are due to Dr. Brian Allen and Mr. John Ingamells, who made generously available to me the invaluable resources of the Paul Mellon Centre for Studies in British Art and the Brinsley Ford Archive. Curators, librarians, and archivists at the Bodleian Library, the British Library, the Ashmolean Art Library, the National Trust, the Norfolk Record Office, and the University of Durham Library could not have been more helpful. Preliminary versions of Chapters 1 and 4 were presented to informed and responsive audiences at Oxford, Cambridge, and the Institute for Historical Research, University of London; I owe Dr. Jonathan Clark, Dr. Susan Manning, and Dr. Robert Oresko respectively the valuable opportunity to address their seminars. For suggestions, criticism, and encouragement of various kinds, I am grateful as well to Professor Jonathan Dancy, Dr. Teri Edelstein, Professor Stephen Fix, Faith Hart, John Nicoll, Dr. David Parrott, Sandra Raphael, Professor Scott Redford, Dr. Isabel Rivers, Professor Lisa Ruddick, Professor Stuart Sherman, the Reverend Michael Suarez, S.J., Professor Ronald Thomas, Dr. Richard Wendorf, Margaret Wind, and Dr. David Womersley.

I wish to thank Robin Simon, the editor of *Apollo*, for permission to incorporate material that originally appeared as "Venice Mythologised" in September 1994.

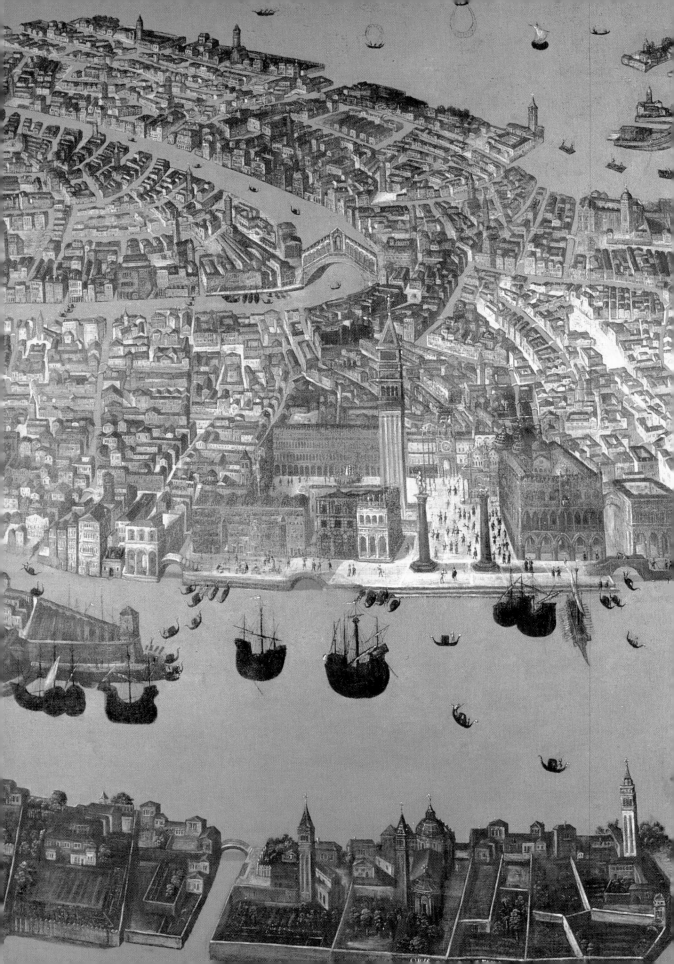

CHAPTER 1

# *Perspectives*

In Book IV of *The Dunciad*, published for the first time in 1742, Alexander Pope builds toward cultural apocalypse by taking us into the throne room of Dulness herself, where various debased constituencies do obeisance to the empress. After satirizing travesties of learning in schools and universities, Pope introduces a tutor who has just returned from conducting his young charge on the Grand Tour. This tutor, or "lac'd Governor" as he is described, presents to Empress Dulness "thy accomplished Son," who stands by—"gay," "embroider'd," and "titt'ring"—with his European mistress close at hand.[1] The governor begins his speech by casting the youthful traveler as an epic voyager:

> Thro' School and College, thy kind cloud o'ercast,
> Safe and unseen the young Aeneas past:
> Thence bursting glorious, all at once let down,
> Stunn'd with his giddy Larum half the town.
> Intrepid then, o'er seas and lands he flew:
> Europe he saw, and Europe saw him too.
>
> <div align="right">(ll. 289–94)</div>

In the compressed narrative that follows, which takes the young man from France to Italy and back home to England, Pope inverts two venerable traditions: the epic tradition of the wandering hero (Odysseus or Aeneas), protected and inspired by a tutelary goddess; and the humanistic tradition of the schoolmaster, who devises a blend of theoretical and practical learning for his pupil.[2] Pope's veteran of the Grand Tour, whom the Argument to Book IV describes as "a young nobleman perfectly accomplished," has returned from this, the most elaborate of finishing schools, utterly finished—not polished but played out. During his continental travels he has

> Dropt the dull lumber of the Latin store,
> Spoil'd his own language, and acquir'd no more;
> All Classic learning lost on Classic ground;
> And last turn'd *Air*, the Echo of a Sound!
>
> <div align="right">(ll. 319–22)</div>

His "Latin store" discarded, his native tongue corrupted, the young traveler—whose command of language ought to function as a badge of high office—has reduced himself

to macaronic incoherence. In one of several significant puns, Pope suggests that the Grand Tour helps to make of Great Britain's aristocratic "heirs" nothing more than "airs"—empty caricatures of the heroic and humanistic ideal that nonetheless remains valid as a cultural norm.

At the heart of Dulness, the exact center of Book IV's satirical anatomy, appears Pope's distillation of the Tour. And at the heart of the Tour, the exact center of the tutor's narrative, comes the portrait of Venice, which bulks larger than that of either Paris or Rome. The reader has been prepared for this portrait by three couplets that, taken out of context, seem to celebrate and not to condemn:

> To happy Convents, bosom'd deep in vines,
> Where slumber Abbots, purple as their wines:
> To Isles of fragrance, lilly-silver'd vales,
> Diffusing languor in the panting gales:
> To lands of singing, or of dancing slaves,
> Love-whisp'ring woods, and lute-resounding waves.
>
> (ll. 301–06)

The vivid imagery and sensuous onomatopeia of these lines assimilate the Italian landscape to Homer's island of lotus eaters, or Spenser's Bower of Bliss, where pleasure reigns but ultimately unmans. And such is pre-eminently the case in Venice:

> But chief her shrine where naked Venus keeps,
> And Cupids ride the Lyon of the Deeps;
> Where, eas'd of Fleets, the Adriatic main
> Wafts the smooth Eunuch and enamour'd swain.
>
> (ll. 307–10)

In this brilliant cameo Pope interprets Venice past and present, condenses a rich tradition of British responses to the Republic, and transforms her into an emblem of the Tour as a whole.

For at least a century and a half, from about 1650 to 1800, "Venice" and "Venus" were pronounced almost identically.[3] As we shall be noticing, Pope was neither the first nor the last to exploit this fact for a variety of associative purposes.[4] Here the pun works in at least three ways. It serves as both a topographical and symbolic marker, clinching Venice's identity (in contrast with Rome's) as locus of decadent Italianate allure. It prepares for the tutor's climactic couplet of presentation, in which the pupil with his imported "Whore" brings Venus / Venice back to Great Britain: "See, to my country happy I restore / This glorious Youth, and add one Venus more" (ll. 329–30). The pun also anchors an allusion to the charged erotic atmosphere of the *unhappy* convent in Pope's own *Eloisa to Abelard*: "But chief her shrine where naked Venus keeps" reworks "Shrines! where their vigils pale-ey'd virgins keep" (l. 21).

Pope drives home the significance of the second line, "And Cupids ride the Lyon of the Deeps," by providing an explanatory note: "*the Lyon of the Deeps*: The winged Lyon, the Arms of Venice. This Republic heretofore the most considerable in Europe, for her Naval Force and the extent of her Commerce; now illustrious for her *Carnivals*." This

line takes the primary emblem of the Venetian Republic and desecrates it by shifting registers and styles. We are jolted out of the linear, the sculptural, the martial, the heroic, into the world of the rococo boudoir fresco.

In the second couplet Pope asks his readers to remember the magnificent Ascension Day ceremony when the doge "married" the sea: this annual event, which exerted a magnetic pull on British visitors in particular, symbolized the coupling of a powerful male force with an acquiescent female Adriatic in order to beget and perpetuate empire.[5] But Venice has dwindled into a maritime playground, La Serenissima gone all too serene. City and sea alike have lost their power; they therefore furnish an ideal abode for the eunuch (exemplified by the castrato of the operatic stage). Earlier in Book IV, Pope personified Italian opera as "a Harlot form," purveyor of "languid and effeminate" chromaticism (l. 45 and note to l. 55). In this couplet the "smooth Eunuch" has left the stage and entered the gondola, where he keeps intimate company with the "enamour'd swain"—"enamour'd" of whom, the line declines to specify. In both Venetian couplets, moreover, Pope activates the latent relationship between rhyme words in order to underline the theme of unmanning: Venus, madam-like, "keeps" the "deeps"; the "main" has become the abode of the "swain," whose degeneracy will presently be imported into England and exalted by Dulness: "Pleas'd, she accepts the Hero, and the Dame, / Wraps in her Veil, and frees from sense of Shame" (ll. 335–36).

## Dependency and Disrepute

Pope speaks for his culture when he presents the Grand Tour as something indispensable yet untrustworthy, and the allure of Venice as magnetic yet subversive. This allure derives in part from imagined kinship: kinship between precious stones set in the silver sea; between fiercely independent island states, perennially at odds with Catholic absolutism; between oligarchical republics, both renowned for "Naval Force" and "extent of . . . Commerce." Venice exerted a cultural pull as well: for the eighteenth-century Grand Tourist, a fledgling member of his country's elite, she epitomized the most compelling achievements in modern politics, painting, architecture, and music (especially operatic music). Yet this sister state had allowed her commerce to be replaced by carnivals, her liberty to degenerate into license, her palaces and convents to be converted into Europe's most notorious brothels. The powerful, masculine lion of St. Mark was no longer plowed by the keels of Venetian fleets but embellished by eunuchs. And to the extent that such a Venice drew and formed its impressionable young aristocracy-in-training, Great Britain was in danger of being straddled and unmanned as well.

Taking my cue from Pope, therefore, I shall be claiming that the mythology and ideology of Venice are intimately connected to the mythology and ideology of the Tour, an institution that decisively shaped eighteeenth-century culture and politics. It did so by helping to form, strengthen, and sustain the patriciate of Great Britain, whose power depended, as Gerald Newman has argued, upon "something immaterial, its 'cultural hegemony'—its *style*."[6] Newman himself builds on the work of E. P. Thompson, who maintained some twenty years ago that "ruling-class control in the

eighteenth century was located primarily in a cultural hegemony, and only secondarily in an expression of economic or physical (military) power."[7]

Hegemony based upon differentiation through style: such is the formula whereby England in the eighteenth century came to acquire "a unified, not a stratified, patrician corps . . . a culturally-defined elite."[8] Such an elite, requiring mechanisms for "social closure," cherished the Tour for its exclusivity: to meet its requirements and thereby to acquire the style associated with it was to possess the time and the financial resources available to the very few.[9] A complex but coherent web of educational, social, and

3. *View of Venice* by Odoardo Fialetti (1573–1638). Oil on canvas, 419 × 492 cm. Eton College, Berkshire. In 1636 the maplike panorama was presented to Eton by its provost, Sir Henry Wotton, who had served three times as ambassador to the Venetian

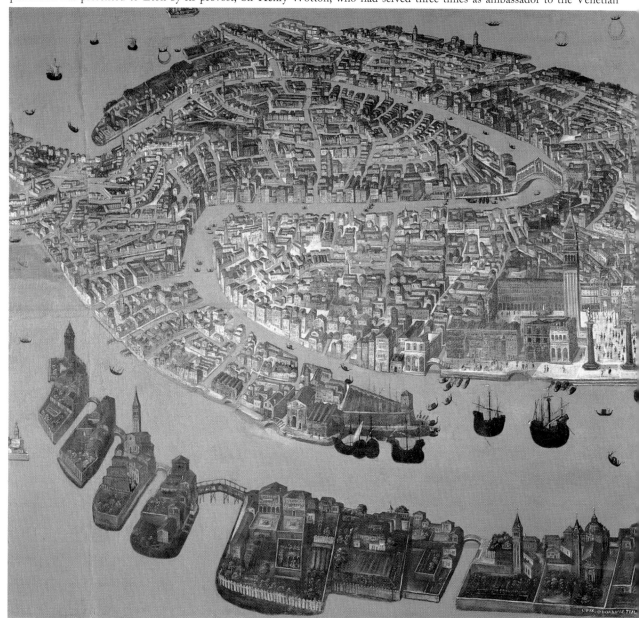

political concerns underlay the construction of the Tour's itinerary—an itinerary that centered on Rome, where the traveler completed his transformation into gentleman-classicist, possessor of the past. Venice by contrast helped to form the gentleman as contemporary cultural leader; it taught modern art, politics, economics, and sexuality. Venice also gave a local habitation and a name to the ambivalence that surrounded the Tour in eighteenth-century culture, which viewed it as a phenomenon both deeply necessary and deeply dangerous, a prop of the hierarchial status quo and a subversive force within it.

Republic (see Chapter 3). His gift of "hanc miram urbis quasi natantis effigiem" (this astonishing image of a city that almost floats) reflected and promoted a passionate belief in the underlying kinship of Great Britain and Venice.

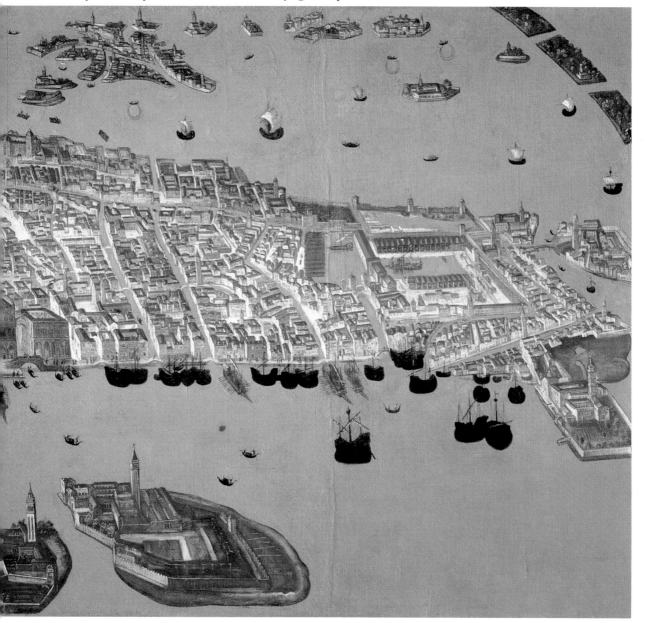

## The Origin of a Species

The charter or foundational text for the Tour is *The Voyage of Italy*, a treatise-cum-guidebook by Richard Lassels (c. 1603–1668). It is one of several ironies attaching to the phenomenon of the Tour that its most important theorist, indirectly responsible for forming the British patriciate, was himself an expatriate Catholic priest, educated at the English College in Douai and resident in Rome for long periods of his adult life.[10] In addition to his activities as scholar and priest, Lassels came (in the words of his contemporary Anthony à Wood) to be "esteemed the best and surest Guide or Tutor for young Men of his time."[11] His practical experience undergirds *The Voyage of Italy*, which went through successive drafts over a ten-year period and appeared posthumously in 1670, first in Paris and then in London.

Taken together, the title page and the dedication establish Lassels' credentials and adumbrate his pedagogical agenda.[12] The author is described as "Richard Lassels, Gent. who Travelled through Italy Five times, as Tutor to several of the English Nobility and Gentry." Such an author—a gentleman born, and a gentleman formed by experience—is ideally equipped to fashion others, witness the kind of paragon exemplified by his dedicatee, Viscount Lumley of Waterford:

> The well grounded experience which you have gained in your travels; the exact and judicious account you are able to give of the places you have seen, which make a great part of the subject of this book; the mature judgment of the interests of states, and manners of people whereof it treats, which in you is not the afterfruit of age; the Gentile and courteous behaviour which you have acquired, and which charmes all those who have the honour to converse with you: These, I say, are vertues so peculiar to your Person, and so conspicuous in the eyes of all the world, that the design of this Book being to form the like in the rest of the Gentry of our Nation that pretend to travel, It would be a wrong to the publick to let it appear under the Patronage of any other than of him that is the Idea of an accomplished consummate Traveller.

This encomium to Waterford accomplishes several purposes: it places Lassels' project within the long tradition of humanistic writing on the educational value of travel; it teaches by concise example the precepts he will be elaborating in the book as a whole; and it establishes his ability to translate theory into practice. If you read my book, believe my claims, and practice my method, then you too can become another Waterford: such is the import of Lassels' opening gambit.

The greater part of Lassels' *Voyage*, which consists of itineraries and descriptions, furnishes a practical guidebook for the traveler. The varied lore presented there not only determined the shape of the Grand Tour, it also conditioned the reactions of thousands of Tourists.[13] As an innovative and influential manifesto, however, the opening "Preface to the Reader, Concerning Travelling" deserves the closest attention. Written with remarkable wit and fervor, this preface makes a case for "the *Grand Tour* of *France*, and the *Giro* of *Italy*" by stressing the advantages accruing to the traveler; these one can group into four categories, the intellectual, the social, the ethical, and the political.

Considered from the intellectual standpoint, travel in accordance with Lassels'

program counteracts the ignorance that results from a sedentary, provincial life. It does so by turning over many pages of "this great booke, the world"—by teaching the traveler the "customes of many men" and by exposing him to a variety of foreign languages, knowledge of which creates a sense of international community: "Traveling takes off, in some sort, that *aboriginal curse*, which was layd upon mankind even allmost at the beginning of the world; I meane, the *confusion of tongues*. . . . traveling takes off this curse, and this moral *excommunication*, by making us learne many languages, and converse freely with people of other countryes." These intellectual gains are closely allied to the social, to the ideal of the cosmopolitan gentleman. Adapting doctrines that descend from Castiglione's *Il Cortegiano*, Lassels emphasizes that travel alone can inculcate "a hansome confidence," "a *bonne mine*," "a good grace," and "a liberty or freedome in all . . . actions, which The French call *liberté du corps*." "And it must appeare," Lassels adds, "to be *à la negligence*, and yet must be perfectly studdyed a fore hand." In short, only the young man who has made the Grand Tour can absorb fully "the *Elements* and *alphabet* of breeding," without which "he can never spel gentleman rightly, though his inside be never so good."

To make the "inside" as "good" as the outside is polished: that is the third or ethical advantage of the Tour, which inculcates modesty and civility by diminishing "self-conceit and pride." Its further advantage is that it teaches the virtues of manly fortitude and self-reliance—"to lye in beds that are none of his acquaintance; to speak to men he never saw before; to travel in the morning before day, and in the evening after day; to endure any horse and weather, as well as any meat and drink." One beneficial result of such toughening is an enlighted, stoic cosmopolitanism: "It makes a man to think himself at home everywhere, and smile at unjust exile." But perhaps the supreme benefit to "my young nobleman" of extended travel in a spartan mode is that it "weanes him from the dangerous fondness of his mother." Lassels is the first but by no means the last writer to emphasize the perils of maternal coddling, or of domination by such surrogates as aunts, nursemaids, and grandmothers.[14] To become completely a man as well as a gentleman, one must shuck off the restricting, feminizing influences of home.

The final, most significant advantage of travel is the political expertise it imparts: rightly conducted, the Tour functions as a school for statecraft, which allows the patrician to fulfil his destiny as ruler of a nation. In exalted metaphoric language Lassels describes the returning traveler, equipped by virtue of his experiences abroad to begin an effective parliamentary career:

> Travelling makes my young Nobleman returne home againe to his country like a *blessing Sunn*. For as the Sunn . . . not onely enlightens those places which hee visits; but also enricheth them with all sorts of *fruits*, and *mettales:* so the nobleman by long traveling, having enlightened his understanding with fine notions, comes home like a glorious *Sunn;* and doth not onely shine bright in the firmament of his country, the *Parlament house:* but also blesseth his inferiours with the powerfull influences of his knowing spirit.

In oblique but unmistakable terms, Lassels makes clear the link between the cultural and the political significance of the Tour. He also points toward the importance of hegemony through display: the "knowing spirit" of the "glorious" sun / son "blesseth

his inferiours" by radiating an authority that is derived from a source to which they themselves are denied direct access.

Yet how can these exalted goals be achieved? Given his own background, it comes as no surprise that Lassels insists on the overriding importance of the tutor in charge. His term for such a tutor is "governor"—a figure who came through much of the eighteenth century to be known as the "bearleader," a word whose origins have remained obscure. However, two passages in Horace Walpole's letters support a case for Lassels' preface as the source not only for "Grand Tour" but also for "bearleader." Writing to Horace Mann in 1749, Walpole refers to a young man's "bear-leader, his travelling governor"; in another letter, he makes mention of "forty dozen of bears and bear-leaders, that you have been endeavouring for these thirty years to tame, and the latter half of which never are licked into form."[15] It is plausible if not probable that Walpole is remembering the first paragraph of "A Preface . . . Concerning Travelling": there Lassels compares his project to an "Embrio" conceived "for the use of a noble person, who set me that taske." Lassels then describes the evolution of his book by comparing it to a bearcub and himself (author and former "governour") to a combination of parent and educator: "Yet this *Embrio* likeing [viz. pleasing] the person for whom it was conceived, obliged me to lick it over and over againe, and bring it into better forme. Second thoughts, and succeding voyages into Italy, have finished it at last, and have made it what it is; *A compleat Voyage*, and an exact *Itinerary* through *Italy*" (Plate 4).

Lassels' "character of a good Governour" begins with the resounding declaration, "I would have him then to be not onely a Vertuous man, but a *Virtuoso* too." Such an ethical aesthete must be learned, equable, discreet, and resourceful. In his capacity as one who licks the unformed into shape, pedagogically as well as stylistically, he resembles such legendary figures as Chiron the Centaur, tutor of Achilles. In addition, the effective governor will be a man "of great parts and excellent breeding," who will function (to cite one of Lassels' more extravagant comparisons) as the pupil's "shirt, which is allwayes next unto his skinn and person; and therefore as yong Noblemen are curious to have their *shirts* of the finest linnen: so should they have their *Governours* of the finest thread, and the best spunn men that can be found." Finally, in order to fulfill all these varied functions, he must be able to rely upon the complete support of his charge's father and mother: "as Governours are the Seconds of Parents, in the breeding of their children, so Parents should second Governours too, in making their children obey them." All the advantages that flow from the Tour depend upon the ability and the power of the governor to act *in loco parentis*.

### The Taxonomy of a Species

The influence of *The Voyage of Italy* can scarcely be overestimated. Lassels' arguments, his phraseology, and his itinerary entered Great Britain's cultural memory, where they were constantly reiterated for over a century.[16] Although he opposed the Tour on the grounds that travel in adolescence was counter-productive, John Locke cogently summarizes the gist of Lassels' case: "Those [advantages] which

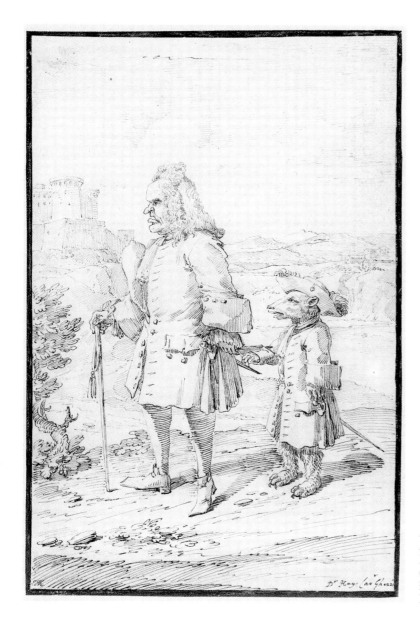

4. *Dr. James Hay as Bearleader* by Pier Leone Ghezzi (1674–1755). Pen and ink. British Museum, London.

are propos'd, as to the main of them, may be reduced to these Two, first Language, secondly an Improvement in Wisdom and Prudence, by seeing Men, and conversing with People of Tempers, Customs, and Ways of living, different from one another, and especially from those of his Parish and Neighbourhood."[17] In a coda to his travel journal, Francis Drake reflects: "The great uses of travelling may be comprehended in these few words, To raise in us new ideas, to enlarge the understanding, to cast off all national prejudices, to chuse what is eligible in other countrys, and to abandon what is bad, in our own, and lastly to learn to love our own happy island, by comparing the many benefits, and blessings we enjoy, above any other country, and climate, in the world."[18] And in the preface to his popular guidebook, *The Grand Tour*, Thomas

13

Nugent codifies what by the mid-eighteenth century had become a commonplace: "that noble and ancient custom of travelling [is one] visibly tending to enrich the mind with knowledge, to rectify the judgment, to remove the prejudices of education, to compose the outward manners, and in a word to form the complete gentleman."[19]

These Lasselian encomia, however, are as noteworthy for their vagueness as for their ardor. It is the varied attacks on the Tour that supply most of the materials for a precise definition. One of the earliest detailed critiques, the peroration of Locke's *Some Thoughts Concerning Education*, refers to "the ordinary *time of Travel*" as running "from Sixteen to One and Twenty."[20] The poet Hildebrand Jacob begins his satirical epistle "Concerning Travel, and Education": "Your *Son* near *eighteen* Years of Age, / Too tall for *School*, or a Court *Page*, / . . . / Sets out. . . ."[21] Hildebrand's portrait of the young traveler is matched by a description of his governor, a clergyman who expects preferment as a reward for supervisory services rendered:

> His *Tutor*, a *meer Scholar* bred,
> With *College Mutton* duely fed,
> *Stranger* to all *Fatigue* before,
> Consents to post half *Europe* o'er
> And guard the *Lad* from foreign Vice,
> Lewd *Women*, *Popery*, and *Dice*
> So that your *Parish* be his *Prize*.

Adam Smith, himself an experienced bearleader, completes the list of essentials: "It becomes every day more and more the custom to send young people to travel in foreign countries immediately upon their leaving school, and without sending them to any university. . . . Nothing but the discredit into which the universities are allowing themselves to fall, could ever have brought into repute so very absurd a practice as that of travelling at this early period of life."[22]

From sources such as these, as well as a variety of individual case histories, I derive my own working definition of the term "Grand Tour"—a definition that is intended to focus and to galvanize discussions of the subject. Previous scholarship on the Tour has tended to extremes: minutely particular case histories on the one hand, vague panoramas on the other. For example, Jeremy Black, whose writings dominate the field, alternates short studies of individual travelers with surveys that approach the Tour as if it were virtually synonymous with continental tourism in general.[23] Robert Shackleton, by contrast, points the way toward the claims I wish to deploy when he observes that the Grand Tour "in its organized form . . . is essentially an English institution [and] a young man's exercise." Such a conception—what Shackleton calls the "special and precise significance" of the term, as opposed to its "broad and nonrestrictive sense"—is exactly what concerns me here.[24]

For purposes of this study, then, the Grand Tour is not the Grand Tour unless it includes the following: first, a young British male patrician (that is, a member of the aristocracy or the gentry); second, a tutor who accompanies his charge throughout the journey; third, a fixed itinerary that makes Rome its principal destination; fourth, a lengthy period of absence, averaging two to three years.

Thus defined, the Tour can be seen to fall into four phases: a period of growing

popularity, from about 1670 to 1700; a heyday extending from about 1700 to 1760; a period of gradual decline, approximately 1760 to 1790; and a restricted revival, 1815 to about 1835. Several plausible explanations can be adduced for the waxing and waning of the Tour. Though a detailed account must await further sifting of the data, it is possible for the time being to isolate two factors, themselves interrelated: first, the perceived decline of the universities as training grounds for all but scholarly clergymen; second, the Tour's function as maker and marker of the elite. It can be no coincidence that less than a third of the British peerage attended Oxford and Cambridge during the heyday of the Tour, which was also the nadir of the universities' reputation.[25] Correspondingly, the decline of the Tour can be linked to the revival of the public schools and the universities, a revival that accompanied new strategies for cementing patrician authority. As Linda Colley has suggested, these included the consolidation of estates and the promulgation of a specifically British cultural identity to replace the cosmopolitan ideal.[26] The Tour was undermined for good by the invention of steam travel and the development of package tourism for a middle-class clientèle. In losing its exclusivity, it lost its *raison d'être*.

## *The Rites of Gentlemen*

Both defenders and critics of the Grand Tour agree on two salient facts: when the traveler leaves Great Britain he is considered a boy; immediately upon return he is expected to fill the offices and perform the duties of an adult. As John Locke observes, the Grand Tourist departs "at Sixteen or Eighteen" and "must be back again by One and twenty to marry and propagate."[27] We have just observed that, for most of the British patriciate, the Tour substituted years of continental separation for years of university education. In doing so it fulfilled for aristocratic culture the function of the male rite of passage, as analyzed by Arnold van Gennep and Victor Turner.[28] Their classic paradigm interprets the initiate's passage into manhood as a three-stage process: first segregation, then margin or limen, and finally aggregation. Such *rites de passage* are, in Turner's view, "transformative," in that they "concern entry into a new achieved status, whether this be a political office or membership of an exclusive club or secret society."[29] As van Gennep emphasizes, "the passage from one social position to another is identified with a *territorial* passage."[30] Both anthropologists stress the importance of the second stage, or liminal period, when the initiate is placed in the condition of "not-boy-not-man."[31] During this stage the neophyte is usually accompanied by an instructor, whose authority embodies the traditional, "axiomatic values of society."[32] The instructor superintends ordeals through which the neophyte is separated from his society, tested and taught, and then reintegrated at a higher level, with enhanced status and power. While the relationship between elder and neophyte is hierarchical, those in "the liminal group" constitute "a community or comity of comrades and not a structure of hierarchically arrayed positions."[33] According to Turner, "the heart of the liminal matter" consists of the "communication of the *sacra*," comprising "exhibitions," or "what is shown"; "actions," or "what is done"; and "instructions," or "what is said." Turner concludes that "the communication of *sacra* both teaches the neophytes how to

think with some degree of abstraction about their cultural milieu and gives them ultimate standards of reference."[34]

This anthropological model maps with remarkable precision onto the phenomenon charted by Lassels and other contemporary observers. In doing so it offers a powerful explanatory framework within which to assess the content, the significance, and the durability of the Tour. Leaving behind the comforts of home, the young traveler, superintended by his bearleader, undergoes a prolonged period of testing and instruction, during the course of which he intersects with fellow travelers at key points along the standard itinerary. Aristocratic bonding thereby takes place along horizontal as well as vertical lines. Detached from normative categories and constraints, the traveler is allowed certain freedoms within a highly ritualized masterplan.

Such a combination of structure and licence was designed to fulfill several important goals: to introduce the "not-boy-not-man" to the full range of his cultural inheritance; to mold him into the poised and polished *cortegiano*; to offer controlled opportunities for acquiring sexual experience; and to communicate aristocratic *sacra*. The *sacra*, especially "exhibitions," are then reproduced or appropriated in the form of *spolia* (antiquities, copies of antiquities, portraits, landscape views, prints and drawings). This practice amounts to a secularized ritual of commodification and consumption, whereby what was seen during the rite of passage itself is acquired in order to be put on show.[35] Possession of both *sacra* and *spolia* not only defined an elite, it ensured the continuing hegemony of that elite. The claim here is that political control depended upon cultural display—depended ultimately, that is, upon what was shown, done, and said during the years of liminal separation on the Continent.

## *Anxieties of Influence*

As the climactic phase in the formation of "the complete gentleman," the Tour was considered indispensable for over a century. Yet from Lassels' *Voyage* onward, the excited conviction of its transformative power was shadowed by caveats and by a sense of foreboding. The agenda of the Tour proved vulnerable from both practical and theoretical vantagepoints. The triangular relationship necessary to its success—the generous parent, the ductile youth, the omnicompetent bearleader— could easily be disrupted by stubbornness, ignorance, parsimony, laziness, or cynicism. Lassels warns against fathers who undermine the authority of governors, young men who desire "nothing but to get loose" from parental control, and governors who "have sacrificed their great trust, to their sordid avarice." When cynicism prevailed, or when human fallibility overcame good intentions, the least dangerous result was wasted money and several years' training in vanity and idleness. As Lady Mary Wortley Montagu observes of milordi in Venice, instead of learning any Italian they keep "an inviolable fidelity to the language their nurses taught them." "Their whole business abroad," Lady Mary concludes, is "to buy new cloaths, in which they shine in some obscure coffee-house, where they are sure of meeting only one another; and after the important conquest of some waiting gentlewoman of an opera Queen . . . [they] return to England excellent judges of men and manners."[36]

16

The most corrosive anxieties, however, relate not to the gap between theory and practice, but to the theory itself. For encounters with the Other, designed to catalyze, could also contaminate. Consequently, what was ardently desired was also profoundly feared. The resulting ambivalence both affects and connects each significant aspect of continental education—the political, the aesthetic, the religious, and the sexual.

According to its official program, as promulgated in a variety of sources, the Grand Tour was meant to strengthen the "constitution." The multiple meanings of this key word, as defined in Johnson's *Dictionary*, highlight those sweeping ambitions that were haunted by the potential for corruption. To make the Tour was to take an extended "constitutional"—improving "temper of mind," "temper of body, with respect to health or disease," and the "established form of government, system of laws and customs."[37] Such exercise was not only beneficial to, it was constitutive of, the true patrician. In theory the Tour worked upon the neophyte in at least four ways: it made him a more loyal supporter of the British political system; it attached him more securely to the *via media* of the Anglican Church; it refined his moral and aesthetic sensibility, teaching virtue through *virtù*; and it supplied the kind of sexual opportunity that would siphon off adolescent ardor, while enhancing potency and skill.

It should come as no surprise, therefore, that the inaugural run of the *Gentleman's Magazine* offered its readers, under the rubric of "weekly essay," the digest of a position piece on continental travel. This piece includes the kind of claim that was often used to justify the Tour: "The rational Design of Travelling, is to become acquainted with the Languages, Customs, Manners, Laws and Interests of foreign Nations; the Trade, Manufactures, and Produce of Countries; the Situation and Strength of Towns and Cities." But the Tour as actually practiced undermined this "rational Design," corrupting rather than consolidating "the Constitution." Young travelers, the essay argues,

> are immers'd in all manner of Lewdness and Debauchery, and their Principles, both *Religious* and *Political*, are corrupted by the Intrigues of *Irish* Romish Priests, and other Emissaries, who swarm in Roman Catholick Countries; and if they once pervert them from the Religion of their Education, will likewise beget in them an Aversion to a *Protestant Prince*, and the Form of Government of their own Country. . . . We have brought home the *French Coifure*, the *Robe de Chambre* of the Women, and *Toupe* and *Solitaire* of the Men; Dancing, Gaming and Masquerades.[38]

The health of "home" is "corrupted" by foreign imports of every noxious description. Such diatribes both reflect and promulgate the underlying metaphor of the diseased constitution, sapped by infections imported from the Continent.

And yet only by going to the Continent could Great Britain's future leaders complete their political education. The preface to Robert Molesworth's *Account of Denmark* exemplifies this paradox in its starkest form. To be of use to his country, Molesworth emphasizes, the traveler "must go out of these Kingdoms" in order to "know experimentally the want of *Publick Liberty*."[39] "'Tis certainly of greater importance," he adds, "to understand how to preserve a sound Constitution, than how to repair a crazed one."[40] Molesworth goes on to cite classical precedent in support of the need for firsthand exposure to European absolutism: "An *English-man* should be shewn the misery of the enslaved Parts of the World, to make him in love with the happiness of

his own Country; as the *Spartans* exposed their drunken Servants to their Children, to make them in love with Sobriety."[41] Yet such a salutary, indeed such a necessary, exercise is figured as a dangerous journey through a zone of plague: "he that travels into a Climate infected with this Disease [of Tyranny]" is terribly at risk of coming back a Catholic, a Jacobite, and a syphilitic dandy:

> The return they make for the Expences laid out by their Parents . . . is an affected Foppishness, or a filthy Disease, for which they sometimes exchange their Religion: besides, the Pageantry, Luxury, and Licentiousness of the more arbitrary Courts have bribed them into an opinion of that very Form of Government: like *Ideots*, who part with their Bread for a glittering piece of Tinsel, they prefer gilded *Slavery* to coarse domestick *Liberty*, and exclaim against their old fashion'd Country-men, who will not reform their Constitution according to the new foreign Mode.[42]

Molesworth's vision of salutary travel is also a nightmare, in which diseases literal and symbolic all pose versions of the same threat to Britain's free and manly essence.

Embarking on his travels through "the enslaved Parts of the World," the Grand Tourist was meant to ponder the connections between absolutism and luxury on the one hand and commercial and intellectual bankruptcy on the other. As A. D. McKillop observes, "an intelligent young man starting on the Grand Tour would know in advance what he was going to see in France and Italy and what as a patriotic Briton he ought to think of what he saw."[43] These orthodox political conclusions stressed the causal link between liberty and prosperity, tyranny and ruin; they also included an historical vision most powerfully articulated by the poet and bearleader James Thomson. In Part IV of *Liberty*, Thomson traces the reappearance of the Goddess of Liberty after "the dark Ages" and "her Progress towards Great Britain."[44] According to Thomson's quasi-allegorical narrative, Liberty has pursued "her Northern Course" from Rome to Great Britain via the republics of central Italy; before crossing the Alps, she pauses at Venice, "Where . . . a Remnant still, / Inspir'd by ME, thro' the dark Ages kept / Of my old Roman Flame some Sparks alive." As we shall be observing in Chapter 3, "this fair Queen of Adria's stormy Gulph, / The Mart of Nations," was thought to anticipate Great Britain's own achievements in commercial vigor and constitutional balance.[45] Fulfillment of her glorious potential depended on a successful adaptation of Venice's "'mixed' government, a balance of monarchy, aristocracy, and democracy, which, if maintained uncorrupted, will ensure the perpetuity of liberty and prosperity."[46] However, not one of Liberty's previous residences has sustained this balance. The repeated consequence is tyranny and servitude, which have "not only extirpated almost human Arts and Industry," as Thomson writes to Lady Hertford, "but even disfigured Nature herself."[47] In this censorious report Thomson anticipates Pope's version in *Dunciad* IV of a debased *paysage moralisé*:

> To where the Seine, obsequious as she runs,
> Pours at great Bourbon's feet her silken sons;
> Or Tyber, now no longer Roman, rolls,
> Vain of Italian Arts, Italian Souls.
>
> (ll. 297–300)

The Tiber is no longer Roman because the true spirit of Rome has migrated, via Venice, to Great Britain. But how long will Liberty, who fled the Continent, be content to live there?

As in politics, so in religion. What H. J. Müllenbrock has called the "ideological patterns" informing the Tour include the doctrine that Great Britain's prosperity derived not only from its mixed government but also from its well-tempered Anglicanism.[48] A corollary to this conviction is that, just as Church and State were beneficently linked at home, they were malignantly intertwined abroad. To make the Tour, in consequence, was to experience salutary revulsion at the "unholy alliance" of "popery and arbitrary power."[49] The great majority of letters, journals, and narratives of the Tour conform themselves to this agenda, duly emphasizing the grim consequences of priestcraft, the "superstitious" invocation of saints, and the ludicrous veneration of relics.

Aversion therapy of this kind, conceived of as working in tandem with exposure to "tyranny," carries with it the potential dangers of atheism or conversion to Rome. Writing in 1699, the Dean of Norwich describes "a yong gentleman" recently returned from the Grand Tour as "all over Italiz'd . . . an Italian I doubt [not] in his moralls, for he cannot be perswaded to marry."[50] For the dean as for many contemporary commentators, "an Italian education" involves the simultaneous loss of faith and of morals. This widespread notion—that as religious belief is undermined, so is sexuality loosed from conventional restraints—reflects a pervasive fear of Catholic theatricality as the catalyst for conversion and atheism alike.

As every account of the Tour makes clear, "Popish" ritual involved elaborate performance. From a wary Protestant perspective, such theatricality suggested both dishonest trickery (as in the widespread charge that the liquefaction of St. Gennarius's blood was faked by cynical priests) and seduction through the senses. To conclude that religion amounted to clever stagecraft was to be well on the road to atheism; to be dazzled and moved by Catholic pageantry was to be halfway to Rome. Satirizing Grand Tour topoi in the act of deploying them, Thomas Gray both registers the allure of Catholic liturgical drama and gently mocks the anxiety aroused by it. Writing from Genoa in 1739, Gray reports to Richard West:

> To-day was, luckily, a great festival, and in the morning we resorted to the church of the Madonna delle Vigne, to put up our little orisons; (I believe I forgot to tell you, that we have been sometime converts to the holy Catholic church) we found our Lady richly dressed out, with a crown of diamonds on her own head, another upon the child's, and a constellation of wax lights burning before them: Shortly after came the Doge, in his robes of crimson damask, and a cap of the same, followed by the Senate in black. Upon his approach began a fine concert of music, and among the rest two eunuchs' voices, that were a perfect feast to [our] ears.[51]

Light, color, sound: a "perfect feast" for the senses, one that could enrapture and ensnare. The Protestant nightmare is even more effectively illustrated by James Boswell's description of his visit to Loreto, the shrine that ought to have repelled him most thoroughly. Instead, Boswell is transported by "the immense riches of our Lady and the Holy House itself" and by "the grandeur of the High Mass"; the civilities of an

English Jesuit complete his contamination.[52] In reacting with awe to sacred spaces and rites, Boswell typifies several generations of Grand Tourists, who tend to dwell obsessively on every detail of such ceremonies as Easter mass in Rome. He is atypical, however, in that he feels no compensatory need to distance himself through anti-Catholic commentary.

The norm for such reportage is a text that churns with ambivalence, with a mesmerized fascination precariously controlled by gestures of strident superiority. Part of this ambivalence has to do with the problematic role of aesthetic experience within a religious context, part of it with the vexed status of an aesthetic warrant for travel. From the beginning, such a warrant had derived its principal justification from a postulated link between improvement in taste and improvement in ethical conduct. The link is usually expressed in terms of wordplay involving *virtue* and *virtù* or *virtuoso*. Richard Lassels is the first to emphasize the importance of a bearleader who is "not onely a Vertuous man, but a Virtuoso too," and can therefore attend to matters of connoisseurship. In the decade following the publication of Lassels' *Voyage*, the fine arts enter the curriculum of the Tour;[53] shortly thereafter, guidebooks begin to appear that deal, as is the case with William Acton's *New Journal of Italy* (1691), with "Antiquities; with strength, beauty, and scituation; with Painting, Carving, Limning, and Curiosities."[54] The increased stress on visual pedagogy is consolidated by the appearance in 1722 of the Richardsons' *An Account of Some of the Statues, Bas-reliefs, Drawings and Pictures in Italy*, one of the Grand Tour guides we will be investigating in the next chapter.

Systematic underpinnings for this growing emphasis on the aesthetic dimension to travel are supplied by the third Earl of Shaftesbury. As Fritz Saxl and Rudolph Wittkower noted several decades ago, "Shaftesbury was the teacher of this new generation [that came of age c. 1700], and set their standards; he preached the unity of morality and taste, and declared that 'the Science of *Virtuoso's*', and that of *Virtue* itself, become, in a manner, one and the same."[55] In *Characteristics* and *A Letter Concerning the Art, or Science of Design*, Shaftesbury offers a "program of gentlemanly formation" that draws together philosophy and the arts.[56] In doing so he makes what prove to be highly influential claims, claims both ethical and political: first, that the acquisition of taste is an important vehicle for moral improvement; and second, that Great Britain, as the land of liberty *par excellence*, is poised to surpass the Continent in cultural refinement. These claims influenced the theory and practice of the Tour both directly and indirectly: directly, through the reading of Shaftesbury's own writings and those based upon them,[57] and indirectly, through the teaching of such ardent disciples as Francis Hutcheson and George Turnbull, who trained many future bearleaders.[58]

Built into Shaftesbury's aesthetic teaching are at least two points of tension, even of contradiction. The first is that, even as he asserts Great Britain's readiness to outstrip Europe, he reveals his awareness of a cultural gap that may be difficult to close.[59] The second point of tension involves the relationship between the aesthetic and the moral, between taste and virtue. Though several of his most memorable dicta proclaim the unity of the beautiful and the good, Shaftesbury in fact looks down upon those virtuosi who treat building, gardening, and collecting as ends in themselves. His strategy is to

simulate approval as a means of capturing attention and then to teach the inferior nature of such pursuits, expanding in the process the limited horizons of the "mere" connoisseur.[60] Thus Shaftesbury's proclamation of virtue through virtuosoship is much more problematic than a few catchphrases would suggest. His ambivalence toward the aesthetic enterprise helped both to create and to confirm his culture's twofold suspicion: that Great Britain was inferior to the Continent, and would have trouble catching up; that improvement in taste was far removed from improvement in morals.

### Rake's Progress

The cameo Grand Tour of *Dunciad* IV concludes with a set of couplets that survey the traveler's activities wherever he goes, be it Paris, Rome, or Venice:

> Led by my hand, he saunter'd Europe round,
> And gather'd every Vice on Christian ground;
> . . . . . . . . . . . . . . . .
> The Stews and Palace equally explor'd,
> Intrigu'd with glory, and with spirit whor'd;
> Try'd all *hors-d'oeuvres*, all *liqueurs* defin'd,
> Judicious drank, and greatly-daring din'd.
>
> (ll. 311–18)

Through chiasmus and inversion—devices chosen to dramatize the travesties that comprise his satirical target—Pope turns suspicion into conviction: promoting connoisseurship means promoting vice; *gust* and *lust* go hand in hand. However, a certain tokenism in both spheres is necessary: the Tour would have failed had not the traveler returned with ways of testifying to his training as lover as well as antiquarian. Indeed the Tourist set out, expecting and expected, to have amours: as Frederick Pottle observes, "Every well-born Englishman who went south of the Alps in that era seems to have assumed that a really complete tour included at least one Italian countess."[61] But moderation was difficult to achieve. Just as Boswell's experience of Loreto testifies to the subversive appeal of Catholicism, his response to Italy's sexual possibilities gives substance to the fears of unbridled raking: "During my stay at Naples [and in Rome and in Venice, as it turns out] I was truly libertine. I ran after girls without restraint. My blood was inflamed by the burning climate, and my passions were violent. I indulged them; my mind had almost nothing to do with it."[62]

Richard Lassels might almost have had Boswell in mind when he adumbrated the most basic anxiety of all—that what modern scholars have called "an instrument of social reproduction" would render itself counter-productive, or even reproductive: "Others desire to go into *Italy*, only because they heare there are fine *Curtisanes* in *Venice*. . . . And thus by a false ayming at breeding abroad, they returne with those diseases which hinder them from breeding at home."[63] By the 1730s the syphilitic alumnus of the Grand Tour had become a standard target of satire:

21

> This is the best you must expect;
> For, shou'd our *Guard* his *Charge* neglect,
> Things may go worse,—the *'Squire* suppose
> At his *Return* without a *Nose;*
> Or forc't on *Marriage* to some poor
> *Coquet,* or cast *Venetian* Whore.[64]

Commentators on the Tour, as well as the occasional rakish traveler himself, brooded over the consequences of importing venereal disease into Great Britain: either "the pox" would be spread to wife and children, or it would prohibit entirely the begetting of future patricians.[65] Such fears were exacerbated by what Linda Colley has called "a major demographic crisis" affecting the elite of Great Britain: "For nearly a century, landed families were . . . not reproducing themselves. . . . And the consequences of this were widespread and considerable," entire families becoming extinct.[66] Given this state of affairs, high-priced "breeding abroad" could seem a problematic investment indeed.

"Those diseases which hinder . . . breeding at home" include "effeminacy" as well. In fact, returning from the Tour a "disabled debauchee" (to quote none other than Lord Rochester) was preferable to returning a feminized debauchee. The likelihood of doing so was considered substantial: by the second half of the seventeenth century, Italy in particular had become firmly associated in the English imagination with rampant homosexuality. Francis Osborne's *Advice to a Son* includes the warning that he "who travells *Italy,* handsome, young and beardlesse, may need as much caution and circumspection, to protect him from the *Lust of men,* as the affections of women; an impiety not to be credited by an honest heart, did not the ruins of *Sodom,* calcin'd by this unnaturall heat, remaine still to witnesse it."[67] In *An Evening's Love,* Dryden makes use of Italy's reputation as a latter-day Sodom for comic purposes:

> *Maskall.* And just now he shew'd me how you were assaulted in the dark by Foreigners.
> *Lopez.* Could you guess what Countrymen?
> *Maskall.* I imagin'd them to be *Italians.*
> *Lopez.* Not unlikely; for they play'd most furiously at our back-sides.[68]

The pun on "play" further associates vice and theatricality: Italians were addicted to staging their propensities in a variety of pernicious ways. By the early eighteenth century this connection was cemented by the importation of Italian opera, whose decadent music seemed doubly "effeminating" by virtue of the presence of castrati as heroic principals.[69] The most virulent of the surviving anti-operatic diatribes, John Dennis's "Essay upon Publick Spirit," imagines that such music can turn its young male listeners actively homosexual:

> The Ladies, with humblest Submission, seem to mistake their Interest a little in encouraging Opera's; for the more the Men are enervated and emasculated by the Softness of the *Italian* Musick, the less will they care for them, and the more for one another. There are some certain Pleasures which are mortal Enemies to their Pleasures, that past the *Alps* about the same time with the Opera; and if our Subscriptions go on, at the frantick rate that they have done, I make no doubt but

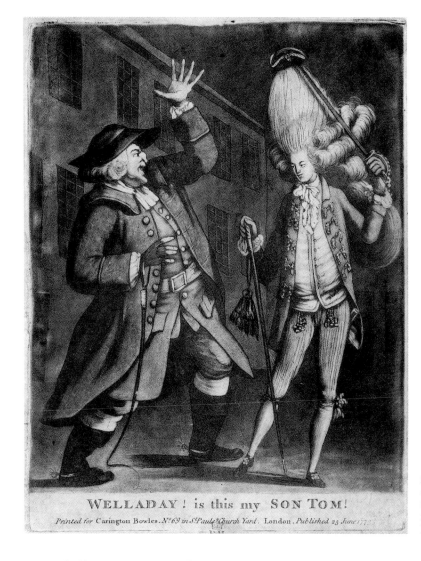

5. *Welladay! is this my Son Tom!* Mezzotint after S. H. Grimm, c. 1770. British Museum, London.

WELLADAY ! is this my SON TOM!

Printed for Carington Bowles. N° 69 in S.ᵗ Paul's Church Yard. London. Published 25 June 177...

we shall come to see one Beau take another for Better for Worse, as once an imperial harmonious Blockhead did *Sporus*.[70]

The story told by Suetonius of "harmonious" Nero, who allegedly castrated his favorite and then married him, served Dennis well, for it brought together Italy, music, young men, and emasculation in ways that suited his ferocious polemic. That Dennis's fears were far from groundless is established by no less a witness than Casanova, who vividly describes the effect of a Roman castrato on his male listeners: "un charme inexprimable agissait sur vous, et on devenait amoureux fou avant de s'apercevoir qu'on fût sensible. . . . Rome la sainte . . . de cette manière, oblige tous les hommes à devenir pédérastes."[71]

The story of Sporus also pointed the satire of Pope and Fielding, both of whom strengthened the association of effeminacy with the Tour through attacks on John Lord Hervey, adviser to both the queen and the prime minister. Hervey was well

known for his Francophilia and his liking for Italian opera; he was also notorious for sexual ambiguity and for "suspect" friendships with young aristocrats.[72] In Pope's "Epistle to Dr. Arbuthnot" he becomes the vicious androgyne "Sporus," in Fielding's *Joseph Andrews* the effeminate Beau Didapper, who "could talk a little *French*," "sing two or three *Italian* Songs," and who "dangled after [Women] . . . yet [was] so little subject to Lust, that he had, among those who knew him best, the Character of great Moderation in his Pleasures."[73]

It is the figure of the macaroni, however, which does the most to establish "effeminacy" as one of the negative consequences of the Tour. As with "bearleader," the term first appears in one of Horace Walpole's letters: writing to Lord Hertford in February 1764, Walpole refers to "the Maccaroni Club (which is composed of all the travelled young men who wear long curls and spying-glasses)."[74] The clubhouse proper for these foppish alumni of the Tour was in King Street, St. James's Square, but they also gathered at the opera.[75] Aileen Ribeiro provides a more detailed description of the macaronis' characteristic garb: "towering wigs with tiny hats, very tight coats . . . with huge buttons, nosegays in their buttonholes and vast shoe buckles."[76] Other accoutrements included parasols and muffs. This elaborate costume, combined with an affected deportment, provoked a large number of nervously scornful responses, best exemplified by a satirical definition of "macaroni" in the *Oxford Magazine:*

> There is indeed a kind of animal, neither male nor female, a thing of the neuter gender, lately started up amongst us. *It* is called a *Macaroni. It* talks without meaning, *it* smiles without pleasantry, *it* eats without appetite, *it* rides without exercise, *it* wenches without passion.[77]

What amounts to an illustration of this very passage appeared the same year in the form of a popular print (Plate 5). Captioned "Welladay! is this my Son Tom!" the print depicts a burly, roughhewn country squire, recoiling in horror from the spectacle of a mincing young man, whose posture, dress, and anatomy all suggest the macaronic androgyne (in the eighteenth-century sense of *androgyne:* "an effeminate Fellow" or "one that is castrated and effeminate").[78]

The most revealing contemporary response takes the form of a play by Robert Hitchcock, *The Macaroni,* which opened at York's Theatre Royal and then transferred to the Haymarket, London, in September 1773. By naming the title character Epicene, Hitchcock affiliates his comedy with Ben Jonson's *Epicoene; or, The Silent Woman,* a favorite with eighteenth-century audiences and a play centrally concerned with exposing the unorthodox sexual behavior of "amphibians" and "hermaphrodites." Hitchcock's Epicene is a fop, a narcissist, and a coward; he has returned from the Grand Tour coldly indifferent to women and bitingly contemptuous of British mores. The play opens with Epicene admiring himself in the mirror while his French valet, Fourbe, adjusts his master's dress:

> *Epi.*   I think this suit will gain me credit in the world—a happy fancy, something of the true *Ton,* without the least tincture of barbarism—What a great pity 'tis, Fourbe, we can't entirely introduce the Italian manners and customs here?

*Four.*   Ah, 'tis great pity indeed—de nation never will do any good till den.

*Epi.*   Never—When do you expect the cargo from Venice?[79]

Much to his distaste, Epicene has long been contracted to Lady Fanny Promise (a betrothal arranged by their fathers). Offended by his coldness, Lady Fanny tricks Epicene into engaging himself to someone else and thereby invalidating the previous marriage contract. In the play's awkward denouement, he is thoroughly punished for deviating from an ideal of British manliness that is associated with his friend the randy Lord Promise: being rakish is much better than being "effeminate."

Print and play alike illustrate, in unambiguously graphic fashion, the transgressive as well as the transformative aspect of the Grand Tour: how does "my son Tom" complete his rite of continental passage without returning an "Epicene"? Dennis Porter does much to explain the cluster of ambivalent responses we have just been exploring when he notes that "the institution of the grand tour embodied a striking paradox": by programmatically exposing the young traveler to opportunities that were also temptations, it continually threatened to undo itself.[80] Porter reminds us as well that borders are associated with taboos, which the traveler fears yet longs to break. The crossing of borders was built into the Tour, for better and for worse. Britain's young patricians, propelled toward adulthood through systematic border-crossing, transgressed boundaries that were meant to remain inviolate.

The awareness of this central paradox haunted the culture that created the Tour and came to depend upon it. Moreover, it was Venice that most fully embodied the paradox and focused the anxieties: nowhere else was there more to learn; nowhere else was there more to lose. For Britannia's lion, symbolic kin of St. Mark's, might also go the way of "the lyon of the deeps."

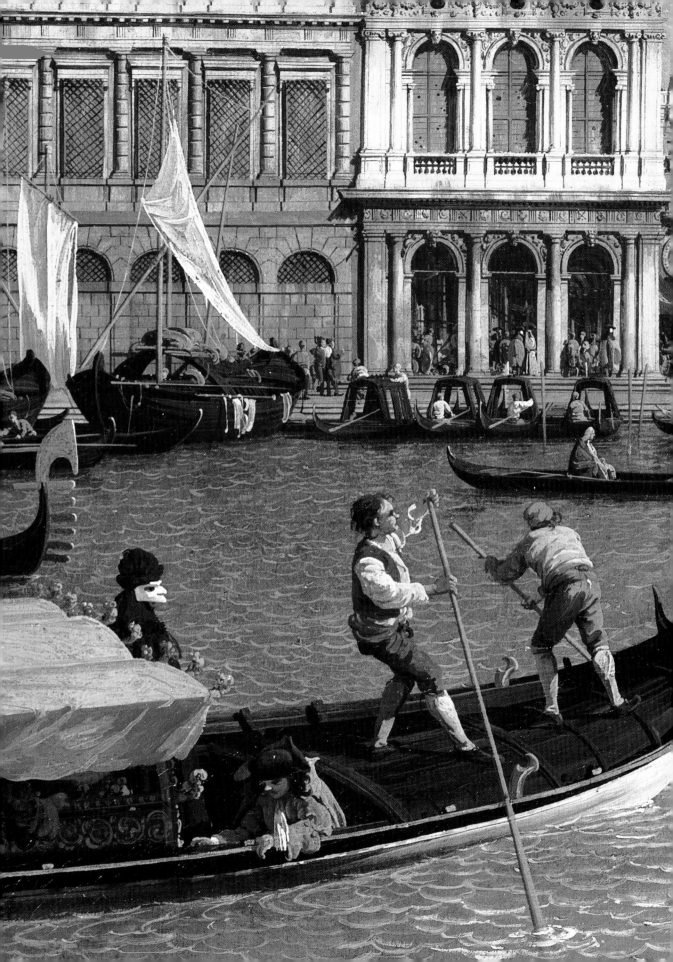

CHAPTER 2

# *Narratives*

In the early spring of 1739, Horace Walpole and Thomas Gray embarked on a two-year excursion to France and Italy. Their time abroad cannot be called a Grand Tour: both travelers, who had reached their early twenties, improvised an itinerary without benefit of bearleader. Nonetheless, the conventions of Grand Tour narrative, as they had developed over the preceding four decades, dominate Gray's epistolary account of the trip. His letters combine exuberant freshness of response with a studied air of belatedness—of seeing and telling what has been seen and told countless times before. Even the vivid experience of crossing the Alps, where "the savage rudeness of the view is inconceivable without seeing it," must be conveyed via quotations from Livy and Madame de Sévigné.[1] To the challenge of originality Gray responds with parody: when the travelers reach Florence, he sends his friend Thomas Wharton an elaborately facetious set of "Proposals for printing by Subscription ... The Travels of T: G: Gent" (i.138). These proposals comprise a satiric pocketguide to the Tour, in which "T: G:" alternates between inappropriate particularity and stultifying vagueness: "the Author spews, a very minute account of all the circumstances thereof. . . . Goes into the Country to Rheims in Champagne. stays there 3 Months, what he did there (he must beg the reader's pardon, but) he has really forgot" (i.138–39). In the final chapter the narrator self-destructs by turning his enterprise into toilet paper: "N:B: A few [copies] are printed on the softest Royal Brown Paper for the use of the Curious" (i.141). "T: G:" goes Dryden's "T. S." one better: this author's text is a *willing* "martyr of the pie, and relic of the bum."[2]

Gray's parody mocks and conflates three different approaches to Touring and to narrating the Tour: the political, the literary, and the aesthetic. "T: G:" remonstrates against various manifestations of Catholic absolutism: "Enters into the Dominions of the Pope o'Rome. meets the Devil, & what he says on the occasion" (i.141). He evokes classical associations appropriate to a given landscape: "crosses the River Trebia: the Ghost of Hannibal appears to him" (i.140). Neither does he neglect to supply "a dissertation upon Taste," "Observations on Antiquities," and samples of connoisseurship: "Arrival at Florence. is of opinion, that the Venus of Medicis is a modern performance, & that a very indifferent one, & much inferiour to the K: Charles at Chareing-Cross" (i.139–41). Gray's parodic pocket-narrative also looks forward as well as backward: in its relentless trivialization of the Tour, and its mockery of those

6. Detail of Plate 10.

who make and narrate it, the proposals anticipate the concerted attacks that would develop late in his lifetime.

Like Gray's incisive miniature, this chapter offers an epitome of Grand Tour narrative. It does so by concentrating on the most influential exemplars of the political, literary, and aesthetic approaches to continental travel. In practice, of course, these three categories overlap. But by separating them out for independent discussion, it is possible to define more precisely the composite agenda of the Tour, and the connections between goals and methods. In its second half the chapter turns to counternarrative, to analysis of the most prominent reactions against the Tour itself and those texts that defined, promoted, and perpetuated it.

## *Learning to Govern*

The political function of the Tour is most powerfully exemplified in Gilbert Burnet's *Some Letters, Containing an Account of what seemed most Remarkable in Travelling through Switzerland, Italy, Some parts of Germany, etc., in the Years 1685 and 1686.* It is significant that Burnet directs his epistolary reports to Robert Boyle: Boyle's reputation for eminent learning, his wide-ranging curiosity, and his high-minded conduct promote Burnet's ethical authority, specifically his posture of authoritative and principled commentator. Such a posture is crucial, for the *Letters* offer a guide not so much to sights as to attitudes. The implied reader is a loyal Briton who travels abroad in order to have his attachments and his prejudices empirically confirmed. It is important to Burnet's rhetorical project that he appear to be collecting and analyzing data—to be proceeding inductively rather than deductively. In fact the opposite is true: Burnet and his imagined reader notice only what can be accommodated within the fixed ideological grid that remains firmly in place from start to finish.

Though Burnet does not describe his personal history, *Some Letters* is shaped by his experience of de facto banishment on the Continent: in 1684 he had been dismissed from all his appointments as a consequence of preaching against popery and opposing the policies of Charles II and the Duke of York. Soon after the accession of James II, Burnet left for France: "The king approved of this, and consented to my going: but still refused to see me. So I was to go beyond sea, as to a voluntary exile. This gave me great credit with all the malecontents: and I made the best use of it I could."[3] Burnet keeps these "malecontents" in view: one motive for traveling and for writing is to position himself more effectively for political action on the domestic front. Read in its immediate historical context, *Some Letters* offers in lightly coded form a commentary on events in England and a preliminary manifesto for the Glorious Revolution. It aspires at the same time to the condition of patriotic pedagogy—addressing, like Xenophon's *Cyropaedia*, the young ruler-in-the-making.

Burnet's orientation and his didactic program assert themselves in the very first section of the elaborate table of contents: "The Desolation that is to be seen all the way from *Paris* to *Lions*, occasion'd by the oppression, which the People lye under."[4] The last item from the same table is similarly instructive: "a large and just Character of the present *Prince of Orange*, and of the glorious service he performed, in rescuing his

Country from the *French*"; this "Character" is succeeded by an appendix that addresses "the Avarice of the Jesuits and *Priests*." Here at the outset we encounter, albeit in condensed and elliptical form, Burnet's essential themes: the evil consequences of absolutist government; the corruption and malignancy of the Catholic Church; the glories of Protestantism, toleration, and limited monarchy.

Burnet's *guide à these* simulates the loose, repetitive form of the private letter in order to keep these themes unabashedly to the fore. The narrative is divided into five bulletins: the first headed "From Zurich," the second "From Milan," the third "From Florence," the fourth "From Rome," and the fifth "From Nimmegen." This structure allows Burnet to strengthen his thematic emphasis on stark contrasts (freedom vs. tyranny, Anglicanism vs. Popery) by framing the Italian section with observations on virtuous Protestant governments. Though he compliments himself in the opening paragraph on a "curiosity almost equal to the advantages I enjoyed" (p. 1), his is not a disinterested inquiry: he goes where he goes, and sees what he sees, with his mind already made up. Thus the itinerary exists as a pretext or armature for mini-treatises on the best and worst in government, religion, and economy.

Early in the first letter ("From Zurich") Burnet sets up a contrast that will play itself out in various forms throughout the work: in France, "misery," "extream poverty," and "visible hardships"; in Geneva, a Protestant democracy and a thriving citizenry. In fact, Geneva could almost be called a utopian state, where a well-balanced constitution undergirds a thriving economy and instils the values of loyalty, learning, and civility (p. 7). Though he pays a modicum of attention in Switzerland to topography and antiquities, Burnet concentrates on the government of the various cantons, drawing what is to become an insistent connection between politics and economics:

> *Switzerland* lies between *France* and *Italy*, that are both of them Countries incomparably more Rich, and better furnished with all the Pleasures and Conveniences of Life than it is; and yet *Italy* is almost quite dispeopled . . . and France is in a great measure dispeopled. . . . On the Contrary, *Switzerland* is extream full of people, and . . . one sees all the marks he can look for of Plenty and Wealth. . . . so an easy Government, tho joyned to an ill soil, and accompanied with great inconveniences, draws, or at least keeps people in it; whereas a severe Government . . . drives its subjects even out of the best and most desirable seats. (pp. 40–41)

Accompanying this paean to "easy Government" is an attack on Catholic ritual, iconography, and religious orders: all three manifest the "Luxury," "Vanity," "Superstition," and "Misery" that feed upon each other. Protestantism and mixed government regulate or even eliminate such evils; Catholicism and autocracy make them inevitable.

When Burnet crosses the Alps into Lombardy he is struck by the contrast between delightful climate and landscape on the one hand and universal wretchedness on the other—wretchedness of diet, clothes, libraries, accommodation, and morals. A potential land of Canaan has been ruined by tyrants and priests:

> Here is a vast extent of Soil, above two hundred Miles long, and in many places a hundred Miles broad, where the whole *Countrey* is equal to the loveliest spots in all *England* or *France;* it hath all the Sweetness that *Holland* or *Flanders* have, but with

a warmer Sun, and a better Air; the Neighbourhood of the Mountains causes a freshness of Air here, that makes the Soil the most desirable place to live in that can be seen, if the *Government* were not so excessively severe, that there is nothing but *Poverty* over all this rich *Countrey*. A *Traveller* in many places finds almost nothing, and is so ill furnished, that if he doth not buy provisions in the great *Towns*, he will be obliged to a very severe *Diet*, in a Countrey that he should think flowed with Milk and Honey. (pp. 101–02)

Burnet goes on to excoriate the nefarious alliance between despotic State and avaricious Church; he also adds (for the first but hardly the last time) an indictment of Catholic hypocrisy, as manifested in various theatrical shams:

> I heard a *Capucin* Preach here; it was the first *Sermon* I heard in *Italy*, and I was much surprized at many Comical Expressions and Gestures, but most of all with the Conclusion; for there being in all the *Pulpits* of *Italy* a *Crucifix* on the side of the Pulpit toward the *Altar*; he, after a long address to it, at last in a forced Transport, took it in his *Arms*, and hugged it, and kissed it; But I observed, that before he *kiss'd* it, he seeing some dust on it, blew it off very carefully. (p. 108)

As this passage suggests, ecclesiastical architecture draws Burnet's attention principally as a distasteful stage set, or as the symptom of diseased priorities, whereby the wealth of the country is tied up in all-too-lavish building programs: "the superstition of Italy is so ravenous, and makes such a progress in this Age, that one may justly take the measures of the Wealth of any place from the Churches" (p. 162).

Writing from Florence, Burnet moves closer to an explicitly Whig message. For example, he angles his report on the balance of constitutional power in Venice so as to jolt the reader into reflecting on the contemporary English scene: the doge's "Authority is . . . so subject to the *Senate*, and so regulated by them, that he hath no more power, than they are pleased to allow him: So that the *Senate* is as really the supream Governour over all persons, and in all causes, as the *Kings* of *England* have pretended to be in their own *Dominions* since the Reformation" (p. 141). By implication, moreover, Burnet presents himself as a victim of tyranny (and perhaps of Catholic priestcraft as well). Though he abstains from frontal attack, or transparent references to his own exile, oblique cues guide the reader. In a passage that juxtaposes Bologna (which flourishes as a result of substantial political autonomy) to Ferrara (which has been taxed and tyrannized into desolation by the pope), Burnet generalizes suggestively from these two contrasting examples:

> It is certain, that few leave their Country, and go to settle elsewhere, if they are not pressed with so much uneasiness at home, that they cannot well live among their Friends and Kindred; so that a *mild Government* drives out no swarms; whereas it is the sure mark of a *severe Government* that weakens it self, when many of the *Subjects* find it so hard to subsist at home, that they are forced to seek that abroad, which they would much rather do in their own Country, if Impositions and other Severities, did not force them to change their Habitations. (p. 165)

Here and elsewhere Burnet analyzes the contemporary state of Italy in such terms ("the Severity of the Government," "the Severity of the Taxes") as to enforce a specific

ideology and to enhance his own position as omniscient observer, infallible analyst, and distinguished victim.

Burnet's fourth letter, written from Rome, opens with a disquisition upon the deserted, malarial Campagna—stark testimony to the devastating consequences of theocracy: "In a word, it is the rigour of the *Government* that hath driven away the Inhabitants; and their being driven away, hath now reduced it to such a pass, that it is hardly possible to repeople it" (p. 180). Of all tyrannies the pope's is the worst, precisely because "the Prince [is] Elective, and yet Absolute"; he therefore exploits his power to the fullest, knowing that his rule must be temporary. In Naples, Burnet interprets the profusion of monasteries, convents, and churches in much the way he had presented the Campagna—as cause and emblem of the country's misery. In the Papal States, land lies sterile that, properly cultivated, would yield abundantly; in the Kingdom of Naples, the fruits of trade and manufacture are engrossed by the religious establishment: "thus all the *Silver . . .* becomes dead and useless" (p. 192).

The encounter with Rome elicits from Burnet his most extensive observations on art and architecture. Almost without exception, however, the aesthetic commentary exists to point a political message. Though he registers the splendors of the Renaissance and Baroque city, he tends to read buildings as mute testimony to oppression: the urban fabric "indeed discovers very visibly the Misery under which the *Romans* groan" (p. 222). Moving backward in time, he concentrates on "useful" applications to the present: "Within the *Capitol* one sees many Noble remnants of *Antiquity;* but none is more glorious, as well as more useful, than the *Tables of their Consuls. . . .* as one cannot see these too often, so every time one sees them, they kindle in him vast idea's of that *Republick*" (pp. 238–39). The frescoes of the Vatican interest him far less than "the *Gallery* of the *English Jesuits*," where he observes with scorn the portrait of Oldcorn hung among "the Pictures of their *Martyrs*" (p. 244). "It seemed a little strange to me," Burnet adds with pointed sarcasm, "to see that . . . a jesuit convicted of the blackest crime that ever was projected [viz. the Gunpowder Plot] should be reckoned among their *Martyrs*" (p. 244). As this episode suggests, even in Rome the reader is never licensed to lose himself in imaginings of the past, or detached contemplation of artistic masterworks. Properly conducted, a tour of Vatican, Forum, and Capitol consolidates contemporary attitudes and roles. It should reinforce in the traveler a vital, specific, self-confident vision of Englishness—one defined in opposition to much of what the city affords.

The final letter, "From Nimmegen," takes the reader even closer to home in several senses. Through Burnet's favorite strategy of juxtaposition, it sets an attack on the persecution of French Protestants against a eulogy of the citizens of Geneva, who function as a vehicle for Burnet's most pressing concerns:

[In Geneva] I gave the *Sacrament* according to the way of the *Church of England;* and upon this occasion, I found a general joy in the *Town*, for this, that I had given them an Opportunity of expressing the respect they had for our *Church*, and as in their publick Prayers they alwayes prayed for the *Churches of Great Britain*, as well as for the *King*, so in private Discourse they shewed all possible esteem for our *Constitutions;* and they spoke of the unhappy *Divisions* among us. (p. 259)

This first explicit mention of "unhappy Divisions" prepares the way for the concluding encomium to William of Orange, who is made to embody those principles that pervade the narrative—principles that James II is busy traducing: "He [William] refused the offer of the *Soveraignty* of its Chief City, that was made to him by a solemn *Deputation*, being satisfied with that *Authority* which had been so long maintained by his *Ancestors* with so much glory, and being justly sensible, how much the breaking in upon established *Laws* and *Liberties*, is fatal even to those that seem to get by it" (pp. 301–02). Burnet concludes his Tour by providing a charismatic exemplum, by rousing the reader to join him in veneration, by forecasting the Protestant wind that will soon be blowing, and by offering a blueprint for future patriotic travelers.

### *Learning to Quote*

Epigraph, dedication, and preface—all position Joseph Addison's *Remarks on Several Parts of Italy, etc.* (1705) in direct line of descent from Burnet. By choosing to place on the title page a quotation from Cicero's *De Amicitia*, Addison suggests that his experience of Italy would be incomplete without the opportunity to share it with a friend: "If a man should ascend alone into heaven and behold clearly the structure of the universe and the beauty of the stars, there would be no pleasure for him in the awe-inspiring sight, which would have filled him with delight if he had had someone to whom he could describe what he had seen."[5] The key verbs in this passage, to see (*perspicere*) and to describe (*narrare*) imply that Addison, like Burnet before him, will be offering a perspicacious narrative of his travels. The dedication that follows— to John Lord Somers, William III's lord chancellor—points toward the political cause that will guide his direct and detailed account: "And I could not but observe when I pass'd through most of the Protestant Governments in *Europe*, that their Hopes or Fears for the Common Cause rose or fell with Your Lordship's Interest and Authority in *England*" (A2r). The Whig allegiance of the author is then confirmed in the preface, which singles out "the Bishop of Salisbury, for his masterly and uncommon Observations on the Religion and Governments of Italy" (A3v). In fact the influence of Burnet's *Letters* pervades the *Remarks*, witness Addison's praise of mercantilism (couched in terms that anticipate the *Spectator* essays on free trade) and his criticism of such holy places as Loreto, where "a prodigious quantity of Riches lye dead, and untouch'd in the midst of so much Poverty and Misery" (p. 146). Addison's political commitments surface most emphatically, however, in his detailed account of the Republic of San Marino, which he presents as a primitive utopia surrounded by tyrannies: "Nothing indeed can be a greater Instance of the natural Love that Mankind has for Liberty, and of their Aversion to an Arbitrary Government, than such a Savage Mountain cover'd with People, and the *Campania* of *Rome*, that lyes in the same Country, almost destitute of Inhabitants" (pp. 139–40). As Peter Smithers observes of this aspect of the enterprise, "the Protestant Establishment, the Revolution Settlement, and Whig economics were confirmed by observing their opposites."[6]

Yet these are superficial trappings: for all the homage it pays to Burnet's empirical narrative and political agenda, Addison's guidebook offers something fundamentally

different—a journey through texts rather than landscapes or institutions. Lord Somers may be the dedicatee, but he is not the primary audience; Addison speaks instead to the reader as humanist, one who seeks an essentially literary experience. He therefore dedicates himself to charting "Classic ground" by creating an anthology keyed to the Grand Tourist's itinerary.[7] As the preface makes clear, "I have taken care particularly to consider the several Passages of the Ancient Poets, which have any Relation to the Places or Curiosities that I met with." The result is an allusive echo-chamber, in which the canon of classical authors mediates virtually every encounter. As Horace Walpole observes, "Mr Addison travelled through the poets, and not through Italy; for all his ideas are borrowed from the descriptions, and not from the reality. He saw places as they were, not as they are."[8]

Addison's approach "through the poets" creates a *paysage textualisé* that subsumes his political *paysage moralisé*. It compels the reader/traveler to turn himself into a collator, experiencing landscape through literature, and validating present experience through constant comparison with the records of the past. Indeed one could go even further to say that Addison effectively defines the Grand Tour as an associative enterprise, one whose essence (as it proceeds) is to make the past present by turning the present into the past. This conception of travel in Italy, though criticized and parodied, rapidly hardened into cultural orthodoxy: several generations of Grand Tourists adopted the book as an indispensable vade mecum, a pair of literary spectacles that "composed" the landscape as powerfully as a Claude glass.[9] Joseph Warton's "To a Gentleman upon his Travels thro' Italy" concisely demonstrates both the procedure and the effect of such textualized Touring:

> Perhaps you cull each valley's bloom
> To strew o'er VIRGIL's laurell'd tomb
> . . . . . . . . . . . . . . . .
> Or wander in the cooling shade
> Of Sabine bow'rs where HORACE stray'd,
> And oft repeat in eager thought elate
> . . . . . . . . . . . . . . . .
> This fount he lov'd, and there beneath that oak he sate.[10]

Addison's references to classical authors fall into four categories. The first consists of quotations introduced by means of an historic or geographic connection. Sometimes the link can be quite crude, a mere peg upon which to hang a decorative tag: "To return to *Milan:* I shall here set down the Description that *Ausonius* has given of it, among the rest of his great Cities" (p. 49). More often, however, Addison emphasizes his own sensibility as the medium that provokes and validates the quotation. He writes from Rome that "One can scare hear the name of a Hill or river near it that does not bring to mind a piece of a Classic Authour, nor cast ones Eyes upon a single Spot that has not bin the Scene of some extraordinary action."[11] If the Tourist's eye cooperates with his memory, then to travel is to make associations: "The Way from *Florence* to *Bolonia* runs over several Ranges of Mountains, and is the worst Road, I believe, of any over the *Appenines.* . . . It gave me a lively Idea of *Silius Italicus's* Description of *Hannibal's* March" (pp. 426–67).

Though topography most often triggers a quotation, Addison also moves by means of topic or theme. The scarcity of fish in Genoa, for example, prompts lines from Horace (p. 6); the architecture of the ancient amphitheater brings to mind Claudian's description of a beast in the gladiatorial games (p. 57). A third kind of reference is justified by antiquarian concerns, as when Addison takes it upon himself to elucidate the iconography of medals or the proportions of lighthouses: "It is made in the Form of the *Venetian Campanello*, and is probably the high Tower mention'd by *Pliny*" (p. 119). Finally, Addison takes clear delight in drawing parallels between modern and ancient Italy, as when he compares a contemporary proverb about the Genoese to Virgil's sentiments on the same subject, or juxtaposes Horace's experience as a traveler to his own: "It is worth while to have an Eye on *Horace's* Voyage to *Brundisi*, when one passes this way; for by comparing his several Stages, and the Road he took, with those that are observ'd at present, we may have some Idea of the Changes that have been made in the Face of this Country since his Time" (p. 186). Pleasure and profit alike derive not from seeing but from matching what is seen to what has been read: "Fields, Towns, and Rivers" scarcely figure in the account unless they happen to be the "Fields, Towns, and Rivers that have been describ'd by so many *Classic* Authors" (p. 186). Throughout the *Remarks*, observation consists of correlation.

Addison's guide to a certain kind of Italian experience not only alludes to a classical heritage, it also alludes to the very channels through which that heritage was transmitted. In form as well as content, the *Remarks* adapt two pedagogical structures with which his contemporary readers would have been well acquainted: the "text-book" and the imitation. Nathan Bailey's *Dictionarium Britannicum* (1730) tells us that "*Text-book* (in Universities) is a Classick Author written very wide by the Students, to give Room for an Interpretation dictated by the Master, etc. to be inserted in the Interlines."[12] In his *Life of Pope*, Samuel Johnson defines "imitation" as a genre in which "the ancients are familiarised by adapting their sentiments to modern topicks, by making Horace say of Shakespeare what he originally said of Ennius. . . . It is a kind of middle composition between translation and original design, which pleases when the thoughts are unexpectedly applicable and the parallels lucky."[13] Unlike the text-book, the imitation transcended the classroom, becoming during Addison's lifetime one of the most versatile and influential of literary modes. Both text-book and imitation, however, worked by juxtaposing past and present; underlying both was the conviction that eighteenth-century Britain could readily and usefully be aligned with ancient Greece and Rome.

The physical attributes of the *Remarks* promote its allusive purposes. The book takes the shape of a handsome octavo, the most common format for editions of classical authors. The type size is large in relation to the dimensions of the page; the margins are wide and the lines generously leaded. Such gaps and margins not only invite the eye; they also define a double role for author and reader alike. Addison, the design suggests, is playing both teacher and student: his commentary in English subordinates itself to the Latin texts while also constructing "an Interpretation dictated by the Master" to his reader / student. Correspondingly, the reader can react to the gaps and margins by filling them with his own glosses, which both acknowledge and usurp the authority of the author(s). So too the visual relationship between English and Latin reinforces the

fundamental strategy of comparison, which is designed to promote just that blend of pleasure and instruction associated with the imitation.

For all its ostensible learning, Addison's parade of texts actually reflects his own limitations as a scholar: as Samuel Johnson observed, "all who go to look for what the Classicks have said of Italy, must find the same passages."[14] Yet Johnson also points to the qualities of "elegance" and "variegation" that not only "gain upon the reader" but also describe every aspect of Addison's enterprise.[15] The fact that Addison had adhered to the beaten track of Latin authors, just as he had conformed himself to the standard itinerary, signals part of his larger project: to reinforce and inculcate the norm of gentlemanly classicism. Style and content, moreover, aim for an updated version of the Horatian balance between the *dulce* and the *utile;* Addison declares in his opening sentence that, "There is certainly no Place in the World where a Man may Travel with greater Pleasure and Advantage than in Italy."[16] The repertoire upon which he draws is extensive enough to establish the necessary humanistic credentials, but by avoiding the esoteric, he forestalls the charge of pedantry.

So too, Addison's own translations from Latin poetry (which are quoted frequently in the *Remarks*) exemplify both norm and goal: those who would imitate Addison (the complete gentleman/scholar/statesman) should be able to turn Horace and Virgil into just such polished couplets. The voice of the author enhances this enterprise: never wilfully eccentric nor blandly detached, it balances objective reportage with subjective commentary. The title itself, furthermore, reinforces the ideal of *sprezzatura*—of graceful self-presentation that both displays and downplays deep cultivation. Every aspect of the book, in short, conveys the status of its author (a gentleman confirmed in his gentility by the experience he describes) and promises a similarly transformative program to those who follow in his path.

### Learning to Look

During much of the eighteenth century the Grand Tourist relied for artistic guidance on An *Account of Some of the Statues, Bas-reliefs, Drawings and Pictures in Italy* (1722), by Jonathan Richardson Senior and Junior. Functioning as his father's "Telescope,"[17] Jonathan Richardson Junior had visited the Continent in 1721, keeping copious notes of what he saw; these on-the-spot records were edited and amplified by Jonathan Richardson Senior. Like Burnet and Addison before them, the Richardsons offer a vade mecum that is designed to fit within a larger didactic program. As Richardson *père* emphasizes in his preface, "Whoever would Travel with Advantage ought to have the Languages, a competent Stock of Learning, and other Gentleman-like Accomplishments. . . . And before he sets out [he] ought to know as much of what he goes Chiefly to Observe upon, as can be learn'd at home."[18] What "can be learn'd at home," and then reinforced abroad, is a political orientation consistent with Burnet: the fervent dedication to *An Account* calls down blessings on "the Illustrious House of Hanover," while the commentary stresses that Italy's artistic treasures are "horridly ill us'd" as a consequence of monkish "Gothicism" and the superstition of "silly People" (p. 37). From Addison the Richardsons inherited a commitment to genteel

enlightenment through an accessible "middle style": avoiding "all harshness and severity of diction," they do for Italian art what Mr. Spectator had done for such topics as *Paradise Lost* and the pleasures of imagination.[19] In their comparable twentieth-century tribute to the Richardsons, Francis Haskell and Nicholas Penny single out this very feature of the guide—what they identify as "a deep culture" combined with "a lack of pedantry."[20] It therefore comes as no surprise that the guidebook both found and made a loyal readership.[21]

These lines of descent, however, should not be allowed to obscure the unique and innovative qualities of *An Account*. The Richardsons have at least four pioneering goals in mind. First, they aim to translate theory into practice by providing "a proper Supplement" to the three treatises (*The Theory of Painting*, *Essay on the Art of Criticism*, and *The Science of the Connoisseur*) in which Richardson *père* "had set out to change the way that Englishmen thought about the arts."[22] Second, they provide a catalogue upon which the traveler can depend for reliable information concerning location, condition, and attribution. Their third and fourth goals blend into each other: to offer an anthology of judgments that serves to constitute an artistic canon, and through the elucidation of such a canon "to enable any clear-thinking and methodical gentleman to become a connoisseur."[23]

The fundamental purpose behind all three treatises is "to endeavour to persuade our Nobility, and Gentry to become Lovers of Painting, and *Connoisseurs*."[24] Richardson *père* sets about promoting connoisseurship by breaking down the analysis of painting into categories (such as "Composition," "Colouring," and "Drawing") that will emphasize the essentially rational, empirical nature of what he seeks to impart. As Carol Gibson-Wood observes, he thereby reduces into a precise, learnable system "the whole procedure of making quality judgements . . . to be followed by the novice connoisseur."[25] Painting by painting, sculpture by sculpture, *An Account* offers "some Illustrations of, and Additions to what has been said in those Discourses . . . [an enterprise] in it Self Useful, and Entertaining to all that Love the Arts" (A4v).

In short, the Richardsons create connoisseurs by practicing connoisseurship. Their chosen vehicle is the first catalogue raisonné in English: "There are indeed Catalogues of her [Italy's] Pictures, and Statues . . . but These are as the Names of Towns in a Map, or Views of the Places, neither of which, not even the Latter are sufficient to give an Ideal of them. . . . We have gone in an Untrodden Path" (A5v–A6r). The way is clear and the need manifest because no one before them has told "not only that there Is such a Picture, and Where it is, but how Large, in what Situation, and in what Condition; what are the Thoughts, and how those Thoughts are Express'd; in short, what are its Beauties, and Defects throughout" (A6v). Their catalogue is "raisonné" in the fullest sense because it locates, describes, evaluates, and teaches the rational craft of judging. Unlike their predecessors, the authors of "Superficial Accounts" and "Panegyricks," the Richardsons "pretend to give a more Distinct Idea . . . . 'tis therefore we write" (A9v).

These "distinct ideas" take various forms. They include a precise listing of locations, organized by city; a catalogue of artists and their works; and a section devoted to "antiques." But the entries themselves do far more to carry out the goals of precision and completeness. The Richardsons' typical procedure is to inform the viewer of size,

medium, subject matter, and condition. He is then guided through the picture with commentary that focuses on composition, color, and iconography. Finally there comes a judgment, sometimes terse and detached, sometimes substantial and highly personal.

The cumulative effect of the Richardsons' annotations is to teach an elementary vocabulary of analysis, and to enforce an awareness of genre, period, and school. The vocabulary ranges from the technical ("chiaroscuro," "fore-shortnings") to the emotive ("prodigious," "gay and lightsome"). Mixing these terms judiciously, Richardson *fils* supplies a full range of exemplary responses—everything from single adjectives ("capital") through concise phrases ("the finest Night-Piece in the World") to pocket-dissertations. Annotated copies of *An Account* suggest that the Dick Minims of the period took up the invitation, culling from the Richardsons' glosses a set of catch-phrases that would form a useful repertoire of concise, memorable, and authoritative aesthetic judgments.

The more extended commentary tends to stress the ethical and intellectual stature of the visual arts, often by means of *ut pictura poesis* comparisons. For example, an inventory of the pictures in Rome's Palazzo del Cavaliere Cassiano dal Pozzo is punctuated with a brief essay on landscape painting that speaks to the Addisonian traveler steeped in Virgil's eclogues:

> Landskips are an Imitation of Rural Nature, of which therefore there may be as many Kinds, as there are Appearances of This sort of Nature; and the Scene may be laid in Any Countrey, or Age, With Figures, or Without; but if there are Any, as 'tis necessary there should be, Generally speaking, they must be Suitable, and only Subservient to the Landskip, to Enrich, or Animate it; Otherwise the Picture loses its Denomination, it becomes History, a Battel-piece, etc. or at least 'tis of an Equivocal kind. This sort of Painting is like Pastoral in Poetry. (p. 186)

As this passage suggests, the Richardsons, for all their interest in providing the tools of visual analysis, are inclined to use questions of decorum and "Denomination" to downplay the medium itself, lest too concentrated a focus on technique undermine their campaign to promote the dignity of art. The visual education available in Italy, they suggest, ranks with and correlates to the historical and literary goals of the Tour. Therefore a Raphael must always take precedence over a Titian, for the one improves the mind, while the other merely gratifies the senses. Accordingly, the Richardsons embellish an extended account of Raphael's Vatican frescoes with their version of an epic simile:

> As in a History, or a Poem, the Goodness of the Language, and the sweet Cadency, and Sonorousness of the Verse will not be sufficient if the Characters be not Just, Proper, and Firmly pronounc'd, and the Story set in the most advantageous Light; So the Great Style of Painting, Beautiful Colouring, True Drawing, and a Free, Bold, or Delicate Pencil make a poor amends for the want of such an Essential, and Fundamental Quality of a Good Picture, as the Fine, and Just Thought. (p. 243)

Such a move from the visual to the verbal and back to the visual typifies their rhetorical strategy throughout, as the text-based Tourist learns to see and to value by experiencing one mode in terms of the other.

37

Nevertheless, the Richardsons' ultimate purpose is more complex and more ambitious than rationalizing connoisseurship on the way to exalting the visual arts: it is to teach taste, which fuses pleasure and knowledge. With this end in view they model a response to painting and sculpture that begins in technical understanding and ends in emotive exaltation. Standing before the *Venus de' Medici* in Florence, Richardson *fils* moves from a precise note on materials and condition ("of clear White Marble turn'd a little Yellowish") through comments on proportion ("the Head is something too little for the Body") to a forceful declaration of rapture: "When I had spent above ten Hours in this Gallery, considering the Beauty of the Statues there, and perpetually found something new to admire, 'twas yet impossible to keep my Eyes off of this three Minutes whilst I was in the Room" (pp. 55–56). The compleat virtuoso, such entries imply, must train his eye to discriminate minutely and to judge incisively; as Lawrence Lipking observes, "Richardson's connoisseur is a sort of intellectual athlete dedicated to the full pursuit of lucidity."[26] Yet lucidity remains the means to an end: the "gust" for sublimity.

For the Richardsons the work of Raphael most fully defines and instils the phenomenon of the sublime. In the entries concerned with his masterpieces, they turn theory into practice, precept into example, analysis into encomium. Recreating his experience of the *St. Cecilia* in Bologna, Richardson *fils* concentrates his attention first on the dimensions, placement, and condition of the picture:

The famous St. *Caecilia*; Figures as big as the Life, and stands where 'twas first placed: it has never been removed since: There is the old, plain, Gold Frame, that seems to be what it had at first. 'Tis very well preserv'd, except a Line of about half a Foot in breadth quite cross the Picture, over against the Candles which are light up before it during Divine Service, and here the Colours are perfectly fry'd.

The next phase is that of judicial criticism, in which he situates the work within Raphael's career and analyzes its composition:

It is not in his last manner (as 'twas done several Years before his Death) but rather something Dry and Stiff, and the Tinct a little Dark. 'Tis not properly a History, but the Pictures of five several Saints; Of these St. *Caecilia*, St. *Paul*, and St. *Mary Magdalen*, stand next the Eye; she from whom the Picture is denominated in the midst; over her Head are Angels with Musick, to which she seems attentive; these take up but little room, and enrich the Picture: In the two Spaces between these three Saints, come in the upper parts of St. *John* and St. *Austin*.

Finally, having criticized Raphael's figures for being "a little hard, and not elegantly drawn," he steps back from the picture and gives way to superlatives, exalting in the process Pope's "grace beyond the reach of art": "At a distance they are much sweeter, and the Colours are very fresh, and pleasing: So that upon the whole this Picture has a certain *je ne scay quoy* that puts it with me on a level almost with any, hardly excepting the Transfiguration" (pp. 33–34).

This passage and others like it fulfil an interlocking set of purposes. They create a hierarchy of value, not only among artists but within a given artistic oeuvre. They construct the connoisseur and define his progress, adding to the Tour a program, a

regime, a route, and a sense of community. As Patricia Meyer Spacks has noted, "the established itinerary of statues and paintings as well as cities unified English visitors in a controlled common experience."[27] Within a matter of years, *An Account* had combined with the narratives of Burnet and Addison to form a joint rule—"rule" in the Johnsonian senses of "canon" and "precept by which the thoughts or actions are directed."[28] By the late 1720s, as John Breval's *Remarks on Several Parts of Europe* makes clear, the educational theory behind the Tour gave equal emphasis to the political, the literary, and the visual aspects of the experience. "The great Rule I would have therefore every Traveller lay down to himself," writes Breval, "is this; that he is entring into a vast School, the Minute he sets his Foot upon the Continent."[29] In this vast school the traveler should aim for "Knowledge of Antiquity, History and Geography." To these, Breval adds "Connoissance, a Study much in Fashion again . . . whose principal Objects are Sculpture, Painting, Medals and Architecture." To a great degree this ambitious composite scheme owes its content and its influence to the three texts we have just been considering.

### Reaction Formation

As we observed in Chapter 1, ambivalence towards the Tour permeates the blueprint itself, Lassels' *Voyage of Italy*, while concerted attacks upon it go at least as far back as Locke's *Some Thoughts Concerning Education* (1693). During the subsequent half-century, the substance of Locke's objections resurfaces periodically in such forms as a letter from "Philip Homebred" (published in the *Spectator*, no. 364), which compares the Tour to building "a gaudy Structure without any Foundation."[30] Not until the appearance of *Dunciad* IV, however, does a continuous tradition of anti-narrative develop. Hard on the heels of Pope's satire appears Soame Jenyns's *The Modern Fine Gentleman;* in swift-moving heroic couplets, the poem describes a Hogarthian "progress" that begins with the Tour:

> Just broke from School, pert, impudent, and raw,
> Expert in Latin, more expert in Taw,
> His Honour posts o're ITALY and FRANCE,
> Measures St. PETER's Dome, and learns to dance.
> Thence, having quick thro' various Countries flown,
> Glean'd all their Follies, and expos'd his own,
> He back returns, a Thing so strange all o'er,
> As never Ages past produc'd before:
> A Monster of such complicated Worth,
> As no one single Clime could e're bring forth:
> Half Atheist, Papist, Gamester, Bubble, Rook,
> Half Fiddler, Coachman, Dancer, Groom, and Cook.[31]

Returned from the Continent, "th'accomplished Gentleman" enters Parliament, loses his money at the gaming table, temporarily recoups his fortunes by marrying "some jointur'd antiquated Crone," and sinks finally into destitution and death.

The plot of Gilbert West's "On the Abuse of Travelling" (1751) centers on the temptation of a Spenserian knight-errant rather than the ruination of a Hogarthian rake. The allegorical narrative begins with praise of ancient Sparta, whose youth were preserved from temptation and consolidated in civic virtue by a prohibition on foreign travel. It then recounts the wiles of Archimago, who lures the Redcross Knight across "the salt wave" (the English Channel) to "a spacious plain . . . with goodly castles deck'd on ev'ry side" (France). There the Knight encounters a damsel called "Politessa" but resists her blandishments and the "gorgeous splendour" around him with the help of a magical mirror, which exposes "the gaudy scene" for what it is—a cankered kingdom of "base Dependence" and "throbbing" discontent. The Knight then progresses to a ruined city (Rome), where he is tempted yet again by "a lady fair" called Vertu. Vertu presides over a court full of "mimes, fiddlers, pipers, eunuchs squeaking fine," as well as those who care for "nought but tunes, and names, and coins." The Knight mourns the spectacle of these "virtuosi vain and wonder-gaping boys," and then addresses a concluding exhortation to "Ye who enjoy that freedom she [Rome] has lost": "Learn virtue, justice, constancy of mind, / Not to be mov'd by fear or pleasure's train; / Be these your arts, ye Brave! these only are humane."

During the course of the 1750s, such Popean attacks spread to other genres as well: for example, Samuel Richardson's massive *Sir Charles Grandison* (1753–54) critiques the Tour through the continental experiences of its exemplary hero, while Thomas Sheridan's *British Education; or, The Source of the Disorders of Great Britain* (1756) inveighs against "the follies, fopperies, vices and luxuries" imported by the Grand Tourist.[32] Attacks like these diminished during the Seven Years' War (in direct proportion, it is likely, to Touring itself) but with the Treaty of Paris (1763), criticism not only revived but intensified. The end of the war, Linda Colley argues, provoked widespread malaise and self-questioning among the victorious British: "rather like the frog in the Aesop fable which exploded in trying to compete with the ox, at the end of the day they were left wondering if they had overstretched themselves, made nervous and insecure by their colossal new dimensions."[33] Part of this national insecurity had to do with Great Britain's ability to respond effectively to the political and administrative demands of farflung empire. How could such power be both wielded and controlled; how could "the Great Game" be played?[34] As a variety of post-war responses makes clear, it was in this atmosphere that the Tour's deficiencies—compounded by the charge of anachronism—came starkly into focus.

In January 1764, less than a year after the official end of the Seven Years' War, there appeared the most systematic of all assaults on the Tour, Richard Hurd's *Dialogues on the Uses of Foreign Travel Considered as a Part of An English Gentleman's Education: Between Lord Shaftesbury and Mr. Locke*. The two dialogues, in essence a single conversation between misguided and former pupil (Shaftesbury) and truth-seeking tutor (Locke), purport to record an exchange that took place in 1700, at a gathering that included Robert Molesworth. Hurd's ultimate inspiration is a Platonic dialogue such as the *Gorgias*, in which a plainspoken Socrates, concerned with the fundamentals of virtue and the Good Life, exposes sophistic rhetoric as superficial "make-up" or "cookery."[35] The immediate occasion, however, is an ongoing campaign against Shaftesbury fueled by the animosity of Hurd's patron, William Warburton: in the

40

"Dedication to the Free-Thinkers" prefixed to his *Divine Legation of Moses* (1738), Warburton had attacked Shaftesbury for his misrepresentation of Locke, and then incited Pope and other friends to carry on the offensive. Hurd's *Dialogues*, therefore, belong to a group of polemical texts that includes *Dunciad* IV and John Brown's *Essays on the Characteristics* (1751).[36] However, they do far more than perpetuate a decades-old quarrel and synthesize a critique that descends from Locke's treatise on education. By adroitly manipulating his two speakers, Hurd first robs the Tour of any claim to intellectual legitimacy and then advances a counter-proposal that responds to Great Britain's newly reinforced imperial identity.

As the full title of the *Dialogues* suggests, Hurd causes his versions of Shaftesbury and Locke to explore the issue of "foreign travel"—specifically, "whether . . . *Travel* be not an excellent school for our ingenuous and noble youth."[37] In the opening skirmish, "Shaftesbury" defines his most basic educational goal—what he calls "civility"—and exalts the Grand Tour as the only means to that end. For the time being, "Locke" refrains from attacking the goal, and limits his criticisms to the Tour as a method. Using the emotive language of disease, he maintains that only if "youths" (young men between the ages of sixteen and twenty-one) are kept at home can they be preserved from "the infection" of the vices that "rage with great virulence" abroad (p. 23). "Shaftesbury" counters by extolling the protective powers of the bearleader or "sage Philosopher" who accompanies the young traveler. His opponent's rejoinder constitutes Hurd's first direct assault on the Tour: "The question at present is . . . of raw, ignorant, ungovernable boys, on the one hand, and of shallow, servile, and interested governors, on the other . . . sauntring within the circle of the grand Tour" (p. 25).

This "circle" is for Hurd's Shaftesbury not constricting but liberating. In an animated paean to the Tour he proceeds to extol its many benefits. Through a sort of reverse Circean "magic" the young Tourist is liberated from boorish manners and insular prejudices, from the "many low habits and sordid practices [that] grow upon our youth of fortune, and even of quality, from the influence of their family, or at best provincial, education" (p. 41). Furthermore, the Tour polishes the "mind," the "person," and the "understanding" of the traveler by acquainting him with "men of eminent parts and genius"; thus the gentleman is formed by the "intimate study and knowledge" of other gentlemen. The Tour also teaches a "Knowledge of the world" that comprises "acquaintance with the customs, and usages of others nations [and] . . . their policies, government, religion" (pp. 48–52). The gentleman is thereby converted into a statesman who will appear with "lustre . . . in the court or senate of his own country!" (pp. 51–52, 54). Finally, the Tour makes the traveler into a connoisseur, teaching the "liberal arts" of painting, sculpture, architecture, and music (p. 57). According to "Shaftesbury," none of these arts can be learned at home, where a "monkish education" enslaves those who do not make the Tour to "servile and false systems" of scholastic learning (pp. 66–67).

In Dialogue II, "Locke" responds with a Socratic series of questions, counter-arguments, and substitute proposals. He begins by suggesting that his opponent's idea of education has more to do with a "varnish of manners and good breeding" than with the "way to erect a solid edifice": "what a reasonable man wants to know, is, The proper method of building up *men*: whereas your Lordship seems sollicitous for little more

than tricking out a set of fine *Gentlemen*" (pp. 70–71). Here and elsewhere, "Locke" attacks "Shaftesbury" for valuing and promoting the merely graceful and attractive—for placing "shewy and ornamental accomplishments" ahead of "solid advantages" (p. 91). Metaphors of acting, painting, and scenic decoration enforce the contrast between education conceived as training in social adroitness and education as the means toward self-knowledge.

In the middle section of the second dialogue, "Locke" moves from goals to methods. Hurd causes him to argue that, even if one grants limited validity to the Grand Tour, one is forced to concede how often it proves counter-productive. For one thing, the experiences that are thought to turn England's male elite into capable leaders actually have the opposite effect: by advocating continental travel as the antidote to "rusticity," "Shaftesbury" actually promotes "an effeminate and unmanly foppery" (p. 105). It is clear that Hurd, speaking through "Locke," would not rule out travel, but would have it occur at a later stage, when the judgment is seasoned: to send young patricians to Europe when "Shaftesbury" proposes is to "cramp their faculties, effeminate the temper, and break that force and vigour of mind which is requisite in a man of business for the discharge of his duty, in this free country" (pp. 114–15).

Hurd's *Dialogues* reach their climax in a fervent recapitulation of this critique, combined with a vision of travel better suited to the formation of manly rulers. For one last time Hurd brings back the image of the Grand Tour as "circle" and adds to it the idea of "prospect": "The tour of *Europe* is a paltry thing: a tame, uniform, unvaried prospect; which affords nothing but the same polished manners and artificial policies, scarcely diversified enough to take, or merit our attention" (p. 156). This concept of educational travel, always questionable, has by now utterly exhausted any utility it might once have possessed. The only means by which the circle can be extended and the prospect diversified is travel in young adulthood, and travel that adopts a radically different itinerary. Instead of embarking at sixteen, the young man should be kept at home ("in his college; in a friend's, or his father's house") until he is less at risk of being swept away by a "torrent" of confused, superficial, and even dangerous impressions (pp. 138–42). And when he does set off on his travels, he should explore the further reaches of the non-European world, specifically the boundaries of Great Britain's newly acquired empire: "I would say then, 'That to study Human Nature to purpose, a Traveller must enlarge his circuit beyond the bounds of Europe. He must go, and catch Her undressed, nay quite naked in *North America*, and at the Cape of *Good Hope*'" (p. 155).[38] Language of observation shades into a sexualized language of conquest: a male traveler "catches" a female Nature "quite naked," and proceeds by implication to possess her. This "lay of the land" trope, which pervades the literature of colonialism, helps to emphasize the political implications of Hurd's scheme.[39] His young traveler, pursuing an exotic new itinerary, substitutes the possession of nature for the acquisition of culture, and thereby equips himself to become a "senator"—"for this is the station to which our greater citizens do, and our best should aspire" (p. 76).

In the course of the two dialogues, both speakers are made to exemplify the ideas they expound. Though polished in manner, "Shaftesbury" betrays a shallow intelligence: exalting style over substance, he despises British "rusticity," and with brittle grace continues to uphold an exclusively European ethos. Once he has been resound-

ingly defeated by "Locke," his only refuge is evasion and condescension to "the old man" (p. 201). "Locke," on the other hand, is polite but forthright, learned but commonsensical, an enemy of specious reasoning and received ideas. He may seem to represent the past, but he speaks powerfully for the future. In staging this confrontation Hurd reaches back to the earliest stages of the debate over the Tour in order to write (somewhat prematurely) its epitaph.

## The Back Parts of Venus

Promoter of cosmopolitan "civility," Hurd's Shaftesbury stigmatizes "the idiot PREJUDICES of our home-bred gentlemen"—those "warm patriots" who, disdaining all that is foreign, are justly "considered by the rest of *Europe*, as proud, churlish, and unsocial" (pp. 35–39). *Travels through France and Italy . . . by T. Smollett, M.D.* (1766) exults in such criticism, making of British insularity a supreme virtue and continental sophistication a pernicious vice. In his structural and stylistic choices, Smollett subverts the literary conventions attached to narratives of the Tour; in his linked array of targets, he explodes the values that give it continuing allure. The intensity of this assault upon the Tour will become apparent if we examine first the identity of the narrator, a stylized version of "T. Smollett, M.D.," and then turn our attention to the objects of his satire.

Smollett's *Travels* takes the form of epistolary reports addressed to a variety of correspondents. In every letter Smollett emphasizes his identity as physician, who travels in search of health but attends as much to the diseases and unhygienic practices of those he encounters as to the condition of his own consumptive body. Throughout the book, moreover, Smollett's diagnoses extend from microcosm to macrocosm: activating the traditional comparison between doctor and satirist, he anatomizes the state in terms of the citizen, and moral disabilities in terms of physical.[40] As physician and as satirist he exhibits the same combination of traits: unflinching care for detail, no matter how minute or repellent; passionate honesty in the compilation of case histories; vigorous impatience with pretense, disguise, ignorance, or affectation. Everywhere and in every way he remains "a man of a true English character," "soon tired of impertinence, and much subject to fits of disgust."[41]

The formal traits of Smollett's *Travels* reflect the same qualities and priorities. As a narrative of extended continental travel, it breaks sharply with tradition in several important respects: the absence of dedication to a prince or aristocrat; the choice of addressees, all of whom appear to come from the professional classes or "middle station"; the rejection of standard Grand Tour routes, responses, and guidebooks (Thomas Nugent's *The Grand Tour* chief among them). Smollett's stylistic choices, moreover, differentiate him from the Addisonian model in particular. Taking his cue from Juvenal, he engages an encyclopedic array of topics through a complete gamut of styles: along with the abrupt rejection of Chesterfieldian graces goes the discordant juxtaposition of privies to temples, the demotic to the erudite, the scatological to the sublime.[42] This offensive is quite deliberately offensive, substituting a vigorous farrago for a decorous rehearsal of commonplaces.

Smollett's most telling assaults on the Tour occur in letters that combine a Juvenalian posture of savage indignation with a detailed satiric catalogue. During his stay in Rome, for example, Smollett eviscerates the young British cognoscenti he has been observing everywhere:

> I have seen in different parts of Italy, a number of raw boys, whom Britain seemed to have poured forth on purpose to bring her national character into contempt: ignorant, petulant, rash, and profligate without any knowledge or experience of their own. . . . One engages in play with an infamous gamester, and is stripped perhaps in the very first partie: another is poxed and pillaged by an antiquated cantatrice: a third is bubbled by a knavish antiquarian; and a fourth is laid under contribution by a dealer in pictures. Some turn fiddlers, and pretend to compose: but all of them talk familiarly of the arts, and return finished connoisseurs and coxcombs, to their own country. (p. 241)

"Poured forth," "stripped," "poxed," "pillaged," "bubbled," "laid under contribution": the sequence of verbs itself offers a satiric redefinition of the Tour. These "raw boys," too young to control themselves or to make intelligent choices, fall victim to a variety of seducers: card sharps, singers, whores, dealers in pictures and antiquities. The narrator's acute vision and truthful reportage contrast ironically with the blindness of those who look but do not see (the prey) and those who see but disguise the truth (the predators). Lassels' worst nightmare comes true in this panorama of national shame that becomes a source of national corruption, as young dupes turned "connoisseurs and coxcombs" return to rule "their own country."

This passage and others like it make coruscatingly clear the reasons for Smollett's opposition to the Tour. It distracts and corrupts at the most impressionable age, initiating young men into a debauched version of adulthood. It offers a mockery of an artistic education. It contaminates the traveler literally by immersing him in dirt—dirt which is everywhere, even in the court of Versailles and the palaces of Rome (pp. 45, 243). It contaminates him socially and ethically by robbing him of delicacy, "which is the cleanliness of the mind" (p. 33). It turns him not only into the parody of a connoisseur but into a fashion plate as well: in Paris the Tourist "cannot appear until he has undergone a total metamorphosis" (p. 49). By aping fashionable dress and manners the traveler learns ostentation, indecency, and an unmanly subjection to the whims of women. Smollett's portrait of the fashionable Parisienne correlates precisely to his version of the Italian virtuoso:

> On the whole, when I see one of those fine creatures sailing along, in her taudry robes of silk and gauze, frilled, and flounced, and furbelowed, with her false locks, her false jewels, her paint, her patches, and perfumes, I cannot help looking upon her as the vilest piece of sophistication that art ever produced. (p. 54)

"Sophistication" of exterior masks "the defects of nature" as well as the absence of education: Frenchwomen are sent, according to Smollett, "for a few years, to convent, where they lay in a fund of superstition that serves them for life: but I never heard they had the least opportunity of cultivating the mind, of exercising the powers of reason, or of imbibing a taste for letters, or any rational or useful accomplishment" (p. 54). As

is the convent, so is the Grand Tour. It is therefore grimly appropriate that the Tourist, in paying court to such "pieces of sophistication" and superstition, becomes what he admires (and often acquires)—that which is decorative but inauthentic, beguiling but corrupting. His continental travels, in short, make the young gentleman not "compleat" but unclean.[43]

To these misguided codes and ruinous practices, Smollett juxtaposes a set of explicit alternatives that are also implicit remedies. Mocking "the nice discernment and delicate sensibility of a true connoisseur" (p. 271), he substitutes for superficial and even duplicitous dilettantism a sturdy independence of judgment: "very likely I may incur the ridicule of the virtuosi for the remarks I have made: but I am used to speak my mind freely on all subjects that fall under the cognizance of my senses" (p. 231). He will admire the *Venus de' Medici*, a canonical favorite before whom the Grand Tourist is meant to rhapsodize, but he will do so strictly on his own terms: "I cannot help thinking that there is no beauty in the features of Venus; and that the attitude is aukward and out of character. . . . [But] the back parts especially are executed so happily, as to excite the admiration of the most indifferent spectator" (p. 227). Another stock object of admiration, Raphael's *Madonna della Sedia*, is judged "defective in dignity and sentiment," and as for the same artist's *Transfiguration*—"if it was mine, I would cut [it] in two parts" (pp. 231, 277). Unlike the Richardsons he cultivates eccentricity of judgment; unlike Addison he finds a great deal wanting in the monuments of classical antiquity. Although the Pont du Garde, a Roman aqueduct outside Nîmes, compels his admiration, none of the bridges over the Tiber can rival "that of Westminster, either in beauty, magnificence, or solidity," and "as for the Tyber, it is, in comparison with the Thames, no more than an inconsiderable stream, foul, deep, and rapid" (p. 237). So too the surviving records and archaeological remains give a "contemptible idea" of Roman naval power: "I do believe, in my conscience, that half a dozen English frigates would have been able to defeat both the contending fleets at the famous battle of Actium" (p. 263). At all times he selects carefully what he includes, records truthfully how he reacts, and describes solely what he sees—unlike the typical Grand Tourist: "If I was silly enough to make a parade, I might mention some hundreds more of marbles and pictures, which I really saw at Rome; and even eke out that number with a huge list of those I did not see; but, whatever vanity I may have, it has not taken this turn; and I assure you, upon my word and honour, I have described nothing but what actually fell under my own observation" (pp. 278–79).

Not only does Smollett reject the stock glorification of "the Ancients" that underpins the Grand Tour, he also finds offensive the extent to which Great Britain takes cultural dictation from France, in much the way that Rome had imitated Greece: "The French, however, with all their absurdities, preserve a certain ascendancy over us, which is very disgraceful to our nation" (p. 48). Behind the diatribes and apparent xenophobia that characterize the *Travels* lies the impulse to demystify the Continent, the classical past, the hegemony of the elite, and the Tour as prop to such hegemony. Along with such demystification goes an implicit call to relocate cultural authority away from the sons of the Tour—to celebrate Great Britain's history, geography, monuments, and citizenry. In his final letter he declares, "I am attached to my country, because it is the land of liberty, cleanliness, and convenience" (p. 327). By the end of the book, the

Grand Tourist has been identified as the great defiler, who imports impurities of every description into his native land. Smollett's healing journey, which appears to have restored his body to health, offers as well a restorative program for his nation.

## The Sentimental Traveler and the Peregrine Martyr

The received approach to Laurence Sterne's *A Sentimental Journey through France and Italy* (1768) is to consider it a riposte to Smollett's *Travels*, in which satire of "the learned SMELFUNGUS" as "splenetic traveler" underscores the importance of "a quiet journey of the heart in pursuit of NATURE."[44] This perspective has several advantages: it highlights the ongoing contrast between "spleen" and "sentiment," quarreling and communing; it draws attention to Sterne's extensive web of allusions to the *Travels*, many of them important but easily missed; and it helps to emphasize the connections between Sterne's philosophy of travel and his idiosyncratic prose. To accentuate the differences, however, is to ignore or to downplay one essential fact: both the *Travels* and the *Journey* define themselves in opposition to the Tour and narratives spawned by it. Moreover, both Smollett and Sterne propose essentially the same solution: education of the young gentleman in a united and enlightened Great Britain. Smollett would improve Raphael's *Transfiguration* by cutting it in two; Sterne would rather observe the temple of the human heart "than the transfiguration of Raphael itself" (p. 219). This contrasting but complementary response to a venerable master-piece exemplifies their unity-in-discrepancy. In equally emphatic ways, both confront the same issue at the same historical moment, vigorously rejecting standard sights, standard agendas, and standard topoi.

*A Sentimental Journey* concentrates and climaxes a satiric campaign that had begun early in Sterne's literary career. It is often forgotten that *Tristram Shandy* originated (according to John Croft, the brother of Sterne's friend Stephen) as a species of Grand Tour narrative: "Sterne said that his first Plan, was to travell his Hero . . . all over Europe . . . and at length to return Tristram well informed and a compleat English Gentleman."[45] Traces of this original conception are reflected in Tristram's promise to tell the "most delectable narrative" of his continental tour as bearleader to "Mr. *Noddy's* eldest son."[46] The promise is unfulfilled: instead, Sterne provides in Volume VII of *Tristram Shandy* what he describes elsewhere as "a laughing good temperd Satyr against Traveling (as puppies travel)."[47]

This "Satyr against Traveling" may be "laughing" and "good temperd," but it is also aggressive and unflagging. Even before Tristram embarks at Dover, he is calling his priorities into question: "Now hang it! quoth I, as I look'd towards the French coast— a man should know something of his own country too, before he goes abroad—and I never gave a peep into Rochester church, or took notice of the dock of Chatham, or visited St Thomas at Canterbury, though they all three laid in my way" (p. 577). No sooner does he reach Calais but he mocks the hallowed conventions and founding fathers of Grand Tour narrative, especially "the great Addison who . . . [wrote and gallop'd . . . gallop'd and wrote] with his satchel of school-books hanging at his a—and galling his beast's crupper at every stroke" (p. 580). Throughout his journey, in fact, he

46

parodies the sober, edifying, standardized approach to traveling and travel-writing. Rabelaisian *contes* take the place of formulaic catalogues (pp. 606–14), and when such catalogues appear, they are deliberately meaningless (p. 602). A story of two separated lovers or communion with "a poor ass" takes precedence over "all the *Frusts*, and *Crusts*, and *Rusts* of antiquity" (pp. 627–29). To such "important" sights as Fontainebleau (allocated several pages in Nugent's *Grand Tour*), Tristram devotes the briefest and most dismissive of comments: "— all you need say of *Fontainbleau* (in case you are ask'd) is, that it stands about forty miles (south *something*) from Paris, in the middle of a large forest—That there is something great in it —" (p. 616). Correspondingly, the one remarkable feature of Amiens is not the cathedral but the fact that the "very handsome" daughter of the innkeeper at Montreuil "went there to school" (pp. 588, 596).

In a pointed display of mock-biblical exegesis, Sterne suggests through Tristram that the Tour fulfills the Psalmist's curse of perpetual motion: "'*Make them like unto a wheel*,' [Psalm 83] is a bitter sarcasm, as all the learned know, against the *grand tour*, and that restless spirit for making it, which David prophetically foresaw would haunt the children of men in the latter days" (p. 592). The Davidic prophecy is fulfilled because the traveler condemns himself to mindless rotation through the circle of the Tour— ignoring the important, magnifying the trivial, and letting guides and guidebooks determine the itinerary. Tristram's mode is both critique and antidote. Speeding through Paris, he

> cannot stop a moment to give you the character of the people—their genius—their manners—their customs—their laws—their religion—their government—their manufactures—their commerce—their finances . . . qualified as I may be, by spending three days and two nights amongst them, and during all that time, making these things the entire subject of my enquiries and reflections—(p. 604)

Refusing to pause and venerate according to expectation, he will linger, observe, and narrate precisely where the Tourist draws only a blank. In his travels he exalts "insignificant" detail, fortuitous encounters, and emotional engagement with people, animals, and landscapes. It is entirely appropriate, therefore, that Sterne's "Satyr" should end by contrasting the blinkered vision of such a traveler, for whom "a large rich plain . . . presents nothing to the eye," with the vividness of Tristram's experience as he crosses Languedoc. His "plain stories" include encounters with a seller of figs, a maker of drums, and a group of dancing peasants at sunset: "In short, by seizing every handle, of what size or shape soever, which chance held out to me in the journey—I turned my *plain* into a *city*" (p. 648). We leave Tristram, not traveling conscientiously and reporting judiciously, but dancing his way in merrily improvised fashion through the fields of southern France.

Sterne's campaign accelerates in a sermon on the prodigal son, whose concluding paragraphs take up the subject of travel in general and the Tour in particular. It is probable that Sterne added this conclusion as he was revising the sermon for publication in 1765: the section on the Tour is tenuously related to the body of the sermon, and in style and substance it shows the influence of Hurd's *Dialogues* (published the preceding year).[48] In the sermon's final stages, Sterne shifts abruptly from an

interpretation of the parable from Luke to an attack on the Tour. He begins by conceding that "this desire for travelling . . . is no way bad,—but as others are,—in it's mismanagement or excess."[49] The advantages of travel "rightly ordered" include knowledge of "the languages, the laws and customs . . . of other nations," acquisition of "urbanity and confidence of behaviour," and removal from "the company of our aunts and grandmothers" (pp. 152–53). Yet the Tour as actually practiced undercuts such potential benefits.

The final part of the conclusion is cast as a dialogue between two unnamed speakers, who reenact a condensed version of the conversation between Hurd's "Locke" and "Shaftesbury." The counterpart to "Locke" begins by pointing out that the Tour "carries our youth too early out, to turn this venture to much account; on the contrary . . . the scene painted of the prodigal in his travels, looks more like a copy than an original" (p. 154). The interlocutor responds with a version of the point made by "Shaftesbury" in the *Dialogues*: "But you will send an able pilot with your son—a scholar" (p. 155). This defense is countered by the objection that, in practice, the so-called "able pilot" is worse than useless: Sterne (who had several times thought of acting as a bearleader himself) proceeds to stress the absurdity of entrusting a pupil to such a guide. The dialogue ends by exploding the hope that, by conversing "with men of rank and letters," the young man will return improved. In fact the opposite proves true: shut out from such company by his inexperience, the traveler "seeks an easier society," and the inevitable result is that "the poor prodigal returns the same object of pity, with the prodigal in the gospel" (p. 160).

The preface to *A Sentimental Journey* (a preface which, with Shandean perversity, is embedded in the narrative) completes and extends the argument of the sermon's conclusion. Strikingly enough, it does not offer a brief for "sentimental" travel; nor does it concentrate on satirizing the "splenetic" mode. Rather, it continues the campaign against the Tour in such a way as to ally Sterne with Smollett. After dividing travelers into three categories—those impelled abroad by "infirmity of body," "imbecility of mind," and "inevitable necessity"—Sterne concentrates on the third category. With biting irony he presents the Grand Tourist as a species of martyr or prisoner, condemned by his elders and shackled to his bearleaders:

> The third class includes the whole army of peregrine martyrs; more especially those travellers who set out upon their travels with the benefit of the clergy, either as delinquents travelling under the direction of governors recommended by the magistrate—or young gentlemen transported by the cruelty of parents and guardians, and travelling under the direction of governors recommended by Oxford, Aberdeen and Glasgow. (p. 79)

After playing variations on the theme of the "peregrine martyr," the preface bursts forth in a patriotic eulogy whose intensity rivals that of Smollett's paean to "my country." Sterne proposes that "the poor Traveller, sailing and posting through the politer kingdoms of the globe in pursuit of knowledge and improvements," stay at home, "especially if he lives in a country that has not absolute want of either." All the more foolish, therefore, is the practice of leaving such a kingdom as Great Britain has become:

But there is no nation under heaven—and God is my record, (before whose tribunal I must one day come and give an account of this work)—that I do not speak it vauntingly—But there is no nation under heaven abounding with more variety of learning—where the sciences may be more fitly woo'd, or more surely won than here—where art is encouraged, and will so soon rise high—where Nature (take her all together) has so little to answer for—and, to close all, where there is more wit and variety of character to feed the mind with—Where then, my dear countrymen, are you going—(pp. 84–85)

Throughout this passage, Sterne echoes Joseph Hall's seventeenth-century treatise *Quo Vadis? A Just Censure of Travel Commonly Undertaken by the Gentlemen of our Nation*, in order to reinforce the truth he is propounding: "knowledge and improvements" are more likely to be acquired from the books in one's library than the itinerary of the Tour.[50] But by intensifying the praise of England, and directing it specifically to the "peregrine martyr," Sterne joins Smollett in a call to shift cultural authority from the Continent to contemporary Great Britain. The preface proposes, in effect, that the Tour be repealed for good. Only the learned reader of *A Sentimental Journey* could have grasped the allusion to Bishop Hall, but all would understand the biblical resonance of Yorick's final question: "Where then, my dear countrymen, are you going —."[51] The dash, as so often in Sterne, conjures up a multitude of possibilities. In this case, none of them can be recommended: to be a "countryman" is quite enough.

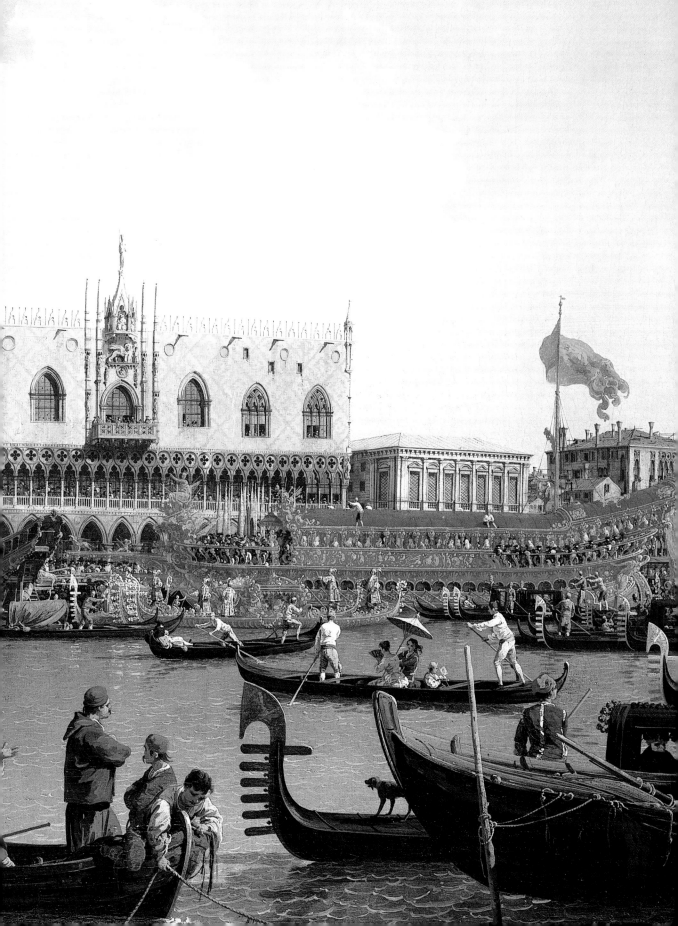

CHAPTER 3

# *Myths*

Samuel Johnson, writing from the Hebrides, converted his own experience into a resonant maxim: "The use of travelling is to regulate imagination by reality, and instead of thinking how things may be, to see them as they are."[1] Canny as he was about the social imperatives behind the Grand Tour—"A man who has not been in Italy, is always conscious of an inferiority"—Dr. Johnson was mistaken when it came to identifying "the use of travelling" to eighteenth-century Venice.[2] The milordi who stopped there on the way to or from Rome went to see what they had already imagined—and the fantasies through which the city was filtered came not from reality but from a potent set of pre-existing myths.

The chapter that follows begins by tracing the Republic's enduring fascination as a political model. It then adduces a wide range of firsthand responses to the city's ambiguous allure. After a close look at the annual ceremony of the "Sposalizio al Mar," the chapter ends by analyzing examples of Venice reimagined and reconstructed in Great Britain. My account of Venice's mythic aura makes use of three aspects or categories: the first ("Venezia-stato-misto") highlights Venice's governmental structure, the second ("Venezia-stato-di-libertà") her reputation for tolerance, the third ("Venezia-città-galante") a culture of diversion and display made possible by the first two.[3] It is these categories I would like to deploy and ultimately to elide in assessing the hold of Venice upon the imagination—largely unregulated—of the British traveler.

## *A Maiden City*

The significance of the "stato-di-libertà" myth can best be summarized by tracing a line of intellectual descent that reaches back to the late fifteenth and early sixteenth centuries.[4] The humanist historiography of this period maintained that from its foundation the Venetian Republic had acknowledged neither imperial jurisdiction nor imperial codes of law, governing itself in all matters according to local custom. The most influential of these humanist texts is Gasparo Contarini's *De magistratibus et republica Venetorum* (1543), whose popularity in England was enhanced by Lewes Lewkenor's eloquent translation (*The Commonwealth and Government of Venice*, 1599). Contarini codifies the "stato-di-libertà" myth and its companion, "Venezia-stato-misto," by arguing that the Venetian constitution most perfectly

51

7. Detail of Plate 10. The *Bucintoro*.

embodies the principles adumbrated by Aristotle and analyzed by Polybius: the ideal polity is that which distributes power amongst the elements of the one, the few, and the many, thereby achieving a harmonious blend of monarchy, aristocracy, and democracy. Such a combination guarantees stability and longevity because it reflects the most basic principle of natural order, a balance among potentially competing forces. In the case of the Venetian commonwealth, an elaborate system of checks and balances ensured that neither the doge (the one), nor the Senate (the few), nor the Great Council (the many) could usurp authority. This system allowed the Republic to steer a middle course between the extremes of tyranny and anarchy, and to resist potentially destructive forces from without.

Contarini explains the details of the Venetian political system as part of his ongoing celebration of the Republic's independence: it is the case that Venice "(which we have not read hath happened to any other city) from the first building therof, even until this time, being now a thousand and one hundred yeares . . . hath preserved it selfe free and untouched from the violence of any enemie."[5] As this proud declaration implies, Venice was superior even to Rome in her record of survival. She excelled Rome in other respects as well: she had never declined from a republic into a tyranny, she had dedicated herself on most occasions to a policy of peace, and she boasted a judicial system that in all its aspects promoted the interests of the state.

Contarini's encomium, and the myth it helped to promulgate, were validated afresh by the Papal Interdict of 1606–07, when Venice successfully withstood Paul V's aggressive attempts to undermine her autonomy. One of the principal architects of the Venetian resistance, Father Paolo Sarpi, acquired a heroic reputation in England for his courageous and eloquent defense of the rights of the secular state. Sir Henry Wotton, ambassador during the Interdict and an active supporter of Sarpi, clinched England's sympathetic identification with the Venetian cause by suggesting that the Republic might well be induced to turn Protestant.[6] Sarpi's writings on the Interdict, and his *Istoria del Concilio Tridentino* (which was smuggled out of Italy and published in London in 1619), emphasized the republican values already associated with Venice: religious tolerance, the value of local custom, the autonomy of the state, and freedom of conscience. Sarpi's career and his great *History*, which was widely read and admired throughout the period of the Tour, gave him the status of a British cultural hero.

By the middle of the seventeenth century, then, the model of the Venetian common-wealth had come to play a pre-eminent role in political theory and controversy. As James Howell's *S.P.Q.V.: A Survay of the Signorie of Venice* (1651) begins by declaring, "Were it within the reach of humane brain to prescribe Rules for fixing a Society and Succession of people under the same Species of Government as long as the World lasts, the Republic of *Venice* were the fittest pattern on Earth both for direction and imitation." Howell's title summarizes one of his major themes, that "the soul of *Rome* seems to have transmigrated into *Venice*"; his dedicatory address to parliament as "Most Noble Senators" suggests further that the soul of Venice has "transmigrated" to England.[7] Comparable admiration of Venice as "pattern" and soulmate underlies the complex republican blueprint of James Harrington's *The Commonwealth of Oceana* (1656). In line with his predecessors, Harrington attributes the vigor of Venice to her mixed government. Accordingly, he devises for England a constitution based on a

system of checks and balances. Harrington's proposals include secret balloting, rotation of offices, and laws enforcing the equitable distribution of land—and therefore of power, which is rooted in the ownership of land.

Though Harrington failed in his attempt, during the final tumultuous years of the Inter-regnum, to implement any aspect of this utopian scheme, a lively interest in the Venetian political model persisted throughout the Restoration. One measure of this interest is the steady stream of books devoted in whole or part to the government of the Republic.[8] The Glorious Revolution intensified England's preoccupation with the "stato-di-libertà" and "stato-misto" myths by finding in Venice a powerful precedent for a specifically Whig conception of constitutional government. To those interested in limiting the power of the monarch, the doge offered a compelling example of a figurehead whose chief importance was symbolic. As Contarini makes clear,

> the Duke of *Venice* is deprived of all meanes, whereby he might abuse his authoritie, or become a tyrant: which ancient and long continued custome from the first beginnings of the citie, even to these times, hath now taken such foundation and roote, that there is nothing whereof the citie of *Venice* need stand lesse in feare, than that their prince should at any time be able to invade their liberty, or trouble their common quiet.[9]

According to Contarini, Venice's ideal government not only limited the one, it gave scope to the few—those who "do chiefliest surmount the rest in vertue, iudgement, and counsell," and yet can be relied upon neither to "exceed, nor go beyond the mean and manner of the popular authority."[10] In this way the Venetian model allowed Whig apologists to do obeisance to mixed government while justifying measures designed to circumscribe the monarchy and consolidate their party's hold on power.

In response to partisan manipulation of the myth, Tory writers made use of such anti-Venetian works as Amelot de la Houssaye's *Histoire du gouvernement de Venise* (1695) in order to brand Whig politicians and Venetian nobles alike as corrupt and tyrannical oligarchs. Nevertheless, the appeal of Venice's mixed government crossed party lines, prefiguring and validating "the perfect plan . . . / Of BRITAIN's matchless Constitution, mix't / Of mutual checking and supporting powers, / KING, LORDS, and COMMONS."[11] Neo-Harringtonian ideas circulated throughout the eighteenth century, often undergirding a bipartisan critique of governmental policies that were perceived as threats to constitutional balance. Whether they considered themselves Whigs or Tories, Britain's rulers-to-be persisted in following the example of Britannia, as expressed in a poem ("Britannia and Rawleigh") that has been attributed to Andrew Marvell:

> To the serene Venetian state I'le goe
> From her sage mouth fam'd Principles to know,
> With her the Prudence of the Antients read
> To teach my People in their steps to tread.[12]

From the late seventeenth to the late eighteenth century, "the serene Venetian state" continued to inspire steps both literal and ideological.

The mythic appeal of "Venezia-stato-di-libertà" and "Venezia-stato-misto" was by

no means a uniquely English phenomenon. Yet the sense of a special relationship between independent island states helped to create not only a charged political conversation but also a literary language of unique intensity. This language centered on the trope of Venice as Virgin. England's experience during the reign of Elizabeth with the powerful symbolism of virginity may help to explain the development of the trope, which attaches itself firmly to Venice in the *Crudities* of Thomas Coryat (1611). Coryat's rambunctious travel narrative includes richly detailed "Observations of the most glorious, peerelesse, and mayden Citie of Venice: I call it mayden, because it was never conquered."[13] Taking his cue from Coryat, James Howell extols Venice's maidenhood in all his writings about the Republic. In Howell's *Instructions and Directions for Forren Travell* (1650), Venice is described as "a rich magnificent City seated in the very jaws of *Neptune*, where being built and bred a *Christian* from her very infancy . . . she hath continued a *Virgin* ever since, nere upon twelve long ages, under the same forme and face of Government, without any visible change or symptome of decay."[14] In his letters, Howell reports on arriving in Venice that he is "ravish'd with the high beauty of this Maid," "so call'd, because she was never deflour'd by any enemy since she had a being." Howell goes on to develop the trope: "This beautious Maid hath bin often attempted to be vitiated, som have *courted* her, som *brib'd* her, som would have *forc'd* her, yet she hath still preserv'd her chastity intire."[15] However, it is Howell's "Upon the Citty and Signorie of Venice," the dedicatory poem prefixed to *S.P.Q.V.*, that constitutes the most emphatic yet also the most disturbing example of this particular encomiastic device:

> Could any State on Earth Immortall be,
> Venice by Her rare Government is She;
> Venice Great Neptunes Minion, still a Mayd,
> Though by the warrlike Potentats assayd;
> Yet She retaines Her Virgin-waters pure,
> Nor any Forren mixtures can endure;
> Though, Syren-like on Shore and Sea, Her Face
> Enchants all those whom once She doth embrace;
> Nor is ther any can Her bewty prize
> But he who hath beheld Her with his Eyes:
>> These following Leaves display, if well observed,
>> How She so long Her Maydenhead preservd,
>> How for sound prudence She still bore the Bell;
>> Whence may be drawn this high-fetchd parallel,
> Venus and Venice are Great Queens in their degree,
> Venus is Queen of Love, Venice of Policie.

Under the guise of panegyric, Howell's stretched-out sonnet trades in ambiguity: both syntax and figurative language define a continual wavering between assertions of purity and suggestions of danger. Venice is "still a Mayd," despite being "Great Neptunes Minion"; she retains her virginity, yet she behaves like a siren. The final couplet drives home this complex double nature: the surface contrast of erotic "Love" with virginal "Policie" is undercut by the puns on Venus/Venice and queen (ruler)/quean (whore).

By praising Venice in these equivocal terms, Howell exemplifies the unstable boundary between "Venezia-stato-di-libertà" and "Venezia-città-galante."

Only in death, as it proves, can maidenhood be securely restored. Wordsworth's "On the Extinction of the Venetian Republic," which answers Howell across the span of the Tour, converts sonnet into epitaph as one way of eliminating all traces of the siren:

> Once did She hold the gorgeous east in fee;
> And was the safeguard of the west: the worth
> Of Venice did not fall below her birth,
> Venice, the eldest Child of Liberty.
> She was a maiden City, bright and free;
> No guile seduced, no force could violate;
> And, when she took unto herself a Mate,
> She must espouse the everlasting Sea.[16]
>
>                                                      (ll. 1–8)

Erasing the complexities of history and myth, Wordsworth takes politic Venus out of Venice. A brilliant encomiast, he falsifies her reputation in order to salvage it. Less eloquent witnesses tell a more absorbing tale.

### Liberty and License

"Venetian Liberty": the term pervades travelers' reports. The noun is usefully rich in meanings, which shade from "freedom" through "exemption from tyranny" to "relaxation of restraint."[17] The adjective can pivot, according to context, from admiration to disgust. Together noun and adjective mirror the ambiguity of the phenomenon they describe.

For all his acuity as a student of Venetian painting, Michael Levey severely underestimates the importance of the "stato-misto" myth when he asserts, "the travellers who visited eighteenth-century Venice in such numbers . . . mostly gave as much thought to the constitution of Venice as Blackpool's visitors nowadays give to the local council."[18] Report after report dwells on the delicately calibrated system of checks and balances, the elaborate processes of balloting, and the structure of civic administration. Joseph Spence, for example, attends carefully to "the Chair, they carry the Doge in after his Election, like our Parliamenteerers," and to the composition of the electorate: "They reckon about 1500 voting Nobles; they vote at 25; when one man is ennobled, it holds for all his Relations. . . . The great Council makes but a poor appearance; there are nine to one in it that look very meanly; the Senate looks better, and is much more regular."[19] It is the Senate that is usually credited with Venice's achievements in statecraft: "They are remarkable for policy, and prudence, in their counsels. . . . this prudent republick always observes a strict neutrality, and enjoys the blessing of peace, while her neighbours all around are tore in pieces, by civil discord, or foreign devastations."[20] Virtually every account, published and unpublished, also describes the architecture and decoration of the Palazzo Ducale as the intricately appropriate setting for Venetian govern-

ment: "Besides the ducal apartments, this palace contains the different chambers of government, the grandeur of which made me blush for our houses of parliament."[21]

The quintessence of "grandeur" and "prudence" in the conduct of Venetian government is the office of the doge. The contrast between the doge's ceremonial importance and his political impotence verges on an obsession with British observers. Their fascinated reportage amounts in many instances to a forum on the nature of the monarchy, with Gilbert Burnet hovering in the background.[22] As Francis Drake emphasizes, "The Doge is the head of the state and senate, and continues in his office for life; he has all the insignia of royalty, but has in fact little more power than any private senator."[23] Edward Wright makes the comparison explicit:

> The *Venetians*, for the *Dignity* of their Government, would represent their *Doge* as a King, but for the *Freedom* of it, as a King without Power; and so indeed he is; for he can't do so much of himself as an *English* Justice of Peace: all there, is the Act of the Council: and even by the Word *Prencipe* the whole Aristocracy is understood.[24]

Such commentary attributes much of "Venetian Liberty" (in the sense of "exemption from tyranny") to a constitution that accords the titular head of state little more than "the trappings of Sovereignty."[25]

From the perspective of contemporary observers, that same constitution had perpetuated a "state equilibrium" which in turn fostered Venice's reputation as "stato-diliberta."[26] The practice of religious toleration won praise from almost every visitor: "*Venice* is a City that gives sufficient Liberty to all People; it has 10000 or 12000 *Jews*, 4000 or 5000 *Greeks*, and indeed all Strangers may live at Quiet and Ease enough in it, provided they'll not meddle with the Government; for that is too sacred to be touched."[27] Because "the Venetians are neither governed by priests, nor monks," they avoid many of the excesses of "superstition." Morover, if the visitor to Venice is "a friend to toleration, he will be pleased to see the Papal Power, that *Imperium in Imperio*, which has disturbed the peace of more than one Government, controuled by the wisdom of the Senate."[28] However, praise for resistance to papal absolutism is often balanced by criticism of the omnipotent Inquisition, whose dark reputation grew as the century progressed. In his sharply divided assessment, John Moore speaks for many: "While you admire the strength of a constitution which has stood firm for so many ages, you are appalled at the sight of the lion's mouth gaping for accusation."[29]

"Venezia-città-galante" provoked a similar response: passionate attraction qualified by (and often responsible for) intense aversion. The reaction of Charles Baldwyn, who visited Venice in 1712, is extreme in tone but representative in substance: "They enjoy a sort of liberty but it is only to be libertines and they are grown so scandalous that I think their whole City may well be term'd the Brothell house of Europe, and I dare say virtue was never so out of countenance or vice so encouraged in any part of the World and I believe not in any age as at this time at Venice."[30] Baldwyn's diatribe suggests that he, like James Boswell and many other Grand Tourists, could have noted truthfully in his journal, "strange gay ideas which I had formed of the Venetian Courtesans turned my head."[31] Indeed the courtesans were legendary for their beauty, their skill, and their availability:

Of these there are whole streets full, who receive all comers; and as the habits of other people are black and dismal, these dress in the gayest colours, with their breasts open, and their faces all bedaubed with paint, standing by dozens at the doors and windows to invite their Customers.[32]

The susceptible milord was at particular risk, as Grand Tourist Edward Thomas records in a letter of March 1751 that describes the sexual highjacking of his sightseeing companion:

The next day we went to see a Church and hear a musical Performance, and this young Gallant could not forbear making love to a Lady, richly dress'd and bedeck'd with Jewels tho she was on her knees and thumping her breast. She to our great surprise before all the People lifted up her Vail and ogle'd him presenting her hand to him to lead her to her Gondola. The bait took and he handed her into the Gondola and the moment he was in with her she becond to the Gondoleers who were in handsom liveries to row off with him in view of all the People who set up a loud laugh and said she was one of the greatest and most dangerous Strumpets of the City.

Thomas concludes his account on a note of fascinated censoriousness that perfectly captures the standard British response: "The wickedness of that Place is beyond all imagination. Whenever I walkd the Place of St Mark I observed several Fellows in Cloaks come up to my Servants . . . and importune them to bring me to some of these Ladies; and in the Island of Murano a child not 8 years old came to them on the same errand."[33]

Liberty degenerating and proliferating into licentiousness: this theme defines the presentation of "Venezia-città-galante." What aroused the intensest response, however, was not prostitution but behavior that flouted or undermined conventional boundaries. Sexuality and religion, the public and the private, were disturbingly intermingled in Venetian convents:

As they [the nuns] are all of the first quality of Venice they have a pretty deal of liberty, and here was a great number of people to see them at the grates . . . but the beggars here are as troublesome as else where coming freely into the parlor and importuning people whilst they are in conversation with the Nuns, which the Sigr. tho a Senator could not prevent not being a part of the Venetian Liberty.[34]

The rule of chastity was widely subverted as well:

The Nuns in Venice seem to have a very different air from those we saw in France. Their Convents are light; the Parlatorio's, of more extent and more open; the Ladies have a gay air, fresher complexions, and a great deal of freedom in their behaviour and manner of talking. . . . I need not add what is said of some greater Liberties of the Venetian Nuns, than we saw.[35]

The city that collapses distinctions between nun and mistress also complicates normative categories of class, sexual identity, and civic space: "The spirit of the stage is so very prevailing in this city, that even the beggars ask alms, in full maske, which

they immediately give for admission to hear an opera, or the jests, or humours of Arlecchino, or Pantaleone."[36] The opera, like the convent, provided a unique hunting-ground, one noteworthy for "the Passionate Lover, with his Effeminate Voice."[37] Sanitary as well as sexual codes were also transgressed: "The Venetians look upon their Liberty in so high [a] Light, that they think one of the greatest Badges is to sh-t and piss all over this great [Ducal] Palace . . . [and] for that Reason Strangers should look before they tread there."[38] In both literal and symbolic forms, Venice abounded with the dirt, infection, and "effeminacy" so feared by opponents of the Tour.

## Marine Matrimonial

"And when she took unto herself a Mate, / She must espouse the everlasting Sea." No event in the civic calendar of the Republic was more significant than the spring Feast of the Ascension, or "Festa della Sensa." The celebrations began with the traditional wedding ceremony, the "Sposalizio al Mar." The key prop in this lavish piece of ritual theater was the *Bucintoro*, "a Great Galley in which the Doge on assension day goes a wooing the Sea which he marries before his return, which is a Custom to maintain the Soveraignity of the Adriatick Sea."[39] The ceremonial itinerary took the doge from the Molo to the Lido, where, in Lord Palmerston's firsthand account, he

> rises up in his Chair of State, the back of which lets down, and turning himself round throws the gold ring, which is provided, into the sea, repeating these words: "*Desponsamus te Mare in signum veri perpetuique Dominii*". After this the whole company go on shore at Lido, where the Doge hears Mass and then returns in the same state to Venice.[40]

Liturgically speaking, this ceremony combines a *benedictio*, or blessing, with a *desponsatio*, or matrimonial covenant. From the anthropological standpoint, it suggests a fertility rite crossed with a ritual voyage, which defines the spatial contours of the community while taming (by feminizing) a potentially hostile outside force.[41] The prayer sung during the *Bucintoro*'s trip to the Lido makes this composite purpose quite explicit:

> Spirto di Dio . . .
> Fate liete quest'acque
>
> ·  ·  ·  ·  ·  ·  ·  ·
>
> E stendasi regnante
> Da Mare a Mar la Veneta Fortuna
> Fin ch'Ecclisse fatal tolga la Luna.[42]

As the Republic's *dominium* shrank, jokes about the cuckolding of feeble husbands and the "Festa *senza* Sensa" proliferated. Yet the Ascension continued to be celebrated with all due solemnity until 1797, when the conquering French made sure to destroy the *Bucintoro*—a gesture that testifies to its residual symbolic power. During the eighteenth century, that power was increasingly tied to commerce: the Sposalizio acted as a

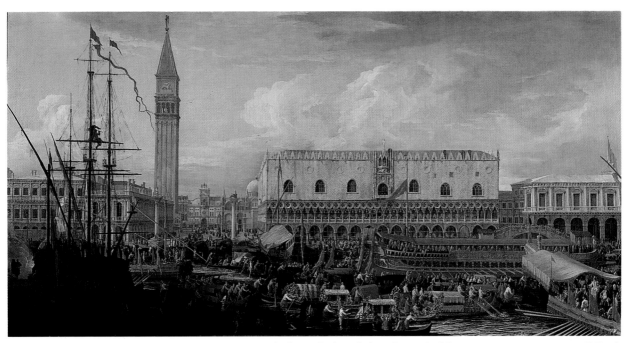

8. *The Bucintoro Departing from the Bacino di San Marco* by Luca Carlevarijs (1663/4–1730). Oil on canvas, 134.7 × 259.3 cm. J. Paul Getty Museum, Malibu, California.

9. *The Arsenal, the Water Entrance* by Canaletto (1697–1768). Oil on canvas, 47 × 78.8 cm. Woburn Abbey, Bedfordshire.

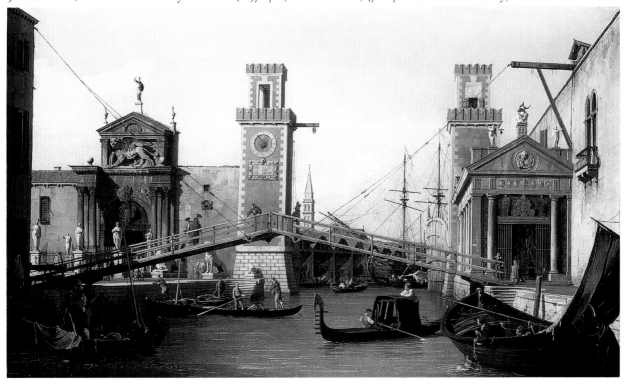

magnet for foreign visitors, who came for the ceremony and stayed on for the spring theater season and the fifteen-day "Fiera della Sensa," which transformed the Piazza San Marco into an alluring bazaar. Added to these attractions was a "conspicuous public parade of courtesans at the marriage-of-the-sea ritual" and "a little sort of *Carnavall* of about a Fortnight's Continuance, being a time of Masking and other Diversions."[43]

Though its appeal was by no means limited to the British, the Sposalizio held a particular fascination for the Grand Tourist, witness the nature and extent of the surviving reportage. A recently discovered set of travel instructions, possibly intended for the Duchess of Marlborough's grandson, exemplifies a widespread conviction that no Tour was complete without the experience of the Festa in all its variety: "Go from Rome by way of *Loretto* to *Venice*, so as to be there the beginning of May, at which time the Ascension begins; which is a better sight than the Carnaval at Venice; You have . . . the opportunity of seeing the Doge go in the *Bucentaure* to espouse the Sea."[44] The letters of Horace Mann to Horace Walpole confirm that many took up this opportunity: over the decades Mann reports rather wearily that, to quote a representative bulletin, "we have crowds of English already here from Rome and many more on the road hither, most of whom are bound for the Ascension at Venice."[45] Lady Mary Wortley Montagu found herself beset by the same crowds: "I cannot absolutely set the day of my departure, though I very sincerely wish for it, and have reason more than usual: this town being at present infested with English, who torment me as much as the frogs and lice did the palace of Pharoah."[46] The plagues of milordi continued from generation to generation: the tenth Earl of Pembroke, a prominent alumnus of the Tour, hoped fervently that his son and his son's bearleader were "running hard" so that "George will be in time for the Ascension at Venice."[47]

What explains the enduring compulsion to attend, to describe, and to comment? The most obvious reason is the spectacular nature of the proceedings, which exceeded in sheer pageantry even the Easter festival at Rome. Writing home in June 1734, Richard Pococke recreates the allure of such unique pomp and circumstance. His account is unusual in several respects: concerned to impart the dazzling effect of the whole, he does not neglect to describe its salient parts, attending closely to costume, chronology, and choreography. In addition, he follows the doge from start to finish, in effect acting out the entire Sposalizio and thereby assisting his reader's vicarious participation. Thus Pococke begins on foot in the Palazzo Ducale, embarks as the principals enter the *Bucintoro*, accompanies the marine procession out to the Lido (Plate 8), and returns to the Molo at the end of the ceremony (Plate 10). The result is perhaps the most vivid of all the surviving accounts in its re-creation of the sensory overload that must simultaneously have exalted and afflicted the careful observer:

We saw the ceremony of the Doges marrying the sea one of the finest sights in the world. About 9 I saw the Doge at Mass in the chapel of the Palace with the Nobles, thence they went in procession to the Bucentaur or fine Galley, with flags displayed, the sword of state going after the Doge before the Procurators and head Nobles, the Popes Nuncio on the right of the Doge, and the Emperors Ambassador a Neapolitan on the left dressd in black, and a flowerd black damask cloak on, the nuntio in

60

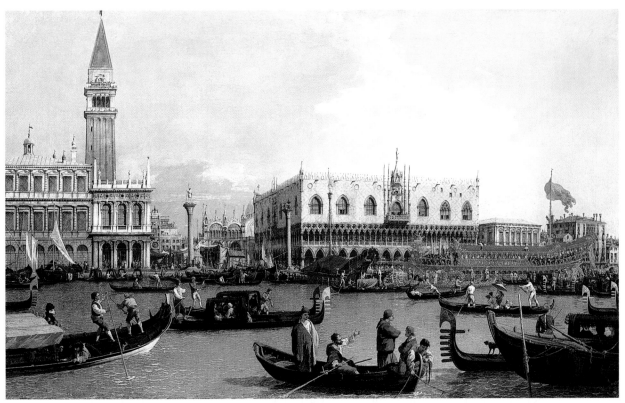

10. *The Bucintoro Returning to the Molo on Ascension Day* by Canaletto (1697–1768). Oil on canvas, 76.8 × 125.4 cm. Royal Collection.

purple, the canons fireing, drums beating, and trumpets sounding. . . . the Doge went in to the Bucentaur . . . this vessel is built like a Galley and without doubt is the finest ship in the world tis about 150 feet long and 25 feet broad, it has two decks one below, where the rowers are and an opening for every oar about 22 on a side, over is the upper deck which is coverd over with wood the top of which is coverd with scarlet velvet. . . . The floor is of wood laid in handsom figures, every thing else you see in side and out . . . is finely carv'd and gilt all over in the most beautifull manner . . . at the helm is the Doges gilt throne the Nobles being rangd all down, this vessel has no mast only a pretty large staff with a flag; being sett off shes rowd by 44 oars, two fine large Galleys of the state row at some distance after, the boats of ambassadors keep near the stern and many thousand Gondolas all about, musick in several boats, the bells all ringing the ships firing as it passd by . . . thus they went above a mile to the Isle of St Nicolas where the army of the state were drawn up and fird several times as it passd . . . the vessel turnd, and the back of the doges throne being let down he got up turnd round and threw the ring in to the sea making use of words to this purpose by this ring I marry the sea in testimonium perpetui dominii, on which all the Guns fird, and they returnd to St Nicolas and landing went in procession to the church where mass was celebrated solemnly by the Bishop calld the Patriarch of Venice. Returning to the Bucentaur, they rowd to Venice, the great

number of fine Gondolas added much to the beauty of this function . . . in a word all agree tis the finest sight they ever saw.[48]

From start to finish Pococke focuses on the *Bucintoro*, which provides him with a principal character in his dramatic synopsis and a focal point for his crowded tableaux. The keynotes are luxury, dignity, and power: nowhere is there a hint of criticism, or a sneer at the discrepancy between liturgical façade and political reality.

More common than Pococke's admiring report are accounts that mingle dazzlement with deprecation. As if they feared charges of naivete, cultural inferiority, or lack of historical perspective, a number of observers take pains to distance themselves from the objects of wonder. Thus Francis Drake, well launched on a circumstantial description, suddenly inserts a rebuke that seems directed as much toward his own uncritical absorption in the spectacle as to the Venetians themselves: "An officer may engage to defend his prince or dye in the attempt, but it seems very prophane, thus to bid defiance to winds and waves, which no human power can controul. That this officer may run no risk of perjury, they delay the ceremony if there is the least cloud or vapour in the air."[49] At its close John Moore's account of the Sposalizio moves from irony to sarcasm: after quoting the doge's Latin formula, Moore comments, "The sea, like a modest bride, assents by her silence, and the marriage is deemed valid and secure to all intents and purposes." "Certain it is," Moore concludes by observing, "the time has been, when the Doge had entire possession of, and dominion over, his spouse; but, for a considerable time past her favours have been shared by several other lovers."[50] Thomas Gray, himself intent on seeing the Sposalizio, made the same point in blunter terms: "next to Venice by the 11th of May, there to see the old Doge wed the Adriatic Whore."[51] From this quip it is a short step to the flippant cynicism of Peter Beckford, who urges a visit to Venice at the time of the Ascension, but then observes: "The day of the Ascension, the Lord Mayor's show of Venice, is as well as any other ridiculous sight that draws idle people together. He may stare at the gaudy Bucentaur; and will laugh at the pompous ceremony of the Doge's Nuptials with the Adriatic, if he consider the infidelity of the Bride."[52] Pococke's dazzling pomp is for Beckford risible pompousness—yet running through all the commentary is a compulsive fascination with the *ne plus ultra* pageantry of the Sposalizio.

The political content of, and context for, this pageantry goes even further toward explaining its magnetic appeal. When not in use, the *Bucintoro* was docked in the Arsenal: both the vessel and its home testified eloquently to the sophisticated technology, craftsmanship, and industrial management that had undergirded Venice's maritime empire (Plate 9). They also evoked parallels with Great Britain, as Martin Folkes's journal testifies:

Then the Consul went with us to the Arsenal which is the best worth seeing of any thing in Venice. . . . This arsenal is like the Kings Yards at Chatham Portsmouth etc in England. . . . We saw here in a house [built] on purpose the bucentor wherein the Doge marries the sea, it is the most beautifull vessel for shape and richness of ornaments all gilt and carvd on by an excellent artist that can be imagind; it gave me much more pleasure and admiration than I could have thought, being indeed a masterpiece of beauty in its kind.[53]

The *Bucintoro* at rest exemplified one kind of craft, the *Bucintoro* in motion another. On his *Italienischereise*, Goethe described the galley as "a true monstrance [*eine wahre Monstranz*] showing the people their masters in a splendid pageant."[54] For the Grand Tourist the *Bucintoro* functioned as another kind of "monstrance." The two principal decks, open for easy viewing; the seating plan, which reflected the pyramidal structure of government; the color-coded robes worn by the various dignitaries—all united to teach an unforgettable lesson in the Venetian political system (Plate 7).[55] This lesson complemented the lesson of the Arsenal, for it demonstrated the ideal union of statesmanship and seamanship.

Other aspects of the ceremony, such as the reception of the patriarch on the way to the Lido and the disposition of the ambassadorial boats, brought to symbolic life Venice's ecclesiastical policies and foreign relations. The liturgy of the ring, moreover, reminded British observers of the basics of maritime empire. They grasped what Edward Muir has described as "the essential political point," that "in marrying the sea the doge established his legitimate rights of domination over trade routes and over the lands lapped by the waters of the Adriatic."[56] Yet this husband-ruler, while lording over Venice's colonial possessions, remained a meekly titular spouse at home. Such a marriage modeled a contract of particular significance to Great Britain.

To the degree that one maritime state replicated the other, the ceremony set parallels vibrating. However, the parallels could be disturbing as well as instructive: to hear the formula "Desponsamus te, mare" was to be reminded of the gap between past hegemony and present debility. An attitude of condescension, as we have already noted, runs through many of the sources, which often betray an underlying sense of unease. Venice's continuing claims of "perpetual dominion" can be dismissed as quaint posturing, but the implications for the British empire remain. Horace Walpole's quip to Sir Horace Mann indexes the extent to which, by the second half of the eighteenth century, myths of Venice had come to shape Great Britain's sense of national identity: "If the Americans provoke us, we will sail forth in our Bucentaur and cuckold them with their spouse the Atlantic."[57]

Interpreted as a whole, the Festa della Sensa both epitomized and conflated the three myths we have been exploring in this chapter. It did so by allowing the essence of the Republic to be observed, interpreted, and enjoyed. In sumptuously symbolic form, the marriage ceremony illustrated the special nature of Venice's political and commercial achievement. Moreover, the Fair and "other Diversions" that followed the Sposalizio showed off the full range of the "città-galante." During the course of the eighteenth century, the composite event, trailing its composite myth, helped to make of Venice a type of Great Britain.

This typological interpretation of the Republic emerged out of a deep-seated cultural practice, which originated in biblical hermeneutics and then entered the domain of political mythmaking.[58] It gained special force from the legend of British liberty. James Thomson's is the classic expression of this legend, but it is William Collins's "Ode to Liberty" that best conveys the contribution of the Festa to Venice's typological identity. Following Thomson, Collins traces the progress of liberty from Rome to Great Britain; unlike his predecessor, he devises for Venice a distinctive cameo that evokes the ceremonies and the identities we have just been considering:

Strike, louder strike the ennobling strings
To those whose merchant sons were kings;
To him who, decked with pearly pride,
In Adria weds his green-haired bride;
Hail, port of glory, wealth and pleasure.[59]

(ll. 42–46)

Collins's encomium plays with the significance of "port," meaning not only "harbor," but also "carriage, air, mien, manner, bearing." Through canny emulation of the "port" of Venice in both senses, Britannia bids fair to fulfil and even surpass her in liberty, glory, wealth, and pleasure.

## Venice Imported

The cultural power to which the Grand Tour gave access had to be channeled and domesticated in order to achieve its maximum effect. It is fortunate, therefore, that the Tour not only conferred prestige but also supplied models for

11. (above left) *Minerva and Fame with William III*, ceiling decorated by Antonio Pellegrini (1675–1741). Kimbolton Castle, Cambridgeshire.

12. (left) *The Triumph of Caesar*, staircase decorated by Antonio Pellegrini (1675–1741). Kimbolton Castle, Cambridgeshire.

13. (right) The King's Staircase, decorated by Antonio Verrio (c. 1639–1707). Hampton Court Palace, London.

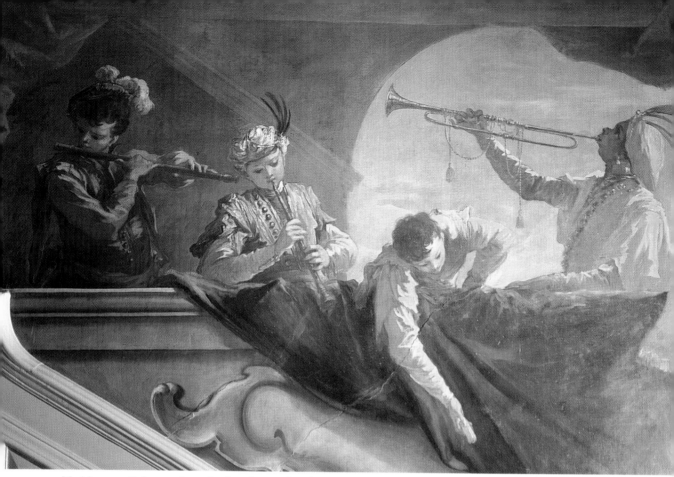

14. *Musicians on a Balcony*, staircase landing decorated by Antonio Pellegrini (1675–1741). Kimbolton Castle, Cambridgeshire.

negotiating between classical past and British present, the gentlemanly values of humanism and the practical necessities of politics. As Dennis Porter observes, "one of the official functions of the Grand Tour was to suggest how, upon one's return to Britain, one might practice what one had seen as well as read about, and live as a patrician Roman in a way that was yet adapted to eighteenth-century British circumstances and the genius of British place."[60] For many the aspiration to "live as a patrician Roman" could best be fulfilled and extended by living as a patrician Venetian in a villa derived from Palladio. During the earlier phases of the Palladian revival, this "villa ideal," as James Ackerman calls it, was promoted almost exclusively by the Whig magnates who saw themselves as rulers of a northern "stato-di-libertà" underpinned by the principles of a "stato-misto."[61]

To embellish their Palladian power houses, these "plutocrats of impeccably Whig allegiance"[62] turned to Venetian artists. The result is a stylistic anomaly—classicizing exterior, rococo interior—that remains an intriguing puzzle. Forty years ago, Francis Watson drew attention to the phenomenon of "Venetian decorators" at work in "English villas": "If we regard the Palladian movement as an attempt in some sense to re-create Venetian villas on English soil, what I am talking about is the corresponding attempt by their builders to decorate the interior of the houses in a style similar to that which they had seen on their travels in Venice." In his response to Watson's paper, Rudolph Wittkower observes:

66

There is one problem on which I might perhaps comment for a moment—the strange fact that we have Palladianism in England from about 1715 onwards—a very simple outside, porticoes, simple windows, and so on. Inside we find the whole of the Venetian decoration, which seems to be a peculiar contrast. We are so used to this contrast that we hardly think about it.... I have often asked myself how they go together—Palladianism and this kind of decoration.[63]

This section proposes to explain Wittkower's "peculiar contrast" by glancing selectively at representative works of art and architecture. The survey begins with Kimbolton Castle, moves on to Stowe and Kedleston, and ends with the English landscapes of Canaletto. Its guiding claim is that, at the outset, the patronage of Venetian artists can be attributed to the desire of Whig patrons to appropriate the mythology of Venice for their own political purposes. For these patrons, to build in a Palladian style was to dramatize an identification with the sixteenth-century Venetian patriciate; to commission decorative schemes from the heirs of Veronese was to cement the parallel. By the middle of the century, however, such schemes had lost their partisan import, as myths of Venice became the property of Whigs and Tories alike. Gradually, even the most diffuse political content drained away entirely, as "stato-misto" and "stato-di-libertà" myths were subsumed into Venice as "città galante."

The pictorial cycle by Giovanni Antonio Pellegrini (1675–1741) for the main staircase at Kimbolton Castle perfectly exemplifies the importation and appropriation of Venetian myths by Whig patrons.[64] Pellegrini was invited to England by Charles Montagu, fourth Earl of Manchester, who had served as ambassador extraordinary to Venice in 1707–08; his mission was to enlist the support of the Republic against Louis XIV. Lord Manchester possessed impeccable Whig credentials: his

15. *Abundance*, staircase landing decorated by Antonio Pellegrini (1675–1741). Kimbolton Castle, Cambridgeshire.

grandfather had supported the Parliamentarians during the Civil War; Manchester himself formed an alliance with the Prince of Orange during the reign of James II, and fought with William III at the Battle of the Boyne. It should come as no surprise, therefore, that the staircase of his remodeled country house celebrates the careers of patron and monarch in tandem, as well as the political convictions underpinning their alliance.

The walls that surround the main flight of steps are treated illusionistically, as if they opened out onto landscape and sky. The medium is oil on plaster, which Pellegrini handles as if it were the *fresco secco* with which he had embellished those Venetian villas that brought him to the attention of Lord Manchester. The subject is the triumph of Caesar, who represents William III; the densely packed procession of soldiers, horses, trumpeters, torchbearers, and other auxiliary forces wraps around two walls (Plate 12). On the ceiling above, Minerva directs the viewer's attention to a portrait of William III, born aloft by putti, while Fame blows a trumpet that points downward to the thicket of brass below (Plate 11).

The subject matter, composition, and modeling of figures all suggest that Mantegna's *The Triumph of Caesar* served as Pellegrini's primary source of inspiration; this famous pictorial cycle, acquired for the Royal Collection by Charles I, hung at Hampton Court, where it had recently been restored. In addition, it would appear that Pellegrini had also studied the King's Staircase at Hampton Court, decorated by Antonio Verrio (c. 1639–1707) at the beginning of the century (Plate 13). Verrio turned to a literary source, Julian the Apostate's *The Caesars*, for the purpose of celebrating the triumph of William III, who is represented in the main fresco as Alexander the Great.[65] Albeit on a reduced scale, Pellegrini takes over Verrio's wraparound treatment of the staircase walls, his illusionistic use of architecture, specific images from ceiling and frieze, and his conversion of classical history into political allegory.

The motif of triumphal music-making helps to unite the various sections of Pellegrini's iconographic scheme and to absorb his quotations into a distinctive individual achievement. The visual highpoint of the upper staircase is a musicians' gallery, from which a fifer, an oboist, and a trumpeter swell the fanfare (Plate 14). However, the decoration of the upper staircase models itself not on Mantegna but on Veronese. In its vivid colors, sumptuous fabrics, and exotic detail the vignette of musicians recalls pictures like *The Feast in the House of Levi*. At the same time, the intimate scale of the upper staircase and the inclusion of such decorative details as *trompe l'oeil* architecture, framing garlands, domestic animals (a dog, a parrot, and a monkey), and allegorical figures of Virtue and Abundance (Plate 15)—all evoke the atmosphere of Veronese's interiors for Palladio's Villa Barbaro at Maser. In the coved ceiling putti elevate the earl's coronet and playfully discard his lesser insignia. The specific prototype for this ceiling is Veronese's *Juno Pouring Forth Her Treasure on Venice*, painted for the doge's palace.[66]

The staircase at Kimbolton offers several different but interlocking experiences. In climbing from the bottom, the visitor moves from the past to the present, from the public to the private, from history to domesticity. He also experiences, pictorially and spatially, the mythic propaganda of the Whig ascendancy, whereby Liberty passes from republican Rome via republican Venice to England under William III. Looking

16. *Design for the Temple of Venus at Stowe* by William Kent (1685–1748). From Isaac Ware, *Designs of Inigo Jones and Others* (c. 1735). University of Virginia Library.

17. The Temple of Venus at Stowe, Buckinghamshire.

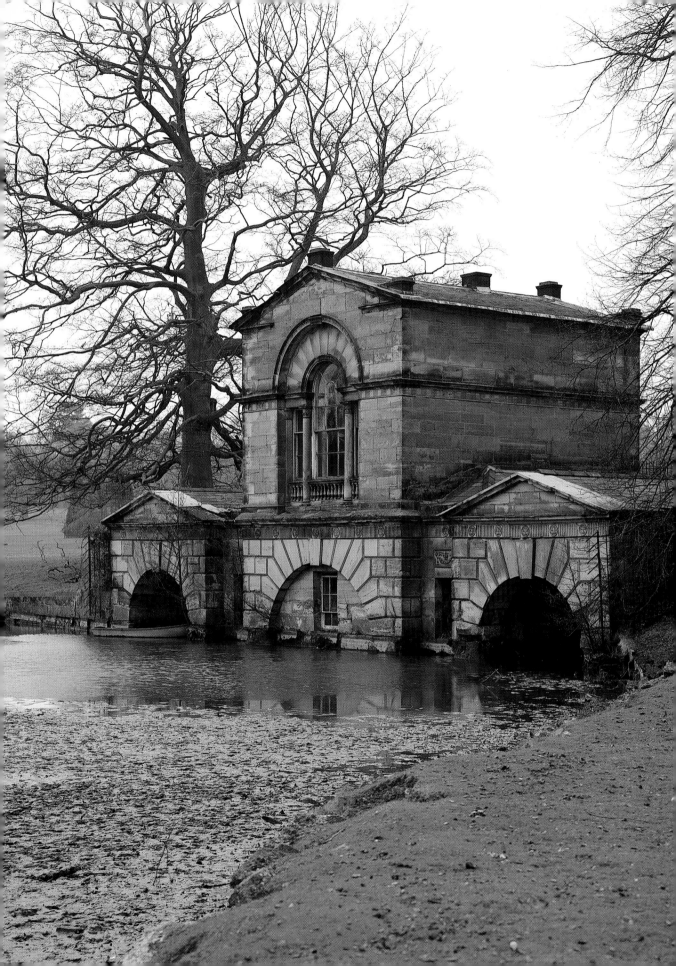

18. (left) The Fishing Room and
Boathouses at Kedleston Hall,
Derbyshire.

19. (right) *Design for the Fishing
Room and Boathouses (North Front),
Kedleston Hall* by Robert Adam
(1728–1792). Sir John Soane's
Museum, London.

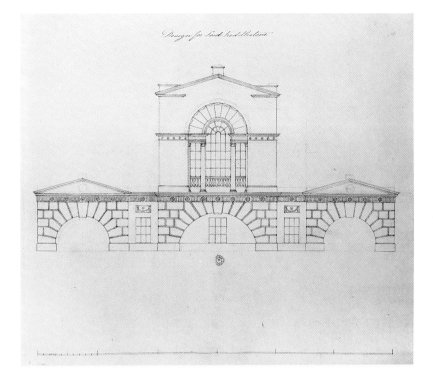

20. (below) *Capriccio: A Palladian
Design for the Rialto Bridge* by
Canaletto (1697–1768). Oil on
canvas, 90.2 × 130.2 cm. Royal
Collection.

outward and upward as he climbs to the landing, he sees a quasi-typological scheme, in which the Roman emperor on the wall anticipates and doubles William III on the ceiling. Once he has reached the landing, he has entered eighteenth-century England figured as sixteenth-century Venice, with the apotheosis of Lord Manchester echoing on a reduced scale the apotheosis of the king. And what better way to promote this self-confident image of Venice translated than to cause it to be executed by a Venetian?

The Temple of Venus at Stowe (1731) makes even more complex use of a coded visual language. Designed by William Kent for Lord Cobham, it occupies the southwest bastion of the Vanbrugh–Bridgeman garden. The temple takes the form of a pedimented central block linked by an arcaded exedra to two smaller flanking pavilions (Plate 17). The closest architectural prototype is Palladio's Villa Badoer, which appears to have inspired not only the general conception but even such decorative details as the cusp and ball capping along the top of the exedra.[67] The temple bore a dedication to "Veneri Hortensi," and an inscription on the frieze invited erotic dalliance: "Let him love now, who never lov'd before / Let him who always lov'd, now love the more."[68] The temple's erotic associations were confirmed and intensified by the decoration of the interior. An anonymous early account of Stowe gardens records that "one Side of the Temple is furnishd with altars suitable to the Deity of the Place, viz Couches and Pillows; and though the whole Room within is not more than 20 feet Square, it is nevertheless Large enough for the Performance of many Sacrifices."[69] The sexual activity implied by the furnishings was made explicit on the walls, which were covered with scenes from *The Faerie Queene* frescoed by the Venetian artist Francesco Sleter (c. 1685–1775).[70] Sleter's murals illustrated a story from Book III of Spenser's epic: the rakish Paridell (a latter-day Paris) seduces the "wanton" Hellenore (a "second *Hellene*"), the young wife of the elderly miser Malbecco (iii.ix.1; iii.x.13).[71] Having run away with Hellenore, Paridell then abandons her, and she becomes the concubine to a group of satyrs. In one of the poem's most explicit sexual scenes, Malbecco watches from the undergrowth as his wife copulates repeatedly with one of her companions (iii.x.44–48). These frescoes, declared "*galantes* à la vérité, mais neanmoins nullement *obscènes*" by a contemporary French visitor, were painted over in the 1820s, but the restoration scheme now in progress has uncovered traces of the original plasterwork—enough to confirm that the murals included a woodland scene with dancing satyrs.[72] In the coved ceiling Sleter also painted Venus accompanied by amoretti.

The Temple of Venus has yet to receive the attention devoted to such monuments as the Temple of British Worthies, the Temple of Ancient Virtue, and the Gothic Temple. The reason for this neglect can be attributed to the building's insistently erotic significance (which might appear to foreclose other meanings) and the fact that the temple predates Lord Cobham's break with the ministry of Sir Robert Walpole: commentators have tended to concentrate on the elaborate iconographic scheme that resulted from the move into Opposition. Yet like its successors, the Temple of Venus should be considered an example of what George Clarke has called "Cobham's political gardening."[73] It conflates and subsumes the three myths of Venice we have just been considering, and it does so in order to tell its own myth of succession.[74] This mythic subtext has three dimensions—political, architectural, and literary.

By placing a miniature Palladian villa on the estate of a Whig oligarch, and causing

21. *A View of Burlington House* by Antonio Visentini (1688–1782) and Francesco Zuccarelli (1702–1788). Oil on canvas, 80 × 130.8 cm. Royal Collection.

it to be decorated by a Venetian artist with scenes from England's national epic, Cobham and Kent invited the viewer to perceive a set of analogies—analogies that are also genealogies. Architecturally speaking, the Temple of Venus proclaims its descent from Roman exedral architecture as adapted by Palladio and mediated by Inigo Jones; this family tree is confirmed by the publication of Kent's plan in Isaac Ware's *Designs of Inigo Jones and Others* (Plate 16). The temple's murals invoke a corresponding literary genealogy: Virgil begat Ariosto and Tasso who begat Spenser ("the English Virgil").[75] The choice of a story from *The Faerie Queene* further links the erotic to the political, seduction to succession: Paridell begins his wooing of Hellenore by telling the story of the destruction of Troy and the founding of Rome; his companion Britomart then continues the tale with the myth of Brutus and "Troynovant" or London: "For noble *Britons* sprong from *Troians* bold, / And *Troynovant* was built of old *Troyes* ashes cold" (iii.ix.38.8–9). The significance of this succession myth from Book III might well have been enhanced for contemporary visitors by the association of *The Faerie Queene* during the 1720s and 1730s with Whig conceptions of liberty.[76] For Kent himself the Temple of Venus possessed a strong Spenserian aura, witness its inclusion in his illustrations to *The Faerie Queene*.[77] In these various ways the Temple of Venus works to affiliate Cobham, his political creed, and his cultural priorities with the patriciate of sixteenth-century Venice, whose achievements perpetuated Rome's and prefigured those of Great Britain under the Whigs.

23. *Westminster Bridge, London, With the Lord Mayor's Procession on the Thames* by Canaletto (1697–1768). Oil on canvas, 95.8 × 127.5 cm. Yale Center for British Art, New Haven.

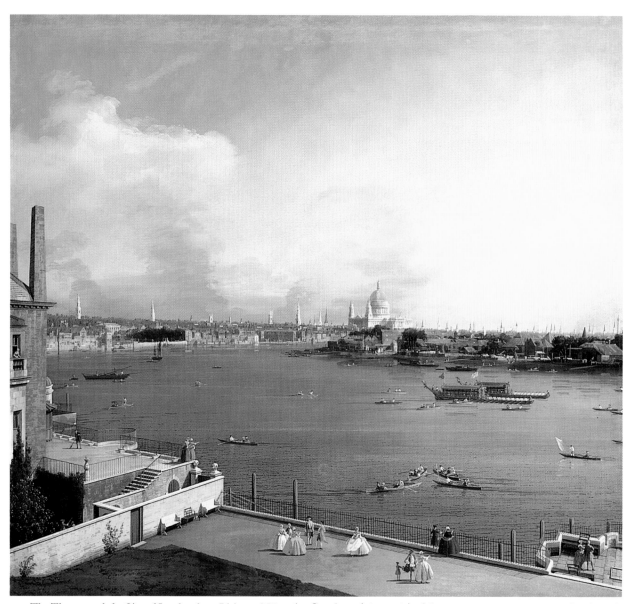

22. *The Thames and the City of London from Richmond House* by Canaletto (1697–1768). Oil on canvas, 106 × 117.4 cm. Goodwood House, Sussex.

24. *The Bacino di San Marco* by Canaletto (1697–1768). Oil on canvas, 124.5 × 204.5 cm. Museum of Fine Arts, Boston.

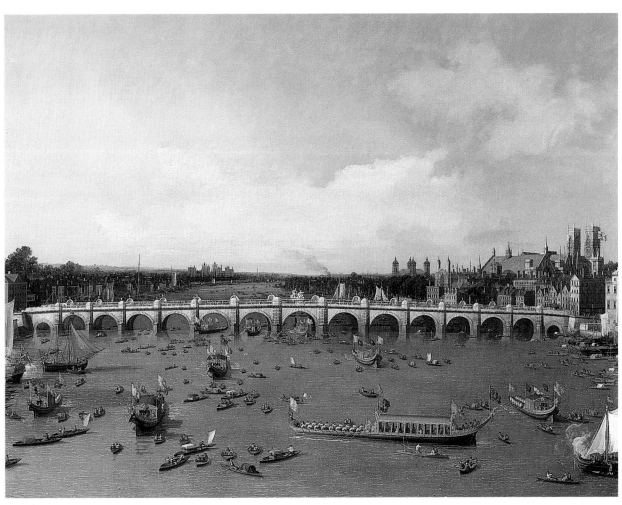

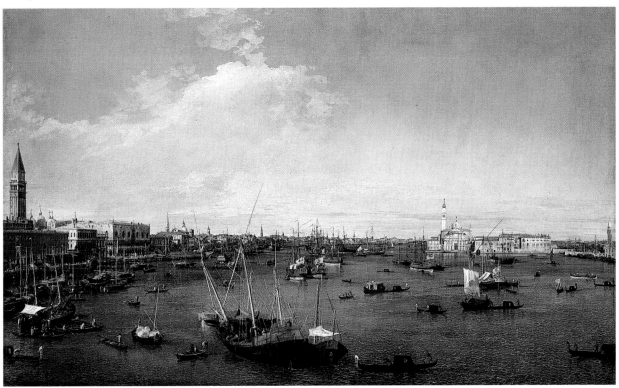

By the time that Robert Adam designed the Fishing Room at Kedleston Hall, Derbyshire (c. 1769), architectural references to Venice had ceased to function as consistent political markers. Indeed Adam's appropriation of Venetian motifs for a Tory patron may be considered part of a larger campaign to counterbalance the Whig stronghold at Chatsworth.[78] Every aspect of the pavilion conjures up and sports with the connections we have been tracing throughout this chapter (Plate 18). On the upper level, the Fishing Room proper is dominated by a large Palladian window and a statue of Venus;[79] its walls are decorated by the Venetian artist Francesco Zuccarelli (1702–1788), a favorite of Consul Smith who also worked for George III and the Earl of Bute. Zuccarelli's frescoes create a version of what one might call "marine pastoral": six small panels depict eels, fish, and lobster, while above the fireplace a fisherman and two female attendants occupy the foreground of a Giorgionesque landscape. On the level below, a pair of boathouses flanks a semicircular cold bath, which is fed by a spring higher up in Kedleston Park. Above the channel that connects spring to bath an epigram from *The Greek Anthology* evokes the birth of Venus, whose origins provide a standard trope in encomia of Venice: "Either such water gave birth to Cytherea, or Cytherea, by bathing in it, made the water such."[80] The decoration of the façade reinforces these mythological and literary connections: on either side of the main entrance are roundels filled with sportive putti mounted on leonine sea-monsters, while the heavily rusticated lower story is banded with lion metopes.

In its general conception as well as its smallest details, the Fishing Room invites the visitor to play self-consciously at being in Venice, a Venice defined by visual and textual offshoots of the Grand Tour. As the design for the lakeside façade makes clear (Plate 19), Adam adapted Palladio's unbuilt project for the Rialto, which had inspired the bridges at Wilton, Prior Park, and Stowe. In addition, he may well have been influenced by Canaletto's reconstruction of Palladio's scheme, an overdoor *capriccio* commissioned by Consul Smith for one of his Venetian residences (Plate 20). Adam strengthened the association with Palladio, and affiliated his project with Venetian domestic architecture, by substituting a window for the central row of columns. The outcome is a miniature hybrid of Rialto and palazzo. Entering this hybrid, one passes between Popean cupids into a space adorned with Venus and decorated by the last of the major Venetian artists to work in England. For Joseph Smith, Zuccarelli had helped to paint imaginary views of English Palladian buildings in settings reminiscent of the Veneto (Plate 21).[81] His decorations for the Fishing Room further a comparable project, whose effect is to take "Venetianness" out of the arena of politics into a realm of sophisticated recreation.

Though Canaletto undertook commissions for several prominent Whigs, his English *vedute*, like Adam's work at Kedleston, transcend the specific program that explains a Kimbolton or a Stowe. They do so by promulgating an intense but elusive version of the mythic affinities we have been investigating thus far. Canaletto manipulates topography, perspective, composition, and allusive detail so as to bring Venice and London into mysterious relation: standing before the great panoramas, we are invited to contemplate two in one and one in two—to experience a subtle amalgam of document, quotation, reminiscence, and pentimento.[82]

It is significant that Canaletto's earliest views of London evoke subjects (and even

25. *Old Walton Bridge* by Canaletto (1697-1768). Oil on canvas, 48.9 × 76.8 cm. Dulwich Picture Gallery, London.

26. *Grand Canal, the Rialto Bridge from the South* by Canaletto (1697-1768). Oil on copper, 45.5 × 62.5 cm. Holkham Hall, Norfolk.

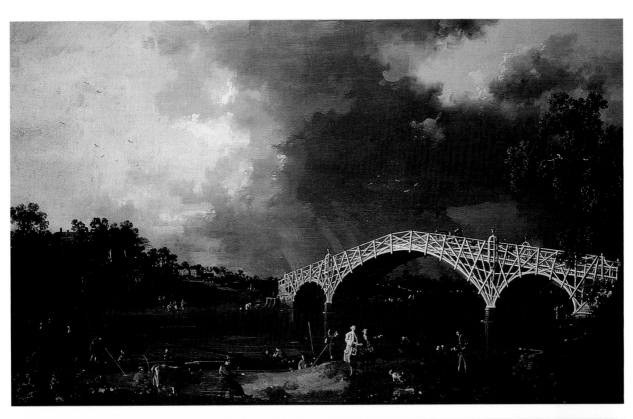

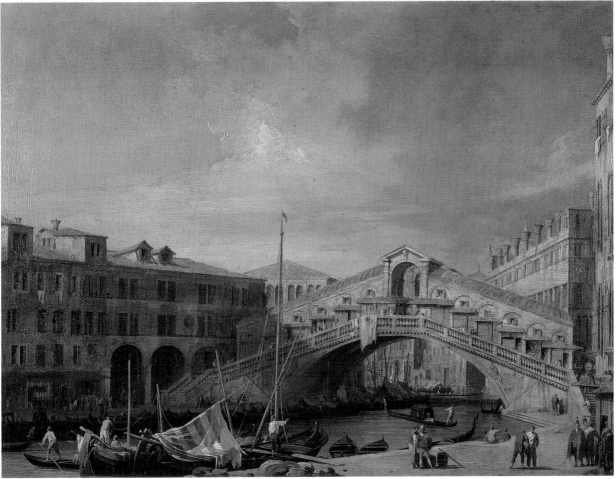

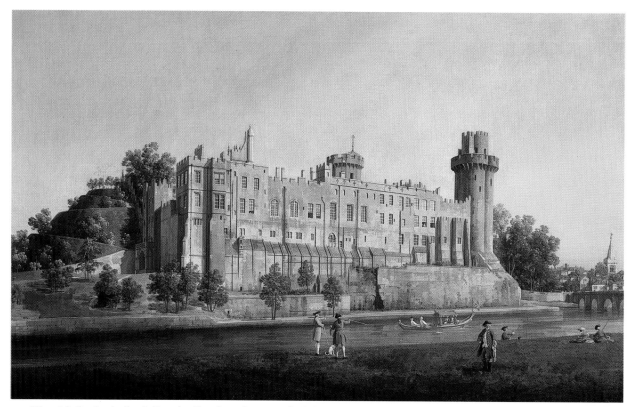

27. *Warwick Castle, the South Front* by Canaletto (1697–1768). Oil on canvas, 75 × 120.5 cm. Museo Thyssen-Bornemisza, Madrid.

specific pictures) that were favored by the Grand Tourist. His panorama of Westminster Bridge on Lord Mayor's Day is organized in three sweeping bands of water, city, and sky. Punctuating the foreground are the City barge, the barges of the various guilds, and a variety of pleasure craft (Plate 23). Only the Lord Mayor's barge, however, is positioned horizontally to the picture plane, thereby achieving maximum visual kinship with the *Bucintoro* (see Plates 8, 10). Indeed every important aspect of the picture—the banded composition, the massing of the boats, the studied legibility of the splendid central barge—defines the event as a northern analogue to the Sposalizio.

For the Duke of Richmond, Canaletto created a panorama that once again gives prominence to the Lord Mayor's barge (Plate 22). Yet this picture's allusive impact depends upon the ways in which the aerial perspective, the curve of the river, the variegated skyline, the imposing bulk of St. Paul's, and the palette of rose, white, and pale blue (colors emphasized by the clothes of the spectators in the foreground) conjure up two Venetian vistas: the Bacino di San Marco with San Giorgio Maggiore (Plate 24), and the Grand Canal with Santa Maria della Salute. It is Canaletto's achievement to keep the two cities and the three vistas simultaneously in play: the London before our eyes and the Venice of our memories (a Venice shaped by the painter himself) sustain a visual and imaginative dialogue.

Canaletto's allusions to Venice are by no means limited to panoramic representations of London. Elsewhere in his English oeuvre, he turns the *veduta* into something

78

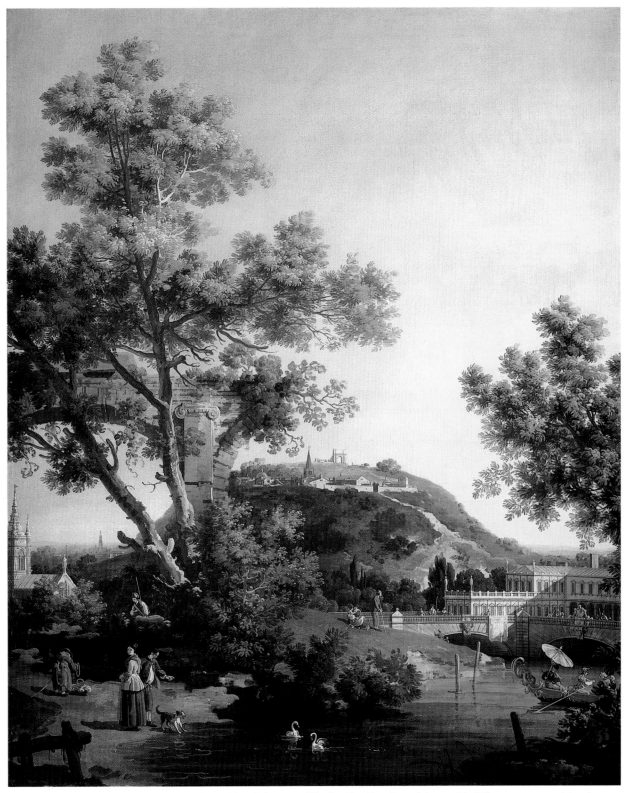

28. *Capriccio: River Landscape with a Ruin and Reminiscences of England* by Canaletto (1697–1768). Oil on canvas, 132 × 106.7 cm. National Gallery of Art, Washington.

approaching the *capriccio* by taking major liberties with architecture and topography. In *Old Walton Bridge* (Plate 25), for example, the intimate scale, rural vignettes, secluded houses, and muted earth tones bear a strong family resemblance to landscapes of the Brenta—a resemblance that would not have been lost on the contemporary viewer. As John Harris observes, "it is often forgotten that the English consciously made a comparison between the houses and villas on the Thames and those on the Brenta, nearly always to England's advantage!"[83] The game of Venice-with-a-difference continues in the treatment of the bridge itself: its actual configuration (flat surface and three bays of equal width) is altered to give it the profile of the Rialto. In fact the picture's basic composition appears to derive from a view of the Grand Canal purchased by Lord Leicester and hung first at his London house and then at Holkham (Plate 26). Canaletto took similar liberties in *Warwick Castle, the South Front*, painted for Lord Brooke, himself a collector of Canaletto's Venetian *vedute*. The picture imagines the castle as it might appear after the improvements that were being projected by Brooke and Capability Brown.[84] In keeping with this campaign of modernization, Canaletto creates a fully planted garden, transforms the castle's fenestration, and gives the river the look of a canal by removing a weir and an old mill. On this spruced up Avon he floats a gondola-like pleasure boat, complete with Venetian *felza* or canopied cabin (Plate 27; frontispiece). His imaginary view of the castle stretches the identification with Venice to its fullest by converting the medieval fortress into an elegant Italianate palace. From Warwick *soigné* it is no distance at all to a full-blown *capriccio* such as the one thought to have been commissioned by Lord King, in which a scarlet gondola and a pair of swans coexist harmoniously (Plate 28). This fascinating hybrid, described by Katharine Baetjer and J. G. Links as "an English landscape with reminiscences of Italy, or vice versa,"[85] suggests the combination of identities that forms the subject of the next chapter.

CHAPTER 4

# *Portraits*

To make the Grand Tour was to acquire a special sort of cultural power. Such power depended upon display. Indeed one might go so far as to say that travel abroad existed for the sake of ostentation at home, the Tour supplying the most effective props of all for what E. P. Thompson has called a "theatre of greatness." In Thompson's analysis, the patricians of eighteenth-century Britain were characterized above all else by their elaboration of "a studied and elaborate hegemonic style" and "the self-consciousness with which it was deployed."[1] The letters and journals of Grand Tourists contributed little to this crucial staging of authority, for they tended to remain within the private sphere of the family. More effective was the kind of sartorial and linguistic performance that in its most flamboyant form led to a variety of satirical attacks, such as Fielding's caricature in *Joseph Andrews* of the posturing *inglese italianato*. No single acquisition, however, testified quite so persuasively to the transformative effect of the Tour as the portrait (or portraits) painted in Italy. Beginning in the 1720s, it became almost *de rigueur* to commission such a portrait, which functioned as a visual curriculum vitae—a way of proclaiming accomplishments, articulating allegiances, and consolidating status. Positioned carefully within the theatrical decor of the town or country house, Grand Tour portraits played the part of advertisements and icons: advertisements for self, family, and class; icons of social, political, and even erotic authority.

Though it is appropriate to speak of Grand Tour portraiture as a coherent genre, with its own set of conventions and purposes, one must remain alert at the same time to marked differences within the genre. No difference is more basic and more significant than that between the Roman portrait as perfected by Pompeo Batoni (1708–1787) and the Venetian portrait in the hands of Rosalba Carriera (1675–1757).[2] While attending to the genre as a whole, this chapter pays particular attention to contrasts—contrasts in composition, in medium, in format, and in decorative function. My fundamental claim is that the differences between Roman and Venetian portraiture correlate to, comment upon, and even help to determine the contrasting valences of the two cities. A corollary to this claim is that the meaning of Venice for those making and remembering the Tour tended to emerge, explicitly or implicitly, from a Roman frame of reference. Venice, one might say, never ceased to be *S.P.Q.V.*

## Swagger and Seduction

As we have already noticed, Rome for the Grand Tourist was by far the most important source of *sacra* and of *spolia*. However, Rome was a dead city, a ruined temple to empire, and therefore had to be recreated through an extended effort of the historical and literary imagination. It existed in the mind of the traveler as a static archaeological phenomenon, a quarry and a backdrop (the one exception being the pomp and circumstance associated with the Vatican and the festivals of Christmas and Easter). The rhapsodic account sent by James Thomson to Lady Hertford exemplifies the reaction of several generations' worth of Grand Tourists: "Behold an Empire dead! and these venerable ruins all around, these triumphal Arches, pillars, remains of temples, Baths, aqueducts and amphitheaters, are her wide-spread monument—a monument, tho' made up of ruins, infinitely infinitely more noble than all the other monuments of the world put together."[3] To move from Rome to Venice, by contrast, was to enter an arena of multiple myths and fluid modernity—an arena that refused to arrange itself for the traveler in scenographic simplicity.[4]

The corresponding differences between Roman portraiture à la Batoni and Venetian portraiture à la Carriera can be defined in the following highly schematic terms. The Roman portrait is painted in oils, with a high finish. The most common format is full-length or three-quarter-length. The view is completely or almost completely frontal (a convention derived from state portraiture) and the viewer looks up at the sitter (a characteristic associated with religious painting).[5] The sitter's dress is always formal, and often ostentatious. He sits or stands in a middle ground that includes either a classical text or an antiquity or both; a prospect of Rome or its environs customarily fills the background. The painter of the Grand Tourist supplies, in Andrew Wilton's terminology, a "swagger portrait," which exhibits "an element of rhetoric . . . even of challenge—the 'insolence' that was always inherent in the meaning of the word [*swagger*]." Wilton calls such an image "a portraiture of ostentation," and he concludes that its "primary impulse . . . was political." Batoni's portraits are "political" in exactly Wilton's sense of the word, for they are calculated to enhance the authority of the traveler—"to invoke and reaffirm" his "right to rule."[6]

The Grand Tour portraits of Rosalba Carriera, on the other hand, are painted in delicate pastels. The qualities that attach to the medium—bravura improvisation, artful intimacy, melting sensuality—convey an important part of the Venetian message.[7] The scale is small, the view limited to head and shoulders or head and bust. The sitter is placed close to the picture plane in a neutral space—though the implication is that this space is private, for the clothes are those appropriate to a domestic *ricevimento*, when one dresses richly but informally. Unlike the Roman portrait, the Venetian portrait emphasizes the social and even the erotic; it suggests voluptuous refinement and eternal play.

Carriera's pastel of an unknown English sitter best represents the characteristic features of her approach to Grand Tour portraiture (Plate 29). The face is softly but brilliantly lit against a dark background; the eyes look boldly out at the viewer and the mouth is curved in a half-smile. The sitter's clothes—a flowing silk robe and matching turban—suggest both ease and refinement. The subject is male, but the modeling

29.  *Young Man in an Embroidered Jacket* by Rosalba Carriera (1675–1757). Pastel on paper, 57 × 45 cm. Private Collection, Switzerland.

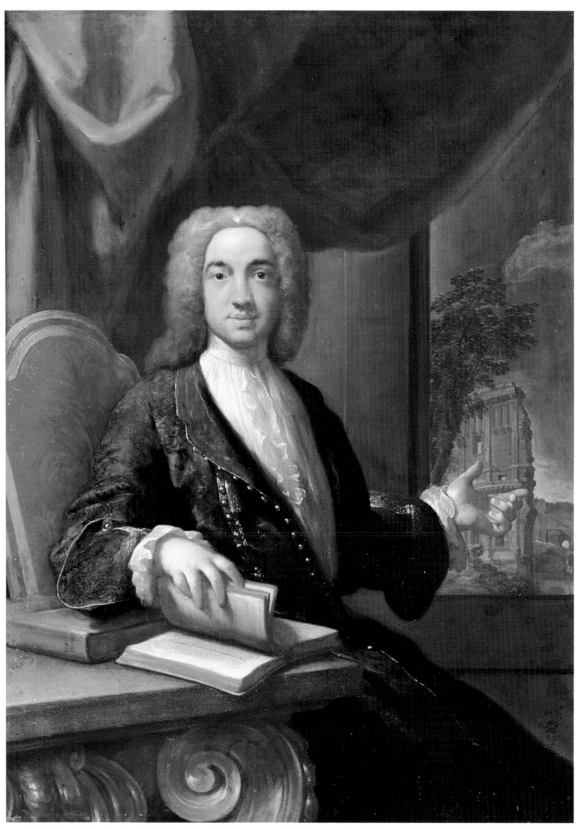

30. *Sir Edward Gascoigne* by Francesco Trevisani (1656–1746). Oil on canvas, 96.5 × 80 cm. Leeds Museums and Galleries (Lotherton Hall), Yorkshire.

of the face and the emphasis on the ivory complexion bring out a suggestion of androgyny. In this pastel and others like it the sitter is detached from the public domain and placed in a condition that is thoroughly ambiguous—ambiguous spatially, temporally, and sexually. But not geographically—despite the fact that Grand Tour portraits painted in Venice never incorporate the city as an explicit backdrop. Such portraits have internalized, as it were, the place of execution: the Venetian milieu is captured and communicated through medium, format, color, texture, dress, and physiognomy. If the grandfather of the Roman Grand Tour portrait is Titian and its father Van Dyck, then Carriera's Venetian portraits descend from Giorgione via Lorenzo Lotto.[8]

## Romanitas

These two strikingly different kinds of portraiture both came to prominence in the 1720s, although the Roman swagger-formula most frequently associated with Batoni was not perfected until the 1750s.[9] Elements of the formula occur in a handful of late seventeenth-century portraits; perhaps the earliest and most striking of these is Carlo Maratta's full-length oil of Robert Spencer, who is portrayed in Roman dress, and posed in an outdoor setting against a carved sarcophagus or pedestal.[10] But a continuous tradition did not develop until Francesco Trevisani (1656–1746) painted Sir Edward Gascoigne (Plate 30), who made his Grand Tour from 1723 to 1726.[11] Sir Edward, wearing a green robe decorated with silver filigree, is seated at an ornate table covered with books; his right elbow rests on a copy of Horace. With his left hand he points to a window that commands a view of the Coliseum. The sitter's social standing is established by dress, pose, and decor, his commitment to humanistic pursuits by the composition, which situates him visually and emblematically between a major literary and a major architectural monument.

A younger generation of portrait painters continued and refined the formula adumbrated in *Sir Edward Gascoigne*.[12] These include Antonio David (b. 1698) and Andrea Casali (c. 1700–1784), whose portrait of Sir Charles Frederick, painted in Rome in 1738 (Plate 31), provides a clear connecting link between Trevisani and Batoni. Casali places Sir Charles at an ornate writing table, where he is engaged in making notes on coins or medals. A dark-toned suit sets off a splendid ivory and gold waistcoat, which is echoed by the gilded base of the table and the trim of the chair. Sir Charles appears to be seated in a curtained loggia, which opens out onto a prospect of the Pantheon. However, this view is not integrated into the chief picture space: it functions as a decorative element, a visual and cultural marker. As yet the sitter is *in* Rome but not *of* Rome.

Like the portraits of Trevisani and Casali, the earliest examples of Batoni's Grand Tour pictures employ the topography of Rome as a reference point that is both visually and symbolically circumscribed. In his *Lord Charlemont* (Plate 32) the composition is somewhat unsophisticated: there is no middleground to speak of, and no classical trappings in close proximity to Charlemont himself; the view of the Coliseum is pushed into the far right-hand corner, and rendered as if it were a small painting

suspended from the back wall. Rome is being quoted, rather than being integrated within a spatial continuum that includes the sitter.

Instead Batoni lavishes most of his attention on face and dress. Charlemont's features are painted in such a way as to suggest not only sensuality and boldness, but also charm and finesse. The clothes play out this balancing of swagger with suavity. Bright red breeches and green coat contrast with the creamy white silk waistcoat; sweeping horizontals and diagonals are counterpointed by the delicate gold frogs on coat and waistcoat, and the tendril-like curves of the black cravat. As Anthony Clark and Edgar Peters Bowron have noted, the coat suggests a hussar's uniform.[13] At the same time, the softness of the curves and the opulent silks moderate quasi-military swagger with aristocratic refinement.

In its dynamic theatricality and intricate composition, Batoni's full-length of Sir Wyndham Knatchbull-Wyndham (Plate 33) represents a major step forward in the development of the formula we have been considering. The more one studies his career, the more one concurs with Francis Russell's judgment, that in this portrait "Batoni attained his majority as painter of the Grand Tourist."[14] And Batoni comes into his own painting Sir Wyndham attaining *his* majority. The choice of costume helps to signal the fact that, among several kinds of homage being paid in this picture, painter and subject alike have chosen to align themselves with Van Dyck and his image of the perfect courtier. What catches the eye immediately is the baroque swirl of the cloak wrapped around Sir Wyndham's right arm, which is balanced by the folds of the curtain in the upper right-hand corner of the portrait. Guided into the picture space by this massing of drapery, we then follow the sitter's left arm into the background, where the Roman landscape is treated as if it were a view of the sitter's own country estate: the Temple of Vesta turns into an eye-catcher in an English park, on the order of the Temple of Ancient Virtue at Stowe.[15] Sir Wyndham's head is slightly tilted toward the right and brightly lit from above; though the gaze is directed outward and downward, Batoni has contrived a subtle compositional relationship with the silhouetted bust of Minerva in the middleground. Every significant aspect of the portrait signals a confident balance between *pietas* and *virilitas*, classical past and British future.

In his portrait of Sir Gregory Page-Turner (Plate 34), Batoni makes even more effective use of the same bust, as part of an emblematic presentation of the young English baronet as connoisseur, assimilator, appropriator, and even conqueror. Sir Gregory stands, dynamically at ease, in a curtained loggia giving on to the Coliseum. On the table are books (a mingling of classical texts and modern guides) and Minerva (whose dual identity as goddess of wisdom and of warfare the portrait subtly activates). Sir Gregory's left hand holds firmly in place a map of Rome, which would slide off the table were it not for his confident grasp. With the other he gestures outward and downward, as if moved to declamation.

Batoni portrays his sitter as worthy of the past, equipped for the present, and confident in the future. Sir Gregory's scarlet-and-gold suit proclaims a wealthy, elegant eighteenth-century gentleman, possessor of a complete set of Chesterfieldian skills and graces. Yet the suit covers a body whose pose is modeled on that of the *Apollo Belvedere*, one of the canonical statues on display at the Vatican, itself a fixed stop on the Grand Tourist's Roman itinerary.[16] As Iain Pears has suggested in a somewhat different

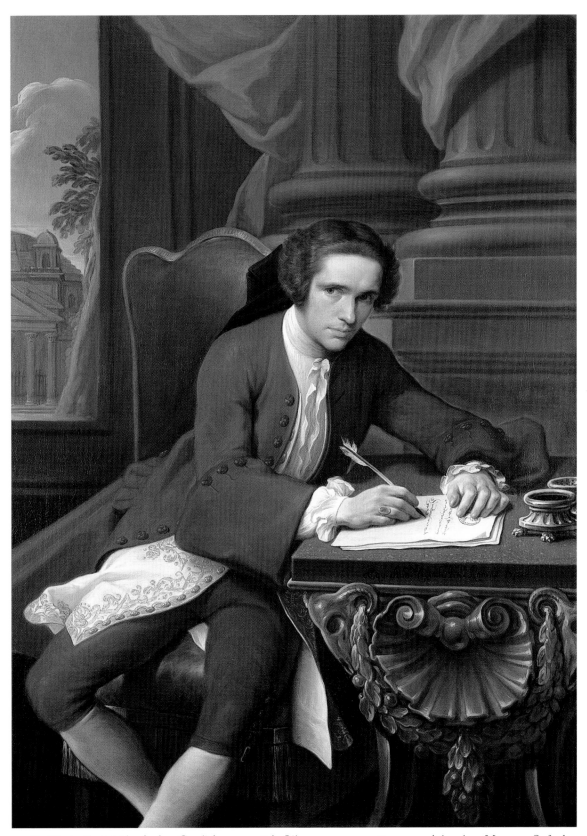

31. *Sir Charles Frederick* by Andrea Casali (c. 1700–1784). Oil on canvas, 133.5 × 95.5 cm. Ashmolean Museum, Oxford.

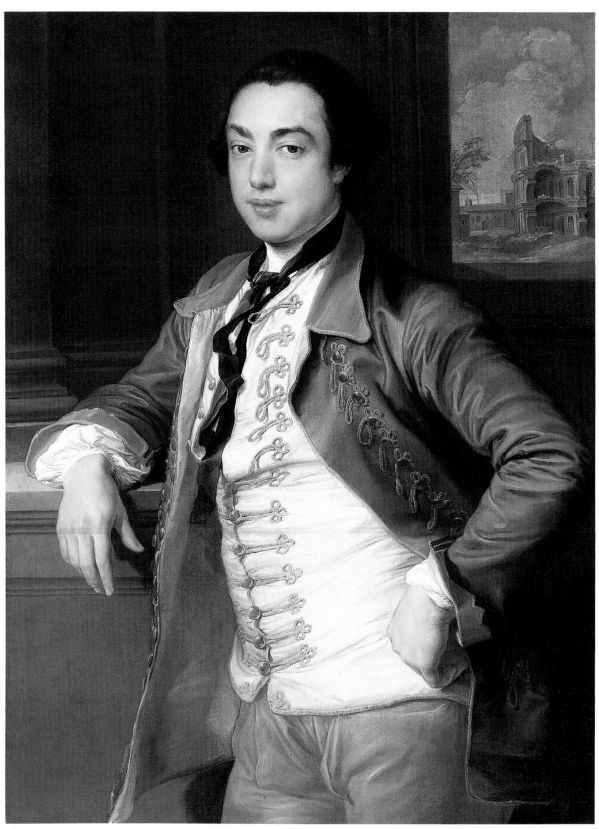

32. *James Caulfield, Lord Charlemont, later 1st Earl of Charlemont* by Pompeo Batoni (1708–1787). Oil on canvas, 97.8 × 73.7 cm. Yale Center for British Art, New Haven.

context, "Possession of taste not only indicated education and hence virtue but also implied and signified the fitness of its possessors to rule."[17] By associating Sir Gregory as he does with Minerva, Apollo, the Coliseum, and comparable monuments of classical literature, Batoni makes his sitter into an imitator of the past, but an imitator in Sir Joshua Reynolds's sense of the term: one who studies in the spirit of respectful rivalry, one who begins by copying and ends by transforming.[18]

*Sir Gregory Page-Turner* can be read as a testimonial, an epiphany, and a power play. At the most basic level it registers the presence of the sitter in the Eternal City and the impact of that city upon him: Rome as agent.[19] Yet its primary energies are directed to transforming Rome into an object, a giant collectible—to subduing the identity of the city to that of the sitter. The picture's ultimate purpose is to join in the category of *spolia* the city it encapsulates, and thereby to work upon its English viewers as part of an essentially political program.

The process of assimilating Rome to England is carried one step further in Batoni's portrait of John Chetwynd Talbot (Plate 35). Batoni places his sitter at the foot of a flight of shallow steps, rising to a wooded landscape that might be either an Italian garden or an English park. The sitter, aligned on a gentle diagonal, is framed by the emphatic horizontal masses of the *Ludovisi Ares* and the *Medici Vase*. Talbot leans nonchalantly but assertively against the pedestal of the vase, as if to take possession of the classical terrain in which he finds himself. Whether Rome has been Anglicized or England classicized is impossible to determine—and that ambiguous but harmonious conflation of the two is precisely what Batoni has in mind.

The composition of Batoni's *Thomas Coke* (Plate 36) is remarkably similar to *Sir Wyndham Knatchbull-Wyndham*. The sitter is clothed in Van Dyck costume and positioned in a classical loggia opening out to a view of the Campagna. A dog gazes up adoringly at his master, whose gaze is angled to the right. The most significant difference between the two pictures is the inclusion of the Vatican *Cleopatra*, which might be said to substitute, as emblematic antiquity, for the bust and temple in *Sir Wyndham*. However, the statue's role is much more complex than that of studio prop. Coke has come to venerate the *Cleopatra*, which ranked with the *Apollo Belvedere* as one of the compulsory sights in Rome; yet the statue ends by worshiping him. As Andrew Wilton notes, "Batoni has so placed the sculpture that the figure seems to lean round in admiration of the young man."[20] Marble Cleopatra, moreover, is painted as if she were halfway to flesh, and the contours of the landscape are made to echo her reclining form—witness the breast-like curve of the Alban hill in the background. "Classic ground" has been feminized, in contrast to and adoration of the young male possessor.[21]

The attitude to Rome implied by these portraits is one of mingled admiration and condescension. In one respect the city deserves the epithet "eternal": she has been and continues to be the source of a humanistic education and the teacher of imperial arts. The poet and traveler George Keate proclaims this continuing allure in "Ancient and Modern Rome" (1755):

> These stately ruins, that from various shores
> Attract the traveller, whose bosom burns

> With strong impatience, by the classic page
> Excited (faithful register of worth)
> To visit thee, thou once great seat of arms,
> Thou nurse of heroes. . . .

But Keate stresses that Rome has allowed herself to slip into decadence and ultimate ruin:

> Here DESOLATION, mocking the vain farce
> Of human labours, and the low conceits
> Of human pride, thron'd on a craggy pile,
> Smiles pleas'd with her own work. . . .[22]

In terms of the myth promulgated by Addison, Thomson, and others, Britain has inherited Rome's mantle and may well avoid her fate:

> From tyrants, and from priests the Muses fly,
> Daughters of reason and of liberty
> ·  ·  ·  ·  ·  ·  ·  ·  ·  ·  ·  ·  ·
> To Thames's flowery borders they retire
> ·  ·  ·  ·  ·  ·  ·  ·  ·  ·  ·  ·  ·
> To sing the land, which yet alone can boast
> That liberty corrupted Rome has lost.[23]

Rome past furnishes one kind of object lesson (in the moral and the material senses), Rome present quite another.

The antiquities on view in Batoni's portraits have a double significance as well. At once timeless sources of cultural value and time-bound relics of vanished glory, they help to create a subtle dialectic between past and present. Their doubleness—eternal touchstones on the one hand, pathetic shards on the other—matches and reinforces the complex identity of the travelers who have made a pilgrimage to see them. Batoni portrays his milordi as contemplative, reverent, backward-looking aesthetes who are also confident rulers in the making. Passive and admiring from one point of view, active and appropriating from another, they are situated at a "breakthrough moment" in their own and their country's history.[24] As Hugh Honour cogently observes, Batoni's gifts were well suited to portraying the "Englishmen who were just then emerging as the young light-hearted masters of the world. For his portraits of them are not only records of the grand tour but of the moment when England began to play a dominant role in European affairs."[25]

### *Masked Gentlemen*

Surviving documents show Rosalba Carriera to be much concerned with the technical aspects of the pastel,[26] but neither her letters nor her diaries contain anything that might be described as aesthetic reflections on the medium or calculated assessments of the market. Likewise the enthusiasm of British travelers is much in evidence, but not the canons of taste that impelled their avid purchasing. One

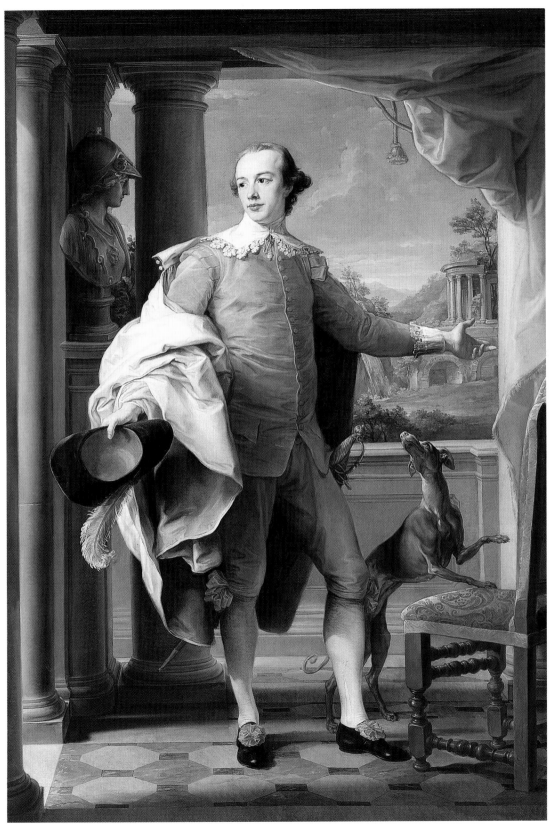

33. *Sir Wyndham Knatchbull-Wyndham, 6th Bt.* by Pompeo Batoni (1708–1787). Oil on canvas, 233 × 161.3 cm. Los Angeles County Museum of Art.

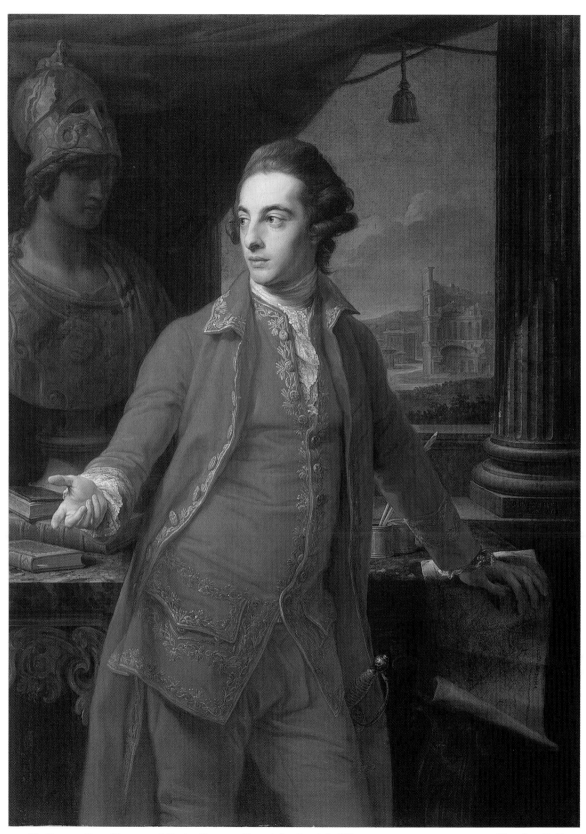

34. *Sir Gregory Page-Turner, 3rd Bt.* by Pompeo Batoni (1708–1787). Oil on canvas, 134.5 × 99.5 cm. City Art Gallery, Manchester.

valuable (albeit somewhat cryptic) exception to this rule occurs in the travel journal of Martin Folkes, who visited Carriera's studio in 1733:

> I went to Signora Rosalbas whose pictures in crayons have been with Justice esteemed the most excellent pieces of art of that sort. . . . I was here extreamly well entertaind with a great number of fine portraits some of my acquaintance very like. Here are 3 sisters which were all together when I was here. Mad. Rosalba her self and one of the others is single, the third is wife to Sigr. Pelegrini and was with him in england, for which she expresses a great regard. I saw among others a fine idea representing musick the face was taken I heard from a person now kept by an English Nobleman.[27]

In this entry Folkes concentrates on the three aspects of Carriera's career that matter most to the student of Venice and the Grand Tour. The first is her expertise in, and reputation for, both portraits and fancy pieces. The "fine idea representing musick," perhaps to be identified with the rendering of *La Musica* now at Knole,[28] exemplifies Carriera's quasi-allegorical pastels, whose ostensible subject provides an excuse for genteely erotic images of winsome, scantily clad young women, all rococo curves and glowing flesh tones. The journal entry also draws attention to the importance of Carriera's English connections, which resulted partially from the efforts of her brother-in-law Pellegrini, and partially from the patronage of the Venetian Resident, Christian Cole, and of Consul Smith.[29] The most absorbing issue, however, is the one touched upon by Folkes when he praises Carriera's "fine portraits" for being "very like"—a phrase that raises more questions than it answers. In this context the criterion of "likeness" involves more than straightforward verisimilitude. Reflecting on the social, even symbolic resonance of Carriera's portraits, Bernardina Sani observes: "It is more difficult to explain the English preference for Carriera's pastel portraits—but it is possible that they gave pleasure because they were so different from the austere magnificence of the formal portrait; moreover, they offered likenesses that were not only truthful but seductive [*immagini seducenti*], likenesses adapted to an aristocracy that wished to provide a new image of itself."[30] But what helps to make of these portraits *immagini seducenti*—so seductive that, until she went blind at mid-century, "every Grand Tourist calling in Venice . . . wished to have his likeness taken" by Carriera?[31] Why was she, in her own words, "attaqué par des Angles"?[32]

The source of her appeal can best be understood if we consider first the work of the Venetian artist whom British visitors to the city chose *not* to patronize: Bartolomeo Nazzari. Nazzari might well have been the Pompeo Batoni of the Veneto. Born near Bergamo in 1699, he studied first in Venice and then in Rome, where he worked in the studio of Francesco Trevisani at a time when Trevisani was painting such portraits as *Sir Edward Gascoigne*. Nazzari had returned to Venice by 1724, where he lived until his death in 1758. There he came frequently into contact with visiting milordi, partially through his extensive involvement in the musical life of the city. Yet these same visitors turned elsewhere for a "Venetian" likeness. When Lord Boyne, for example, stopped in Venice on his Tour, he commissioned from Carriera one of her most memorable pastels, while turning to Nazzari for something quite different: a conversation-piece depicting Boyne and his friends gathered round a table in a ship's cabin, where they

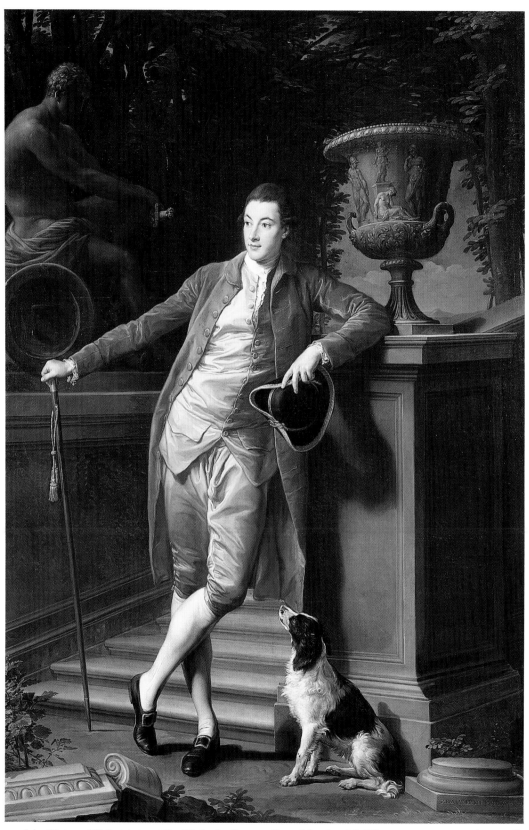

35. *John Chetwynd Talbot, later 1st Earl Talbot* by Pompeo Batoni (1708–1787). Oil on canvas, 274.3 × 182.3 cm. J. Paul Getty Museum, Malibu, California.

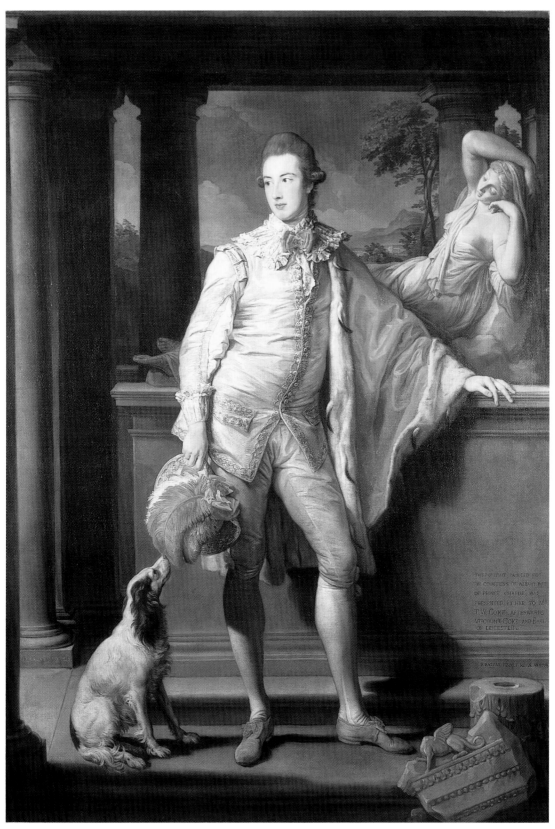

36. *Thomas William Coke, later 1st Earl of Leicester* by Pompeo Batoni (1708–1787). Oil on canvas, 245.8 × 170.3 cm. Holkham Hall, Norfolk.

are engaged in drinking punch and consulting a map (Plate 37). The subject matter is strongly reminiscent of seventeenth-century Dutch genre painting, its treatment so unVenetian that the picture was long attributed to Hogarth.[33]

The sole surviving portrait of an eighteenth-century Englishman in an explicitly Venetian setting is Nazzari's *Samuel Egerton* (Plate 38), which shows a certain indebtedness to the Roman swagger-formula without qualifying as a Grand Tour portrait.[34] When the picture was painted the sitter had been serving for three years as Consul Smith's assistant. He is positioned on a terrace above the Grand Canal; to his right is a table covered with dark red drapery and piled with books. Wearing a brocaded waistcoat and a turban-like hat, Egerton rests his right hand on his hip and gestures with his left toward a prospect that includes the Grand Canal, the Dogana (or Customshouse), and a distant glimpse of Palladio's *Le Zitelle*.[35]

Nazzari depicts a young merchant-on-the-make, proud of his prospects (witness the prominent appearance of the Dogana in the background) while aspiring to the status of gentleman. Comparison of the final version with the preparatory oil sketch (Venice, Museo Correr) confirms what the portrait suggests—an element of strained display, of uneasy playacting. The face in the oil sketch is a good ten years younger, the pose somewhat gauche, the clothes less sumptuous. Nazzari has collaborated with his sitter, one feels, to produce a somewhat grandiose image for home consumption—a visual testament to professional success abroad and to the social aspirations that accompany such success.[36]

The aristocratic traveler, by contrast, turned not to Nazzari but to Carriera for portraits that would be "very like"—just as he gave overwhelming preference to Canaletto for *vedute* designed as topographical souvenirs. The figure-in-a-landscape approach that typifies Roman Grand Tour portraiture splits in Venice into the topographical and the non-topographical, the city copiously displayed and the city selectively implied. For certain milordi Carriera created a variant of special piquancy, in which the sitter's association with Venice is signalled by three elements of carnival dress: a white mask, a richly trimmed hat, and a *bauta*. In one of the most popular narratives of the Tour, Edward Wright describes this assemblage in such a way as to convey its utility as a unisex disguise:

> The most common Masking Dress is a Cloak, a *Baout*, and a white Mask: this Dress with a Hat over all is the general one for both Sexes, Women as well as Men. The *Baout* is a sort of Hood of back Silk, which comes round the Head, leaving only an opening for the Face, with a Border of black Silk Lace which falls about the Shoulders. The white Mask comes no lower than the bottom of the Nose, the *Baout* covers the rest.[37]

Such dress both enables and incarnates the spirit of Carnival. Joseph Spence, who as prominent bearleader ought to have been downplaying rather than exalting the lure of masquerade, nonetheless conveys its irresistible impact on those very travelers who found time between revels to sit for Carriera: "The Carnival seems at first a mighty foolish thing, but in 8 or 10 days, you find it pleases you insensibly more and more, and anybody that has sense enough, may easily grow as great a fool as the rest. The air is even infectious, and you have nothing to do but not to be too wise."[38]

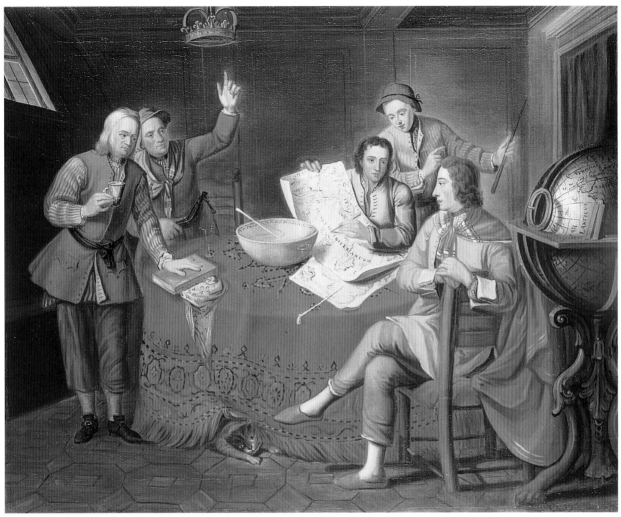

37. *Lord Boyne and Companions* by Bartolomeo Nazzari (1699–1758). Oil on canvas, 66 × 81.5 cm. National Maritime Museum, London.

The best-known example of the carnivalesque sub-genre is Carriera's portrait of Lord Boyne (Plate 39), long thought to be of Horace Walpole.[39] Boyne is pictured as if caught between sessions of the Carnival, white mask pushed sideways over black *bauta*. His clothes likewise proclaim the gentleman of pleasure: blue velvet coat edged with fur; underneath, a pink and white satin waistcoat. Carriera here offers us the ultimate image of mondanity—of poised and inviting elegance, of the young aristocrat as *galant'uomo*. She does so through what Thea Burns has called a sophisticated "interplay of pastel medium, technique and meaning." In such portraits, as Burns observes, "the material resemblance of the powdery, evanescent surfaces to make-up, particularly theatrical make-up, underlined the conceit understood by the contemporary viewer in which theatricality signalled 'a condition of leisure and, therefore, of nobility.'"[40] In Carriera's version of "the theatre of greatness," the element of play-acting enhances rather than subverts the aristocratic aura of the sitter. Only in portraits

97

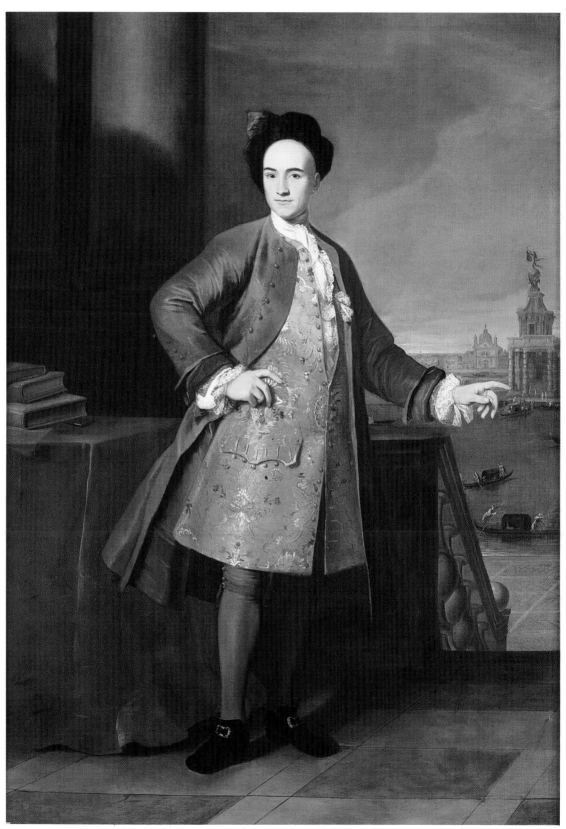

38. *Samuel Egerton* by Bartolomeo Nazzari (1699–1758). Oil on canvas, 215.5 × 154.5 cm. Tatton Hall, Cheshire.

coded "Venice," and "carnivalesque Venice" in particular, could such a combination be achieved. The sole analogues (perhaps even sources) are Watteau's *fêtes galantes*: Carriera met Watteau in Paris and painted his portrait at a time when he had recently finished his major works in this specialized genre.[41]

*Lord Boyne* gives us Pope's "enamoured swain" *en travesti*, who inhabits Venice much differently than Sir Gregory Page-Turner inhabits Rome. The swain, moreover, suggests the "smooth eunuch." When Michael Levey criticizes the portrait for what he calls "a sort of epicene silliness," it might be possible to dismiss the reaction as unhistorical. However, no less authoritative a contemporary than Horace Walpole, several of whose family members were painted by Carriera, himself calls her men "effeminate"—ample warrant for applying the term "androgynous" to the Venetian pastels.[42]

Carriera's masterpiece in this specialized form is her pastel of Charles Sackville, second Duke of Dorset, painted when Sackville was a precocious nineteen and already notorious for the eminently Venetian qualities of extravagance, promiscuousness, and love of opera (Plate 40). Indeed Carriera herself seems not only to have painted him but also to have acted as a go-between in a passionate romance.[43] Unlike *Lord Boyne*, the torso in this pastel is angled away from the picture plane, the arms are linked, and the face is lit brightly from the left. The result is to focus attention on Sackville's profile (particularly the curve of his upper lip), on the jauntily cocked mask and tricorn hat, and on the sumptuously brocaded robe. The lace of the hat, the *bauta*, and the stock are rendered with utmost delicacy, as is the floral pattern of the brocade. Even more effectively than in *Lord Boyne*, Carriera contrives an aura of hothouse luxuriance—the curves of the robe, veil, and hat softly framing a face of androgynous plasticity. At the same time, she imbues her sitter with a self-assurance verging on the arrogant: this is no gawky or swooning adolescent, but a poised young aristocrat seizing Venetian days and nights with supreme nonchalance.[44] In no other portrait are medium, technique, and message more successfully interwoven.

### *One Venice More*

This interpretation of Carriera's Grand Tour portraiture can be strengthened and extended if we consider the nature of the vogue it was instrumental in creating. As Francis Russell confirms, "The rich traveller on the Grand Tour would sit to Rosalba Carriera, who exercised a more direct influence on British contemporaries than any other Italian painter of the century."[45] Carriera's most important English followers, whose careers flourished from the 1740s to the 1790s, were George Knapton (1698–1778), William Hoare (1707–1792), Francis Cotes (1726–1770), and John Russell (1745–1806). Her pastels remained for both these artists and their clients a fundamental *point de repère*. But the fact of influence is much easier to document than the attitudes that helped to create and sustain the vogue for this kind of portraiture. Perhaps the best place to begin is with three brief but revealing commentaries on the medium: a diatribe from George Vertue, an appreciative comparison by Horace Walpole, and a brief treatise by Francis Cotes.

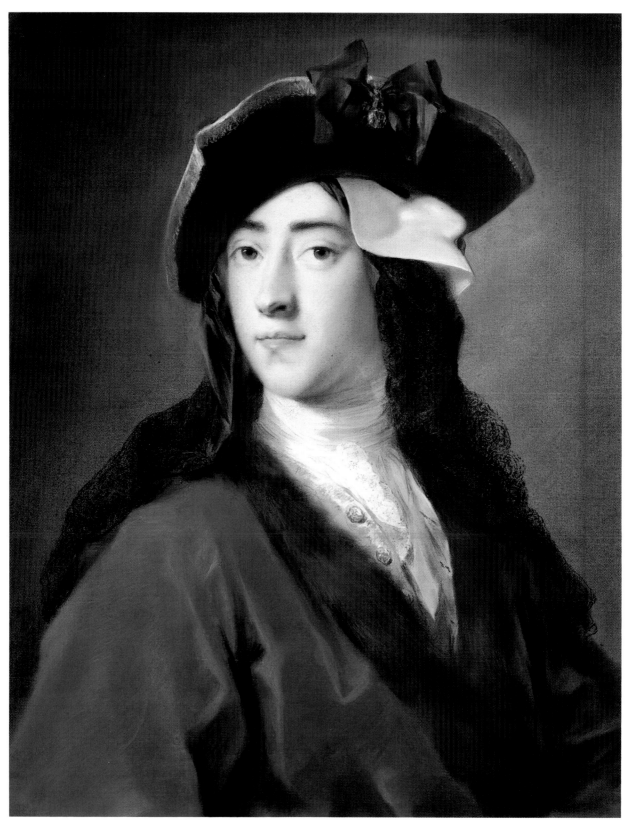

39. *Gustavus Hamilton, 2nd Viscount Boyne* by Rosalba Carriera (1675–1757). Pastel on paper, 62 × 50 cm. Private Collection, England.

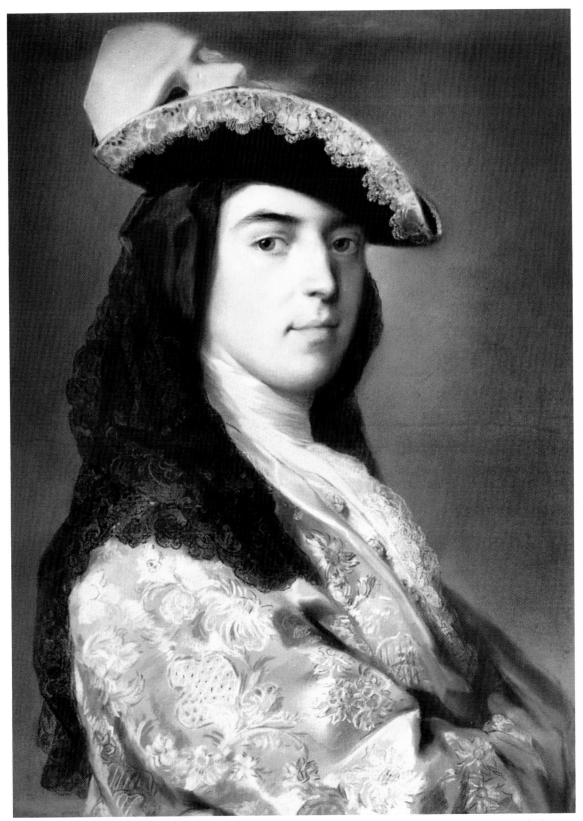

40. *Charles Sackville, 2nd Duke of Dorset* by Rosalba Carriera (1675–1757). Pastel on paper, 59.5 × 53.3 cm. Private Collection, England.

George Knapton returned from his *Italienischereise* in 1732, William Hoare in 1737, and both achieved such rapid success that in 1742 George Vertue was grumbling in his notebook:

> Crayon painting . . . looking pleasant and coverd with a glass large Gold Frames was much commended for the novelty—and the painters finding it much easier in the execution than Oil Colours readily came into it. . . . But all this is the depravity of skill, and lowness of Art by which means the unskillful are deceivd—and pay for their Ignorance . . . the want of Ambition in Art thus shows its declineing State. Small pains and great gains, is this darling modish study.[46]

Vertue's criticism centers on two points: the decorative value of the portrait, and the fact that the pastel medium allegedly exacts fewer pains from the artist than does the oil portrait. The key term for Vertue is "ease," which for him is a sign of decadence. For Horace Walpole the opposite is true: ease of technique, which celebrates and promotes a certain "air" or aura, explains much of the pastel's allure. Comparing the portraits of the Swiss pastellist Jean-Étienne Liotard with those of Carriera, he comments: "Truth prevailed in all his works, grace in very few or none. Nor was there any ease in his outline; but the stiffness of a bust in all his portraits. Thence, though more faithful to a likeness, his heads want air and the softness of flesh, so conspicuous in Rosalba's pictures."[47] Elsewhere in his *Anecdotes*, Walpole compares Carriera to Cotes: "His pictures . . . are portraits which, if they yield to Rosalba's in softness, excell her's in vivacity and invention."[48] It was left to Cotes himself to celebrate the pastel in similar language but in terms of decoration rather than representation: "Crayon pictures, when finely painted, are superlatively beautiful, and decorative in a very high degree in apartments that are not too large; for, having their surface dry, they partake in appearance of the effect of Fresco, and by candlelight are luminous and beautiful beyond all other pictures."[49]

The career of William Hoare best exemplifies the values associated with the pastel portrait, and the contexts within which it flourished. In his twenties Hoare studied under Francesco Imperiali in Rome, where he began to develop his skills as a pastellist. As Evelyn Newby observes, "Hoare's interest in pastel could only have been strengthened by visits to Venice—he had firsthand knowledge of the Venetian school which makes a stay there a certainty—and it is just possible that he may have met Rosalba herself."[50] Soon after his return to England, Hoare settled in Bath, where he began to specialize in pastel portraits. As an advertisement for his wares, he placed in his studio two works by Carriera and a self-portrait modeled on her Grand Tour pastels (Plate 41). In the tradition of her "fancy" pictures, he also produced discreetly erotic images of such subjects as the "Four Seasons." Hoare's success testifies to a canny perception that visitors to Bath looked for much the same kind of gratification—and therefore the same kind of visual memento—as did visitors to Venice. Both cities had economies largely based upon a specialized kind of tourism; both cities catered, in Daniel Defoe's words, to "the Indolent and the Gay."[51] We might legitimately compare Hoare's Bath pastels to studio portraits by a photographer such as Cecil Beaton: produced quickly, expertly, and stylishly, both exude the *bon ton* associated with a certain kind of "easy" urbanity.

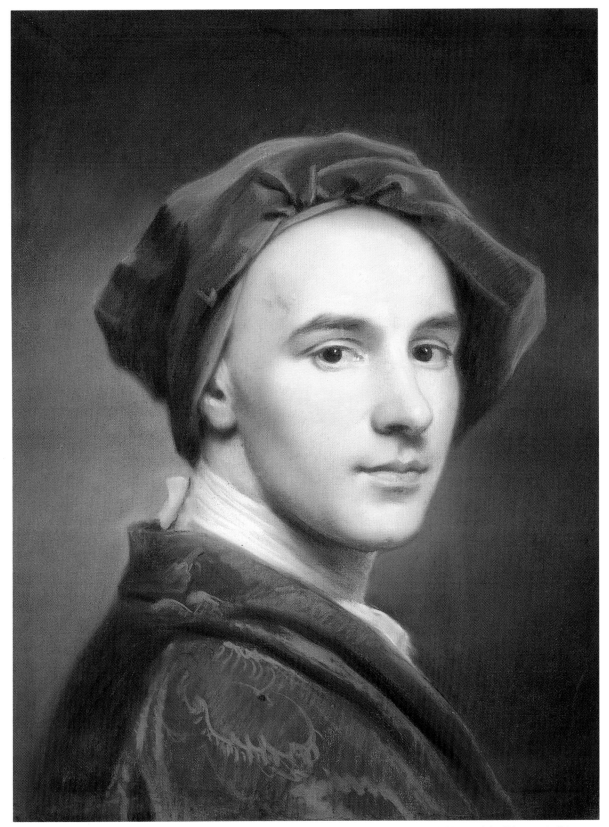

41. *Self-Portrait* by William Hoare (1707–1792). Pastel on paper, 49.5 × 38.1. Royal National Hospital for Rheumatic Diseases, Bath.

It is time to step back from Carriera's career and its impact on English portraiture to reflect for a moment on the allure of the pastel. At least four factors help to explain its appeal to a privileged British clientele. The first is that the pastel exuded a continental and an aristocratic aura: as Edward Mead Johnson explains, "most of the royal families of Europe had sat to Rosalba."[52] The second factor is that, while high in prestige, the pastel was relatively low in cost. The third is that a pastel portrait could be produced quickly: unlike Batoni's oils, for which some sitters waited for years, pastels could be finished while the sitter was on the spot, and then transported home without delay. The comparative brevity of the Grand Tourist's sojourn in Venice made this consideration especially attractive. Finally, the pastel combined glamor with intimacy: the medium of the bravura sketch was ideally suited to capturing a stylized version of the private self.

Cotes's remarks supplement what we know of the original "hang" of eighteenth-century town and country houses: the pastel was valued as an ideal pendant to the oil portrait, in terms of both its representational and its decorative value. It balanced the public rhetoric of the oil portrait with a more private, a more insinuating form of visual address; it also provided the ideal grace note for the secluded spaces of the house (the closet, the alcove, the boudoir, the bedroom). Hung in juxtaposition to large-scale oils, Carriera's pastels and those of her followers joined Venice to Rome, the private to the public, the *galant'uomo* to the statesman, the social to the political, seduction to swagger. Within the conceptual scheme of a house such as Holkham, whose decoration offered "a carefully composed intellectual autobiography" of the owner,[53] such portraits completed the display of credentials that proclaimed the unity of *virtù* and virtue.

# *Transformations*

The meeting of William Beckford and Lord Byron is one of the great might-have-beens of literary history. The two men themselves, as well as many of their contemporaries, were struck by parallels in temperament and taste, both literary and sexual; those same parallels now seem almost uncanny, given our more complete knowledge of the writers' private lives. However, Beckford's perception that the younger poet was replaying, *mutatis mutandis*, his own scandalous career sufficed to keep them apart: in embittered middle age, the Caliph of Fonthill would not compromise his reputation further by consenting to the interview that Byron so ardently desired. Byron's enthusiasm originated in his reading of *Vathek*, which influenced such oriental tales as *The Giaour*, and his sense of kinship with "the great Apostle of Paederasty" who was also "the Martyr of Prejudice."[1] This attachment could only have been strengthened by the opportunity to read Beckford's suppressed narrative of his Grand Tour, *Dreams, Waking Thoughts, and Incidents*. Byron's friend Samuel Rogers was presented with one of the few surviving copies when he visited the reclusive Beckford at Fonthill Abbey. Rogers' account of the visit reached Byron in Venice soon after he had completed *Childe Harold's Pilgrimage*, Canto IV—a poem that parallels and completes Beckford's transformation of Grand Tour narrative. Unknown to each other, both men abandoned all conceptions of the Tour as a training-ground for public life, and all literary conventions that were designed to instruct and improve. In their place, they offer a solipsistic autobiographical enterprise, which subordinates the external world to the troubled consciousness of a traveler whose primary quest is directed inward. As they transform the Tour, moreover, Beckford and Byron radically rework the myths of Venice we have been exploring. *Dreams, Waking Thoughts, and Incidents* turns the city into a debased peep-show, while Canto IV of *Childe Harold's Pilgrimage* makes her into a mirage and a mirror.

## *Picturing the Tour*

The title of *Dreams, Waking Thoughts, and Incidents* adumbrates its priorities and its contents. The sequence of nouns measures the difference between Beckford's enterprise and all who had gone before, both as travelers and travel-writers: dreams and reveries take absolute precedence over the realm of mere "incident." The

42. *The Eidophusikon* by Edward Francesco Burney (1760–1848). Watercolor on paper, 21 × 29 cm. British Museum, London.

*caveat lector* declaration with which the book begins turns its back even more emphatically on those who expect to be informed and edified: "But stop, my good friends; patience a moment!—I really have not the vanity of pretending to make a single remark, during the whole of my journey: if —— be contented with my visionary way of gazing, I am perfectly pleased; and shall write away as freely as Mr. A, Mr. B, Mr. C, and a million others, whose letters are the admiration of the politest circles."[2] Here Beckford jettisons the *utile* in order to celebrate a sensibility—the sensibility of England's Grandest Tourist, who has invented a "visionary way of gazing" and of traveling.

The revolutionary nature of Beckford's undertaking is emphasized by its gestures toward tradition. *Dreams, Waking Thoughts, and Incidents* recounts a Tour whose basic itinerary deviates from the norm in only two important respects—the slighting of Rome (where Beckford spent less than a week) and the relegation of Paris to the end of the journey. Nineteen years old when he set out, Beckford traveled with his tutor, the Reverend John Lettice, and returned in time for his twenty-first birthday celebra-

tions; he kept a journal, which served as a basis for letters addressed to an unnamed correspondent (his drawing master and confidant, Alexander Cozens). Beckford alludes to the accounts of Smollett and Sterne, and periodically invokes the standard norms, if only to reject them. At the beginning of his journey, he imagines "some grave and respectable personage chiding me for such levities, and saying—'Really, Sir, you had better stay at home, and dream in your great chair, than give yourself the trouble of going post through Europe, in search of inspiring places to fall asleep'" (pp. 56–57). And when he reaches Rome, the ostensible focus of pilgrimage, he turns his back on instruction in favor of twilight rambles through the Forum: "I absolutely will have no antiquary to go prating from fragment to fragment, and tell me, that were I to stay five years at Rome, I should not see half it contained. The thought alone, of so much to look at, is quite distracting, and makes me resolve to view nothing at all in a scientific way; but straggle and wander about, just as the spirit chuses" (p. 194). In the event, the book flouted so many conventions, and celebrated its author's deviations so extravagantly, that it was suppressed on the eve of publication in 1783.[3]

Beckford's narrative—if "narrative" is still the appropriate term for what the author himself calls a "luxuriant and sentimental" monologue—transforms the Tour in four significant ways.[4] First, *Dreams* everywhere insists upon the primacy of the subjective viewer, who delights in filtering what he sees through the equivalent of a theatrical scrim: "A frequent mist hovers before my eyes, and, through its medium, I see objects so faint and hazy, that both their colours and forms are apt to delude me" (p. 53). Second, it cultivates with the reader a relationship of confessional intimacy. The book's first sentence perfectly captures the prevailing tone of desultory yet intense engagement: "Shall I tell you my dreams?—To give an account of my time, is doing, I assure you, but little better" (p. 53). To tell his dreams, and to make the telling pre-empt all other concerns, is to implicate the reader in fantasies of escape, exaltation, innocence, and masochistic pleasure.

Third, *Dreams* abjures all forms of conventional coverage: like Sterne in this respect, Beckford ignores or speeds through what is expected, and celebrates what others might consider trivial or even decadent. Architecture, antiquities, religion, statecraft: these are marginalized or treated as incitements to reverie or ecstasy. In Mantua he pays brief homage to the frescoes of the Palazzo del Te, but soon wanders outside to meditate in the ruined garden: "I gathered a tuberose, that sprung from a shell of white marble, once trickling with water, now, half filled with mould; and carrying it home, shut myself up for the rest of the night, inhaled its perfume, and fell a dreaming" (p. 150). The mecca of the Uffizi prompts neither erudite concentration nor classical comparisons but hallucinatory rapture:

> I thought I should have gone wild upon first setting my feet in the Gallery and when I beheld such ranks of Statues, such treasures of gems and bronzes—I fell into a delightful delirium—which none but Souls like ours experience, and, unable to check my rapture, flew madly from Bust to Bust and Cabinet to Cabinet like a Butterfly bewildered in an Universe of Flowers.[5]

As such accounts make clear, Beckford displaces education in favor of imagination, whose contemporary meaning as defined by Johnson ("fancy; the power of forming

ideal pictures") goes far toward explaining the book's fourth and most significant innovation: the dominance of landscape.

With the exception of Venice's marine cityscape, Beckford turns away from the built environment to celebrate the natural world through which he passes. Landscape with particular literary or artistic associations exerts one kind of hold: in Florence he makes a special Miltonic pilgrimage to Valombrosa, while the environs of Padua are extolled for their "herbage, and . . . irregular shrubby hills, diversified with clumps of cypress, verdant spots, and pastoral cottages; such as Zuccarellli loved to paint!" (p. 145). Beckford also gravitates toward, and rhapsodizes over, landscapes that offer an intense synaesthetic experience, in which several senses can be gratified simultaneously. He is powerfully attracted as well by manifestations of the picturesque, whose emphasis on the occluded and the irregular helps to support his "visionary" enterprise.[6] Wherever he finds himself, his eye searches out what is distant, shadowy, and mirage-like:

> The full moon shone propitiously upon me, as I ascended a hill, and discovered Florence at a distance, surrounded with gardens and terraces, rising one above another. The serene moon-light on the pale grey tints of the olive, gave an elysian, visionary appearance to the landscape. I never beheld so mild a sky, nor such soft gleams: the mountains were veiled in azure mists, which concealed their rugged summits; and the plains in vapours, that smoothed their irregularities, and diffused a faint aerial hue, to which no description can render justice. (p. 155)

Because the "visionary" picturesque so often vanishes when encountered close at hand, Beckford prefers to keep or retrieve his distance. In this instance, to enter the city is to lose much of its magic: "I could have contemplated such scenery for hours, and was sorry when I found myself shut up from it, by the gates of Florence" (p. 155).

No matter what kind of landscape he encounters, however, Beckford's impulse remains the same: to compose the terrain, to make it into an ordered picture or spectacle, which he can then contemplate or penetrate. Intensive study with Cozens and work on the *Biographical Memoirs of Extraordinary Painters* (published just before he set off for the Continent) had trained his eye, his brush, and his pen. Nevertheless, talent and training go only so far toward explaining the book's fundamental descriptive pattern: encountering a desirable landscape, Beckford finds a lofty or sequestered vantagepoint, from which he can survey and pictorialize. The prospect is mapped, but mapped in such a way as to infuse every feature with the emotions of the beholder, and even at times to dissolve the distinction between perceiver and perceived. The beholder, moreover, is almost always alone: even in the rare scenes that are shared with others, Beckford's solipsistic orientation dispeoples the landscape. We are invited to peer over his shoulder as he journeys in solitude through tableaux of his own making.

Beckford's radical transformation of the Tour into an emotionally charged diorama can best be understood if we consider his achievement in relation to its likeliest model—the theatrical innovations of Philippe Jacques De Loutherbourg (1740–1812). De Loutherbourg, a Swiss painter and stage designer, had revolutionized productions at Drury Lane during the 1770s.[7] One contemporary observer described him as "the first artist who showed our theatre directors that by a just disposition of light and shade, and critical preservation of perspective, the eye of the spectator might be so effectually

deceived in a play-house as to be induced to take the produce of art for real nature."[8] De Loutherbourg experimented with silk screens, transparencies, and colored side-lights to enhance the detailed naturalism of his sets with a variety of atmospheric effects. In 1779 he achieved a particular triumph with a pantomime called *The Wonders of Derbyshire*, whose eleven scenes evoked various picturesque landscapes at different times of the day. De Loutherbourg last worked for Drury Lane on *The Carnival of Venice*, which ended with "a View of St. Mark's Place, and a grand *Representation of the Carnival*."

In February 1781 (two months before Beckford's return from the Continent) De Loutherbourg inaugurated his "*Eidophusikon; or, Various Imitations of Natural Phe-nomena, represented by Moving Pictures.*" On a miniature stage (approximately six feet wide by eight feet deep) were performed five scenes:

1. Aurora; or, the Effects of the Dawn, with a View of London from Greenwich Park.
2. Noon; the Port of Tangier in Africa, with the distant View of the Rock of Gibraltar and Europa Point.
3. Sunset, a View near Naples.
4. Moonlight, a View of the Mediterranean, the Rising of the Moon contrasted with the Effect of Fire.
5. The Conclusive Scene, a Storm at Sea, and Shipwreck.

These five scenes included appropriate sound effects, such as the crashing of waves and the roaring of cataracts. Although human figures occasionally appeared, the displays remained essentially plotless. Scenery and not story engrossed the audience, which was invited to admire the semi-magical ingenuity at work in this forerunner of the diorama (Plate 42). During the interval between scenes a scrim was lowered; the subjects painted on these scrims included "A View of the Alps" and "Summer Evening, with Cattle and Figures." The performance also included musical interludes, supplied at first by Michael Arne and then by Charles Burney.

In January 1782 a new program was inaugurated, which began with "The Sun rising in the Fog, an Italian Seaport," and ended with "Satan arraying his Troops on the Banks of the Fiery Lake, with the Raising of Pandemonium, from Milton." The inclusion of a scene from *Paradise Lost* appears to be related to the Christmas revels at Fonthill Splendens, to which De Loutherbourg brought his *Eidophusikon* and for which he designed an array of scenic effects.[9] The only surviving description comes from Beckford himself:

I still feel warmed and irradiated by the recollections of that strange, necromantic light which Loutherbourg had thrown over what absolutely appeared a realm of Fairy, or rather, perhaps, a Demon Temple deep beneath the earth, set apart for tremendous mysteries—and yet how soft, how genial was this quiet light. Whilst the wretched world without lay dark, and bleak, and howling, whilst the storm was raging against our massive walls and the snow drifting in clouds, the very air of summer seemed playing around us—the choir of low-toned melodious voices con-tinued to soothe our ear, and that every sense might in turn receive its blandishment

tables covered with delicious viands and fragrant flowers—glided forth, by the aid of mechanism at stated intervals, from the richly draped, and amply curtained recesses of the enchanted precincts.[10]

Fonthill itself had been turned into a giant *Eidophusikon*, in which Beckford and his party (which included De Loutherbourg himself) functioned as both actors and viewers. Beckford credited this experience as an important influence on *Vathek*. What has gone unnoticed, however, is that De Loutherbourg's invention also provided a model for *Dreams, Waking Thoughts, and Incidents*, which Beckford had begun writing the previous summer and to which he returned, galvanized by fresh "fancies and inspirations," in January 1782—immediately after the Fonthill revels.[11]

Predisposed as he was to multimedia effects, Beckford takes over from De Loutherbourg the theatrical presentation of natural landscape, the re-creation of changing light, the emphasis on viewing through a veil or colored transparency, and the emotive effects of sound (particularly of music) upon the viewer. So ubiquitous are these descriptive elements and procedures that the book in effect constitutes itself a textual version of the *Eidophusikon*: the reader turns into a spectator, before whom is projected a sequence of "Moving Pictures." As Beckford travels south from Munich, for example, he offers what might be called—taking a leaf from De Loutherbourg's program—"Sunset; a Prospect of the Tirol":

Twilight drew on . . . ascending a steep hill, under a mountain, whose pines and birches rustled with the storm, we saw a little lake below. A deep azure haze veiled its eastern shore, and lowering vapours concealed the cliffs to the south; but over its western extremities a few transparent clouds, the remains of a struggling sun-set, were suspended, which streamed on the surface of the waters, and tinged with tender pink, the brow of a verdant promontory. I could not help fixing myself on the banks of the lake for several minutes, till this apparition was lost, and confounded with the shades of night. (p. 99)

Like each episode in the *Eidophusikon*, this scene enacts a transformation. Its drama derives from the threat of storm, the advent of night, the obbligato of forest murmurs, and the mingling of the Burkean sublime with the beautiful: on the one hand, impending darkness and cliffs veiled in mist; on the other, "tender pink" light upon a verdant promontory. Whenever possible, Beckford enhances natural sound effects with musical accompaniment, playing simultaneously the roles of De Loutherbourg and Burney:

We found an apartment over the Arno prepared for our reception. The river, swollen with rains, roared like a mountain torrent. Throwing open my windows, I viewed its agitated course by the light of the moon, half concealed in stormy clouds, which hung above the fortress of Belvedere, and cast a lowering gleam over the hills, which rise above the town, and wave with cypress. I sat contemplating the effect of the shadows on the bridge, on the heights of Boboli, and the mountain covered with pale olive-groves, amongst which a convent is situated, till the moon sunk into the blackest quarter of the sky, and a bell began to toll. Its sullen sound filled me with

sadness: I closed the casements, called for lights, ran to a harpsichord Vannini had prepared for me, and played somewhat in the strain of Jomelli's *Miserere*. (p. 172)

At the beginning of this passage, Beckford positions the viewer and frames the view, as if within a proscenium arch. He then recreates the effects of moonlight upon a landscape which is organized carefully into foreground, middleground, and background. Almost as if he were cuing a stage designer and a lighting director (roles united by De Loutherbourg), he specifies key details of the spectacle. Finally, he lowers the curtain and supplies an appropriate musical interlude.

## Peeping at Venice

Nowhere does Beckford exploit the *Eidophusikon* prototype more fully than in the letters that describe his time in Venice—letters whose central position, panoramic detail, and emotional charge usurp the place conventionally occupied by responses to Rome. As metaphor and model for his presentation of the city, Beckford adopts a variant on (historically a predecessor of) De Loutherbourg's miniature theater: the "show box" or peep show.[12] At such places as Southwark Fair, where the "show box" was a staple entertainment, "a penny bought a performance consisting of a series of scenes that the showman successively lowered into view as the spectator kept his eyes glued to the hole."[13] Such *trompe l'oeil* boxes contained painted backdrops or glass slides that were artificially illuminated; before them modeled figures and props told a story or enacted an event, which the viewer observed through a magnifying glass. Although as distinguished a painter as Gainsborough used the show box as an aid to composition, it carried with it in general the aura of tawdry popular amusements and even of freak shows.[14]

Two of the three myths whose influence we investigated in Chapter 3 leave vestigial traces on Beckford's representation of Venice. As he enters the territory of the republic he calls its people "free and happy" (p. 108); he also attends fitfully to its governmental proceedings, and extols its resistance to papal and clerical control:

The republic . . . by encouraging the liberty of monks and churchmen, prevents their appearing too sacred and important in the eyes of the people, who have frequent proofs of their being mere flesh and blood, and that of the frailest composition. Had the rest of Italy been of the same opinion, and profited as much by Fra Paolo's maxims, some of its fairest fields would not, at this moment, lie uncultivated; and its ancient spirit might have revived. (p. 114)

However, such references to Venice as "stato di libertà" pale in comparison to the importance of her identity as "città-galante." For all his occasional praise of the republic's enlightened policies, Beckford judges that Venice has made an alluring but debased spectacle of herself. He therefore proceeds to do likewise.

Before invoking the "show box," however, Beckford makes use of the *Eidophysikon*: he constructs his arrival as a Loutherbourgian sequence of tableaux, each one keyed to a different perspective and a different effect of light. Even though "the pencil of

Canaletti . . . render[s] all verbal description superfluous," he cannot resist *vedute* of his own, designed like Canaletto's views of the Grand Canal to be contemplated both singly and as part of a whole (p. 111). These tableaux begin with a distant panorama at sunset. The eye is positioned at water level, as we look upward and eastward along with Beckford in his gondola: "Still gliding forwards, the sun casting his last gleams across the waves, and reddening the distant towers, we every moment distinguished some new church, or palace in the city, suffused with the evening rays, and reflected with all their glow of colouring from the surface of the waters" (p. 110). The next tableau frames a view of the Grand Canal with the arch of Beckford's balcony window and adds *son* to *lumière*:

> As night approached, innumerable tapers glimmered through the awnings before the windows. Every boat had its lantern, and the gondolas, moving rapidly along, were followed by tracks of light, which gleamed and played on the waters. I was gazing at these dancing fires, when the sounds of music were wafted along the canals, and, as they grew louder and louder, an illuminated barge, filled with musicians, issued from the Rialto, and, stopping under one of the palaces, began a serenade, which was clamorous, and suspended all conversation in the galleries and porticos; till, rowing slowly away, it was heard no more. The gondoliers catching the air, imitated its cadences, and were answered by others at a distance, whose voices, echoed by the arch of the bridge, acquired a plaintive and interesting tone. (pp. 111–12)

Beckford then describes himself as a species of Aeolian harp, played upon by the waterborne music: "I retired to rest, full of the sound, and, long after I was asleep, the melody seemed to vibrate in my ear" (p. 112). This musical interlude connects the second to the third tableau. The final scene depicts the same view from the same vantagepoint—but dawn light has succeeded to darkness, the gondolas have given way to barges loaded with fresh fruit and vegetables, and "a loud din of voices" now rouses where nocturnal serenades have soothed. The one constant is the presence of those revelers who had begun their night in the cushioned cabins of gondolas, favored spot for erotic activity, and now "refresh themselves with fruit, before they retired to sleep, for the day" (p. 112).

As this sequence illustrates, the "città-galante" aspect of Venice enters the text by pictorial implication. Beckford's own gallantry remains similarly oblique: his all-consuming love affair with a young son of the Cornaro family is allowed to express itself only in cryptic references to himself as "a frail, infatuated mortal" (p. 137) or to "strange fancies and imaginations" (p. 181). Instead, libido is displaced onto landscape, which Beckford observes, penetrates, and transforms in alternating spells of "transport" and "repose" (pp. 115, 118). One moment he is "shooting" in a frenzy across the lagoon, another becalmed in voluptuous immobility (p. 115). Cryptic references to "Mad. de R.," his chief guide and companion, supply a further clue to this erotic subplot: the Contessa Giustiniana Wynne d'Orsini-Rosenberg, widow of the Austrian ambassador, was a lady of ambiguous reputation and refined skills as a procuress.[15]

It is "Mad. de R." who introduces Beckford "to some of the most distinguished of the Venetian families" (p. 119) and gives him direct experience of their days and nights.

112

The resulting portrait of a decadent aristocracy allows him to mask the extent of his involvement with the "città-galante." In the casinos of Venice's best families—"fitted up in a gay, flimsy taste, neither rich nor elegant"—he finds both men and women in a post-coital stupor: the women "negligently dressed, their hair falling very freely about them, and innumerable adventures written in their eyes"; the men "lolling upon the sophas, or lounging about the apartments" (p. 119). Terminal languor reigns, the consequence of a played-out patriciate: "Their nerves, unstrung by disease and the consequence of early debaucheries, impede all lively flow of spirits in its course, and permit, at best, but a few moments of a false and feverish activity" (p. 120). A carnivalesque spirit seems to prevail all the year round, so that even "a magistrate or senator . . . lays up wig, and robe, and gravity, to sleep together, runs intriguing about in his gondola, takes the reigning sultana under his arm, and so rambles half over the town, which grows gayer and gayer as the day declines" (p. 118). The entire city, in short, has become "the resort of pleasure and dissipation" (p. 118).

Beckford derived this characterization from firsthand experience: his indiscreet and unorthodox amour agitated even the Contessa d'Orsini-Rosenberg, and led to an agitated departure from the city.[16] Indeed the vehemence of his attack on Venice's degenerate self-display might be interpreted as the result of inner turmoil. Whatever his motivation, Beckford chooses to make of himself a spectator on the margins: his most active engagement with the city comes in the form of solipsistic theatrics. In the empty doge's palace, standing among "the statues of ancient heroes," he recites the opening of *Oedipus Rex*, while outside in the Piazza San Marco the unworthy heirs to Venetian greatness frolic heedlessly (p. 118). This fit of Sophoclean "enthusiasm" brings to a close an extended tour of an architectural complex haunted by images of the Republic's epic achievements, which rivaled those of "the ancient Romans, in the zenith of power and luxury" (p. 116). Beckford worships the neglected "tutelary dieties," Neptune and Mars, and then offers his impassioned performance as a further rite of homage to "the consecrated fanes and images around" (p. 118). These acts of veneration (which "transported [him] beyond himself") contrast starkly with the "thoughtless, giddy transport" that convulses the Piazza.

Beckford's harshest critique of the Republic, and his most extended presentation of the modern city as show box, takes the form of an equally theatrical private ceremony. Rowing out to the Lido, Beckford devises his own version of the Sposalizio al Mar:

> Forlorn as this island appeared to me, I was told it was the scene of the Doge's pageantry at the feast of the Ascension; and the very spot to which he sails in the Bucentaur, previous to wedding the sea. You have heard enough, and, if ever you looked into a show-box, seen full sufficient, of this gaudy spectacle, without my enlarging upon the topic. (p. 121)

The status of Venice's great imperial rite, Beckford suggests, has sunk even lower than that of international tourist attraction: it is now a tawdry side-show for the British populace. To imagine the Sposalizio in terms of Canaletto's panoramic views is one thing, to think of it as a fairground spectacle quite another. Yet he proceeds to pay it an unusual tribute—that of half-mocking, half-serious reenactment.

Beckford begins by taking "the same road as the nuptial procession, in order to reach

the beach," where he is "broiled and dazzled" (p. 121). In his version of the ceremonial journey to the Adriatic, the attendant throngs (British visitors prominent among them) are represented by insects and corpses: "At last, after traversing some desart hillocks, all of a hop with toads and locusts (amongst which English heretics have the honour of being interred) I passed under an arch, and suddenly the boundless plains of ocean opened to my view" (pp. 121–22). The tone then suddenly changes from the sardonic to the rapturous, as Beckford plays out an inverted version of the Sposalizio itself:

> I ran to the smooth sands, extending on both sides out of sight, cast off my cloaths, and dashed into the waves. . . . The tide rolled over me as I lay floating about, buoyed up by the water, and carried me wheresoever it listed. It might have borne me far out into the main, and exposed me to a thousand perils, before I had been aware; so totally was I abandoned to the illusion of the moment. My ears were filled with murmuring, undecided sounds; my limbs, stretched languidly on the surge, rose, or sunk, just as it swelled, or subsided. In this passive, senseless state I remained, till the sun cast a less intolerable light. (p. 122)

In this nuptial rite, the public has become private, the political sexual, the active male passively female. Nonetheless, a rite of union and possession has been consummated, with Beckford casting himself as a show-box version of the doge. He carries out this role to the hilt by returning to the exact point at which the *Bucintoro* was moored, entering the Palazzo Ducale, and ascending to one of the principal seats of government, the Sala del Maggior Consiglio (p. 122).

Just as Beckford reduces the Sposalizio to an item in the repertoire of a showman, he shrinks the dominion of Venice to a pair of claustrophobically enclosed spaces—its love-nests and its prisons. Both enable the patriciate to gratify illicit appetites while evading the consequences of lust and tyranny. Beckford describes them as shadowy dens of vicious behavior, hidden away at the heart of a secret labyrinth. The nests of erotic dalliance make possible a variety of mysterious vanishing acts:

> Many of the noble Venetians have a little suite of apartments in some out of the way corner. . . . To these they sculk in the dusk, and revel undisturbed with the companions of their pleasures. Jealousy itself cannot discover the alleys, the winding passages, the unsuspected doors, by which these retreats are accessible. Many an unhappy lover, whose mistress disappears on a sudden with some fortunate rival, has searched for her haunts in vain. The gondoliers themselves, though often the prime managers of intrigues, are scarce ever acquainted with these interior cabinets. . . . Surely, Venice is the city in the universe best calculated for giving scope to the observations of a Devil upon two sticks. What a variety of lurking-places would one stroke of his crutch uncover! (pp. 118–19)

The same kind of devilish concealment is a distinguishing feature of the *piombi* and the *pozzi*. Lingering in his gondola before the Bridge of Sighs, Beckford looks upward to "the highest part of the prisons," and imagines the dungeons "beneath these fatal waters" (pp. 123–24). His final composition is derived not from the repertoire of Canaletto or Zuccarelli but from the images of another Venetian artist: "Snatching my pencil, I drew chasms and subterraneous hollows, the domain of fear and torture, with

chains, rocks, wheels, and dreadful engines, in the style of Piranesi" (p. 124). This climactic spectacle positions the viewer precisely where Byron begins Childe Harold's "voyage of Italy": "I stood in Venice, on the Bridge of Sighs; / A palace and a prison on each hand."[17]

## Byron with a Baedeker

Canto IV of *Childe Harold's Pilgrimage* smells not of the lamp but of the guidebook. As Byron makes clear in his dedicatory remarks, he has dropped the mask of the pilgrim to tell his own story, the story of a journey from Venice to Rome. The purpose of this journey is "to meditate amongst decay, and stand / A ruin among ruins; there to track / Fall'n states and buried greatness" (st. 25). By "tracking" the remains of classical antiquity, Byron creates the narrative occasion for, and emblematic equivalent to, his own "fall'n state." "A ruin among ruins," he uses the "sepulchres of cities" to brood upon his own past and his poetic vocation. The result verges on a personal allegory that depends upon its vehicle to establish its tenor.

The nature of that vehicle can best be established by turning first to the letters that describe Byron's trip. These letters not only supplied the poet with source material for his poem: they serve us as a reminder of the canto's origins in a specific itinerary. Byron timed his trip to avoid "the first rush" of Tourists that followed the end of the Napoleonic Wars; as he writes to Thomas Moore early in 1817, "I wished to have gone to Rome; but at present it is pestilent with English,—a parcel of staring boobies, who go about gaping and wishing to be at once cheap and magnificent. A man is a fool who travels now in France or Italy, till this tribe of wretches is swept home again" (5.187). When Byron himself goes "gaping" about Rome, he does so with the assistance of such aids as John Chetwode Eustace's *A Classical Tour through Italy*. To Moore he claims simultaneously that he *won't* report on his experiences and that he *can't* do so: "Of Rome I say nothing; it is quite indescribable, and the Guidebook is as good as any other. . . . As for the Coliseum, Pantheon, St. Peter's, the Vatican, Palatine, etc. etc.— as I said, vide Guidebook" (5.227). Byron's declaration to John Murray is even more illuminating:

I am delighted with Rome. . . . As a *whole—ancient & modern*—it beats Greece— Constantinople—every thing—at least that I have ever seen.—But I can't describe because my first impressions are always strong and confused—& my Memory *selects* & reduces them to order—like distance in the landscape—& blends them better— although they may be less distinct. (5.221)

Yet Byron's descriptive enterprise was only temporarily checked by his awareness of pre-existing accounts. Soon after returning to Venice, he found the necessary "distance" and threw himself into composing Canto IV. The result is a poem about the memory of landscape and the landscape of memory—a poem that "meditates" as it "tracks." To read it and to grasp its structure is to carry out Byron's instructions: "vide Guidebook."

Throughout the canto Byron achieves his subtlest effects through fluid metaphoric

and thematic associations, as when the thought of Rienzi as latter-day Numa prompts an excursus on Numa and his tutelary nymph. However, these abrupt or oblique shifts of thought are positioned within a chronological narrative and a geometric structure. In fact the poem as a whole can be diagrammed both as a sweeping diagonal (which stretches from Venice to Rome, the Adriatic to the Tyrrhenian) and as a circle (ocean prospect to ocean prospect). Byron follows a standard route, which takes in Arqua Petrarca, Ferrara, Florence, and the Lago di Trasimeno. When the reader arrives in Rome he is conducted along a second diagonal, proceeding from the Appian Way to the Vatican via the Palatine, the Forum, the Coliseum, the Pantheon, Hadrian's tomb, and St. Peter's. En route, Byron frequently makes use of verbs that evoke the bearleader ("view," "turn," "enter," "pause and be enlightened") and keys his commentary to notable antiquities.

While it is undeniable that Byron takes over the traditional routes and the traditional sites, he does so with a difference. Not only the Colisseum, but almost every monument of consequence, commands the poet's attention as a "long-explored but still exhaustless mine / Of contemplation" (st. 128). The result is that topography is always turning into autobiography: these ruins are inhabited, and by a fellow victim of time: "Among thy mightier offerings here are mine, / Ruins of years—though few, yet full of fate" (st. 131). Given such insistent allegorizing, therefore, it would seem that Byron in Rome could not be more unlike Edward Gibbon, who "tracks" the past with a professional historian's commitment to observing closely and recording accurately. Yet Canto IV, considered as a whole, commits itself to Gibbon's own combination of passion and detachment:

> At the distance of twenty five years I can neither forget nor express the strong emotions which agitated my mind as I first approached and entered the *eternal City*. After a sleepless night I trod with a lofty step the ruins of the Forum; each memorable spot where Romulus stood, or Tully spoke, or Caesar fell was at once present to my eye; and several days of intoxication were lost or enjoyed before I could descend to a cool and minute investigation.[18]

Canto IV organizes its "strong emotions" along geographically coherent lines; moreover, it surrounds itself with an elaborate scaffolding of notes, which balance poetic "intoxication" with prosaic "investigation."

As Byron makes clear in the dedication, he turned to his close friend and traveling companion "John Hobhouse, Esq. A.M., F.R.S." for "elucidation" of a text that had grown to include a "labyrinth of external objects" (ii.123). During the summer and fall of 1817 the two men worked closely together, Byron expanding and revising his poem and Hobhouse attending to the annotation. When Canto IV appeared in print, it was accompanied by 135 pages of endnotes, all but a handful by Hobhouse. These notes were not signed: they therefore registered as the commentary of a single authoritative voice. By collaborating with Hobhouse in this fashion, Byron confirmed the poem's engagement with the particulars of history and geography, as well as its identity as companion guide to Italy. Indeed Hobhouse's notes make clear the assumption that some readers, at least, will be taking the poem with them on their travels.[19]

So voluminous, diverse, and densely textured is this annotation that it threatens

at times to relegate the poem to the status of gloss on the explanatory apparatus. Hobhouse elucidates Byron's oblique or cryptic allusions with reference to Greek and Latin sources, sometimes quoted *in extenso*. He supplies mini-dissertations on notable curiosities. He corrects other historians, even those of the stature of Gibbon and Winckelmann. He offers biographical and historical vignettes, such as a profile of Petrarch's Laura and a summary of the Battle of Trasimene. His not infrequent political commentary cues the reader to support patriotic Italians in their "aversion" to foreign rule.[20] The most engaging notes supply personal reminiscences, such as the account of Byron's and Hobhouse's encounter with Venetian boatmen who sing stanzas from Tasso. Much of the annotation leads away from Byron's text—especially when the reader is directed to Hobhouse's own separately published volume, *Historical Illustrations of the Fourth Canto of Childe Harold*.[21] At their most disciplined, however, the notes excavate and elucidate the canto in such a way as to moor it to the *giro d'Italia*. So effective is this contextualization that excerpts from the poem were soon padding the commentary of nineteenth-century guidebooks.[22]

For all its peculiarities, Canto IV may fairly be called the last important Grand Tour narrative. Yet it also turns its back decisively on the subjects, purposes, and methods we investigated in Chapter 2. The political education of the reader is the only objective that Byron shares with his predecessors—and even then, the poem's republican sentiments remain comparatively muted.[23] What Canto IV actively abjures is the kind of literary and aesthetic response inculcated by Addison and the Richardsons. For the Byronic traveler, "classic ground" is neither a provoker of quotations nor a training ground for the connoisseur.

As he approaches Rome, Byron pauses to take note of Mount Soracte, the subject of one of Horace's most famous odes (I.9). Declining to perform the conventional obeisance through allusion, he makes of this refusal the subject both of his next three stanzas and of a fervent note:

> All, save the lone Soracte's height, displayed
> Not *now* in snow, which asks the lyric Roman's aid
>
> For our remembrance, and from out the plain
> Heaves like a long-swept wave about to break,
> And on the curl hangs pausing: not in vain
> May he, who will, his recollections rake
> And quote in classic raptures, and awake
> The hills with Latin echoes; I abhorr'd
> Too much, to conquer for the poet's sake,
> The drill'd dull lesson, forced down word by word
> In my repugnant youth. . . .
>
> (st. 74–75)

As the recollections of Harrow in the accompanying note confirm, Byron's "sickening memory" of his educational regime, with its "daily drug" of Latin authors, continues to inspire intense revulsion. Therefore he will abstain from the kind of move that Addison makes as he tours the same territory: "The *Roman* Painters often work upon this Landskip, and I am apt to believe that *Horace* had his Eye upon it in those Two or

Three beautiful Touches that he has given us of these Seats."[24] In its place Byron supplies, as in the lines quoted above, an evocation of place that simulates a direct, unallusive engagement.

I say "simulates" because Canto IV is dense with literary reference: in his own way, Byron has "got among the Poets" as much as Addison.[25] His description of the view from the Alban Mount, for example, teems with references to Virgil, Cicero, and Horace—as well as silent borrowings from "the Guidebook":[26]

> And near Albano's scarce divided waves
> Shine from a sister valley;—and afar
> The Tiber winds, and the broad ocean laves
> The Latian coast where sprung the Epic war,
> "Arms and the Man", whose re-ascending star
> Rose o'er an empire:—but beneath thy right
> Tully reposed from Rome;—and where yon bar
> Of girdling mountains intercepts the sight
> The Sabine farm was till'd, the weary bard's delight.
>
> (st. 174)

The difference between the Addisonian and the Byronic approaches is that in Canto IV the prime object of cultivation is not the traveler's literary repertoire but his faculties of wonder and introspection. Texts and textualized landscapes have value to the degree that they stimulate the individual, preparing him not for a public role but for sustained self-scrutiny.

Just as Byron refuses to quote by the book, he refuses to look as expected. Analytical language can never do justice to the ineffable; in fact, such language violates the work it attempts to describe. Gazing at Mount Soracte, he banishes Horace; gazing at the *Venus de' Medici*, he scorns the vocabulary of the connoisseur and the dealer:

> Away!—there need no words, nor terms precise,
> The paltry jargon of the marble mart,
> Where Pedantry gulls Folly—we have eyes.
> . . . . . . . . . . . . . . . . . . .
> I leave to learned fingers, and wise hands,
> The artist and his ape, to teach and tell
> How well his connoisseurship understands
> The graceful bend, and the voluptuous swell:
> Let these describe the undescribable.
>
> (st. 50, 53)

The sarcastic inflection of "his connoisseurship," signifying both noun and title, further distances Byron from anything that smacks of expert evaluation. In place of comments on technique and genre, he substitutes the language of the sublime.

The stanzas devoted to praise of the *Venus de' Medici* model a response for the viewer, who must erase all traces of "his connoisseurship" and work himself into a state of aesthetic, quasi-mystical inebriation:

There, too, the Goddess loves in stone, and fills
The air around with beauty; we inhale
The ambrosial aspect, which, beheld, instils
Part of its immortality; the veil
Of heaven is half undrawn; within the pale
We stand, and in that form and face behold
What Mind can make, when Nature's self would fail;
And to the fond idolaters of old
Envy the innate flash which such a soul could mould:

We gaze and turn away, and know not where,
Dazzled and drunk with beauty, till the heart
Reels with its fulness. . . .

(st. 49–50)

These stanzas grow out of a passage from Byron's account to John Murray of his visit to the Uffizi:

At Florence I remained but a day—having a hurry for Rome to which I am thus far advanced.—However—I went to the two galleries—from which one returns drunk with beauty—the Venus is more for admiration than love—but there are sculpture and painting—which for the first time at all gave me the idea of what people mean by their *cant* & (what Mr. Braham calls) "entusimusy" (i.e. enthusiasm) about those two most artificial of the arts. (5.218)

In both poem and letter, Byron records the visual equivalent of the "estro," or poetic furor, which inspires his own art. Only in the grips of "estro" can he create; only in the grips of a comparable state of inebriation can he apprehend, and participate in, the "dream" of ideal beauty.

Byron responds even more intensely, and non-technically, to sculpture and painting that represent human subjects. Face to face with the *Dying Gaul* or the *Laocoön*, he immediately creates a narrative context that will explain what he sees and heighten what he feels. He situates the *Dying Gaul* in particular within a rousing mini-epic:

I see before me the Gladiator lie:
He leans upon his hand—his manly brow
Consents to death, but conquers agony,
And his drooped head sinks gradually low—
And through his side the last drops, ebbing slow
From the red gash, fall heavy, one by one,
Like the first of a thunder-shower; and now
The arena swims around him—he is gone,
Ere ceased the inhuman shout which hail'd the wretch who won.

He heard it, but he heeded not—his eyes
Were with his heart, and that was far away;
He reck'd not of the life he lost nor prize,
But where his rude hut by the Danube lay

*There* were his young barbarians all at play,
*There* was their Dacian mother—he, their sire,
Butcher'd to make a Roman holiday—
All this rush'd with his blood—Shall he expire
And unavenged?—Arise! ye Goths, and glut your ire!

<div align="right">(st. 140–41)</div>

In this ecphrastic passage, Byron exalts a timeless work of art by moving it back into time. His purpose, unlike the connoisseur's, is to subordinate rational assessments of craft so thoroughly to emotional encounters with subject matter that the distance between viewer and viewed is eliminated: "his eyes / Were with his heart."

Museum-going should be—and for Byron *is*—no different from other kinds of spectatorship. On the eve of his departure from Rome, he attended a public execution, to which he devoted an epistolary set-piece as finely honed as any section of Canto IV:

The day before I left Rome I saw three robbers guillotined—the ceremony—including the *masqued* priests—the half-naked executioners—the bandaged criminals—the black Christ & his banner—the scaffold—the soldiery—the slow procession—& the quick rattle and heavy fall of the axe—the splash of the blood—& the ghastliness of the exposed heads—is altogether more impressive than the vulgar and ungentlemanly dirty "new drop" & dog-like agony of infliction upon the sufferers of English sentences. Two of these men—behaved calmly enough—but the first of the three—died with great terror and reluctance—which was very horrible ... the head was off before the eye could trace the blow—but from an attempt to draw back the head—notwithstanding it was held forward by the hair—the first head was cut off close to the ears—the other two were taken off more cleanly. ... The pain seems little—& yet the effect to the spectator—& the preparation to the criminal—is very striking & chilling.—The first turned me quite hot and thirsty—& made me shake so that I could hardly hold the opera-glass (I was close—but was determined to see—as one should see every thing once—with attention). (5.229–30).

As this description makes clear, Byron sought out an execution in the same spirit that he made sure to visit the sculpture gallery in the Vatican. The letter's mesmerized attention to horrific detail, and its relationship between spectator and spectacle, make it an exact prose analogue to the encounter with the *Gaul*. "One should see every thing once—with attention"—and the effect should be, not informative or edifying, but "striking & chilling." Intensity of sensation has become the most important goal of travel, and the principal criterion of success.

### The Withered Lion

Byron's Venice, his "ocean-Rome," is a city not so much ruined by time as existing outside of it (8.186). Here, as John Pemble observes, "history had stopped."[27] Out of her servitude, her passivity, and her forlorn abandonment Byron

makes a new myth, which transforms the identities we have been tracing through the course of this book. In two respects this myth perpetuates versions of what had gone before. Venice still bears lingering traces of her "stato-di-libertà" inheritance: "Venice, lost and won. / Her thirteen hundred years of freedom done, / Sinks, like a sea-weed, into whence she rose!" (st. 13). But as these lines suggest, she has lost control of her own destiny, to become a victim of tyranny and a quasi-organic creation that must inevitably rejoin the sea that made her. Past freedom and current decay intensify the haunting sense of kinship between island-states, but in such a way as to make manifest, as in a mirror, the skull beneath the skin:

> thy lot
> Is shameful to the nations,—most of all,
> Albion! to thee: the Ocean queen should not
> Abandon Ocean's children; in the fall
> Of Venice think of thine, despite thy watery wall.
>
> (st. 17)

That Britain had helped to engineer the return of Venice to Austria in 1814 made her directly responsible for the continuing outrage of Venetian servitude; that Albion's own international maritime empire now rivalled Venice's at its peak made her particularly in need of learning the lessons inherent in her history and her stones.

The stones of Venice are vocal, but they are also "crumbling" and "silent." The opening of Canto IV is permeated by an atmosphere of fragility and evanescence, which the notes repeatedly accentuate. To emphasize this atmosphere, Byron devotes a stanza to the discontinued Sposalizio and to its origins in the legendary encounter between Emperor Frederick I Barbarossa and Pope Alexander III. In the conflict between the two, Venice sided with the pope, and when the Republic's fleet defeated the imperial forces, the doge forced Frederick to do homage to Alexander at the entrance to San Marco. In gratitude for Venice's support, the pope gave the doge dominion over the Adriatic and instituted the ceremonial marriage, complete with ring.[28] In his commentary, Hobhouse tells the story as if it were fact, and interprets the emperor's humbling as a "triumph of liberty. . . . The states of Lombardy owed to it the confirmation of their privileges; and Alexander had reason to thank the Almighty, who had enabled an infirm, unarmed old man to subdue a terrible and potent sovereign."[29]

Past potency and present impotence are Byron's central concern in his treatment of the Sposalizio, as he exploits the powerful symbolic potential of Venice's masculine role in both legend and rite. No longer does a doge-husband marry his marine bride "in signum veri perpetuique dominii":

> The spouseless Adriatic mourns her lord;
> And, annual marriage now no more renewed,
> The Bucentaur lies rotting unrestored,
> Neglected garment of her widowhood!
>
> (st. 11)

The *Bucintoro* still exists, but in a decaying and dismembered condition; the lyon of the deeps still stands on its column in the Piazetta, but its erect state belies its impotence:

"St Mark yet sees his lion where he stood / Stand, but in mockery of his withered power" (ll. 95–96). Byron concludes the stanza by reaching back to the regal imagery of the Canto's opening:

> her daughters had their dowers
> From spoils of nations, and the exhaustless East
> Pour'd in her lap all gems in sparkling showers.
> In purple was she robed, and of her feast
> Monarchs partook, and deem'd their dignity increas'd.
>
> (st. 2)

Venice, which had begun the stanza as "lord," ends it as "queen": "And monarchs gazed and envied in the hour / When Venice was a queen with an unequalled dower" (ll. 98–99). The shift in gender keeps disturbingly to the fore the theme of unconsummated marriage: imagined as male, Venice has lost his potency; as female, her dowry.

Yet power the city still possesses—the power to kindle the imagination. The Byronic myth of Venice makes her into an emblem, not only of lost freedom and vanished imperial achievement, but of the triumph of art: the literary responses she has inspired will secure her immortality. "Otway, Radcliffe, Schiller, Shakespeare's art" (l. 158) preserve the glory of Venice, and Byron (inspired by them) engages in powerful acts of remembrance and recovery. The elegiac tribute of Canto IV conjures up a city "vaporized and de-substantiated,"[30] in which there is room for "Venezia-stato-di-libertà" but none at all for "Venezia-città-galante." At best the songless gondolier, in his very muteness, can evoke faint memories of "The plesant place of all festivity, / The revel of the earth, the masque of Italy!" (ll. 26–27). But as Canto IV writes an epitaph for the unrecoverable past, its companion poem, *Beppo*, restores the city to all its festive glory. This "Venetian Story" was written at top speed in the autumn of 1817, as Byron was completing Canto IV. It counterpoints and dialogues with *Childe Harold* in a number of fascinating ways,[31] but here I wish to consider the degree to which it refurbishes the "città-galante" myth by splitting it off from Venice as "stato-di-libertà."

In its effervescent *ottava rima* and its jaunty celebration of the carnivalesque, *Beppo* has often been approached as a forerunner of *Don Juan*, or as a lightly fictionalized account of Byron's own Venetian revels. Both perspectives yield their own rewards, but neither takes proper account of the poem's status as an historical fiction and as a distillation of the "città-galante" myth. In *Beppo*, Byron makes expert use of a double time-scheme: commenting in the present on England and English affairs, he situates his main plot in the late eighteenth century: "But to my story.—'Twas some years ago, / It may be thirty, forty, more or less, / The carnival was at its height" (ll. 161–63).[32] Alluding (as he had done in Canto IV) to James Howell's *S.P.Q.V.*, Byron establishes this period as a golden age of revelry: "Venice the bell from every city bore, / And at the moment when I fix my story, / That sea-born city was in all her glory" (ll. 78–80).

The poem's subtitle, "A Venetian Story," and its double epigraph collaborate in suggesting that the story could only take place in Venice, that it crystallizes the carnivalesque spirit of the city, and that this spirit could not be further from British Puritanism. The first epigraph comes from Rosalind's parting speech to Jacques in *As You Like It:* "Farewell, Monsieur Traveller. Look you lisp, and wear strange suits;

disable all the benefits of your own country; be out of love with your Nativity, and almost chide God for making you that countenance you are; or I will scarce think that you have swam in a Gondola." Through Rosalind, a witty heroine *en travesti* who banishes melancholy from the "green world" of Arden, Byron prepares us for Laura, his masked protagonist, who epitomizes the benign comic spirit of an Edenic Venice. The perspective of Rosalind/Laura is the perspective of the narrator, an English convert to Mediterranean ways: "With all its sinful doings, I must say, / That Italy's a pleasant place to me" (ll. 321–22). Parodying his self-presentation in Canto IV as a "ruin among ruins," he describes himself as "a broken Dandy lately on my travels" (l. 410), but a dandy whose jaunty monologue, with its tantalizing autobiographical subject, suggests rejuvenation and not dejection.

Just before writing *Beppo*, Byron had reread Pope with utmost admiration:

> With regard to poetry in general I am convinced . . . that we are upon a wrong revolutionary poetical system—or systems. . . . I am the more confirmed in this—by having lately gone over some of our Classics—particularly *Pope*—whom I tried in this way—I took Moore's poems & my own & some others—& went over them side by side with Pope's—and I was really astonished (I ought not to have been so) and mortified—at the ineffable distance in point of sense—harmony—effect—and even *Imagination* Passion—& *Invention*—between the little Queen Anne's Man—& us of the lower Empire. (5.265)

This recantation, which amounts as well to a forecast of new directions, helps us to understand the ways in which *Beppo* asks to be read as an homage to Pope.[33] Byron not only adopts a radically new tone, subject matter, and verse form, he quotes the *Dunciad* and adopts several of its satirical techniques. One of these is heavy-handed commentary from a learned scholiast. A descendant of Martinus Scriblerus supplies the second epigraph by glossing the first: "That is, been at *Venice*, which was much visited by the young English gentlemen of those times, and was then what *Paris* is *now*—the seat of all dissoluteness."[34] This disapproving censor acts as a foil to the voice of Rosalind and the perspective of the narrator, who like his counterpart in Canto IV makes Venice into an instructive mirror to England—but one that reflects not likeness but difference.

It is therefore appropriate that the opening of *Beppo* should counterbalance in every significant respect the opening of Canto IV. This Venice is not "silent," "songless," dispeopled, and phantasmal, but rather a city of music, motion, and joyous physicality:

> The moment night with dusky mantle covers
>     The skies (and the more duskily the better),
> The time less liked by husbands than by lovers
>     Begins, and prudery flings aside her fetter;
> And gaiety on restless tiptoe hovers,
>     Giggling with all the gallants who beset her;
> And there are songs and quavers, roaring, humming,
> Guitars, and every other sort of strumming.
>
> (ll. 9–16)

Moreover, the varieties of "strumming" that dominate the story are purged of tawdriness and enfeebling consequences. As if in response to Beckford's show box, Byron restores to Venice her dignity and her vitality; license is insulated from licentiousness. *Beppo* purports to document, but in effect creates, a sphere of pure play in a "land which still is Paradise!" (l. 361).

Byron's praise of Italy in general and Venice in particular revisits, but also revises, Pope's "Love-whisp'ring woods, and lute-resounding waves" (*Dunciad* iv.306). Yet Popean ambivalence is eliminated by banishing Venice's political identity and by suggesting that sexual gratification has no serious consequences. Just as *Childe Harold's Pilgrimage* undermines the constituent features of the Tour, so Canto IV, together with *Beppo*, promotes what Denis Cosgrove has called the "*Disneyfication* of Venice."[35] Deprived of her complex mythic identity, she becomes for the Victorian traveler on his Cook's tour the analogue to a modern theme park, which specializes in a heady but safely packaged blend of politics and eros. In a different but no less relevant sense, cupids continue to ride the lyon of the deeps.

# Notes to the Text

## Notes to Chapter 1

1. *The Dunciad*, ed. James Sutherland, vol. 5 of *The Twickenham Edition of the Poems of Alexander Pope*, ed. John Butt et al., 11 vols. (London, 1950–69), pp. 371–72 (ll. 275–76, 282). All subsequent quotations will appear parenthetically in the text.

2. Aubrey L. Williams points to both traditions in his analysis of Book IV (*Pope's "Dunciad"* [London, 1955], pp. 122–23). Maynard Mack suggests that "in the fourth book, the supreme trivialization is that of the classical and Renaissance ideal of wisdom ripened by commerce with men and cities: the Grand Tour" (*Alexander Pope: A Life* [New Haven and London, 1985], p. 791).

3. See examples in *OED* s.v. "Venus." One of the editors of the *OED*, Edmund Weiner, kindly informs me that his study of late seventeenth-century inventories furnishes the supporting example of "Venus turpentine" (letter, 8 Feb. 1994). Hester Piozzi remarks on the confusion in her *Observations and Reflections*, 1789 (ed. Herbert Barrows [Ann Arbor, 1967], p. 89).

4. For James Howell's play on Venus/Venice, see the discussion of the prefatory poem to *S.P.Q.V.* in Chapter 3, pp. 54–55. Pope had made use of the pun before *The Dunciad*: in Epistle IV of his *Essay on Man* (1734), he had absorbed and reworked a couplet from Swift's "The Lady's Dressing Room" (1732). Swift's Venus ("Should I the queen of love refuse, / Because she rose from stinking ooze?" [ll. 131–32]) prepares the way for Pope's Venice: ("From dirt and sea-weed as proud Venice rose" [iv.292]).

5. For a full discussion of the "Sposalizio al mar" and its impact, see Chapter 3 ("Myths").

6. Gerald Newman, *The Rise of English Nationalism: A Cultural History, 1740–1830* (New York, 1987), p. 39.

7. E. P. Thompson, "Patrician Society, Plebeian Culture," *Journal of Social History* 7 (1974), p. 387.

8. J. C. D. Clark, *English Society, 1688–1832* (Cambridge, 1985), p. 103.

9. I take the term "social closure" from Newman, *Rise of English Nationalism*, p. 29. John Stoye makes a similar point in his introduction to *English Travellers Abroad, 1604–1667* (New Haven and London, 1989), p. 11: "travel seemed to provide a new method of education, more attractive and more extravagant, distinguishing its pupil (as it were) from others who could not afford the time or money."

10. The most comprehensive and the most reliable biographical account is found in Edward Chaney, *The Grand Tour and the Great Rebellion: Richard Lassels and "The Voyage of Italy"* (Geneva, 1985).

11. *Athenae Oxonienses*, ii.419, quoted in ibid., p. 94.

12. All quotations from Lassels' *Voyage* are taken from the first (London) edition. The preface is unpaginated and most of its leaves are unsigned.

13. I capitalize this word advisedly. The term "Grand Tour" enters the language in 1670 via Lassels' text. But "tourist" does not appear until the late eighteenth-century and "tourism" not until the early nineteenth—precisely when the Grand Tour was giving way first to quick and inexpensive imitations and then to the full-fledged "package tour."

14. For useful references to this anti-maternal literature, see Michèle Cohen, "The Grand Tour: Constructing the English Gentleman in Eighteenth-century France," *History of Education* 21 (1992), pp. 249–50.

15. *Horace Walpole's Correspondence*, ed. W. S. Lewis et al., 48 vols. (New Haven, 1937–83), xx.64, xxiv.16 (4 June 1749, 8 June 1774). This conception of the formless bearcub can be traced back to Pliny's *Natural History* (Book 8, ch. 54). As Theodore Ziolkowski notes, "Pliny tells us that young bears are nothing but white, unshaped flesh, a bit larger than mice, without eyes or hair, but with conspicuous claws—a mass of flesh that the parents must lick into shape" ("Judge Bridoye's Ursine Litigations," *Modern Philology* 92 [1995], p. 348).

16. As Edward Chaney points out, "Apart from Ray, Skippon, Clenche, Acton, Misson, Bromley, Addison and Stevens, all of whom used Lassels to compose publishable travel accounts, there were many others who borrowed from the *Voyage* when writing up the travel sections of their memoirs" (*Grand Tour*, p. 142).

17. John Locke, *Some Thoughts Concerning Education*, 1st ed. (London, 1693), pp. 253–54.

18. Francis Drake, Magadalen College, Oxon MS 247, iii.89.

19. Thomas Nugent, *The Grand Tour* (London, 1749, 3rd ed. 1778), i.xi.

20. Locke, *Thoughts Concerning Education*, p. 254.

21. *The Works of Hildebrand Jacob, Esq.* (London, 1735), p. 117.

22. Adam Smith, *An Inquiry into the Nature and Causes of the Wealth of Nations*, ed. R. H. Campbell, A. S. Skinner, and W. B. Todd (Oxford, 1976), ii.773–74.

23. See especially Jeremy Black, *The Grand Tour in the Eighteenth Century* (New York, 1992).

24. Robert Shackleton, "The Grand Tour in the Eighteenth Century," in *Studies in Eighteenth-Century Culture*, ed.

Louis T. Milic, vol. 1 (1971), p. 128.

25. John Cannon, *Aristocratic Century: The Peerage of Eighteenth-Century England* (Cambridge, 1984), p. 48. See also Lawrence Stone, "The Size and Composition of the Oxford Student Body, 1580–1909," in *The University in Society*, ed. Stone (Princeton, 1974), i.37–59.

26. Linda Colley, *Britons: Forging the Nation, 1707–1837* (New Haven and London, 1992), pp. 155–70.

27. Locke, *Thoughts Concerning Education*, p. 260.

28. Dennis Porter observes of the Tour that "from the point of view of the individual, it has the character of a rite of passage following upon which one accepts the responsibilities of the well-born male to family, class, and nation" (*Haunted Journeys: Desire and Transgression in European Travel Writing* [Princeton, 1991], p. 35). See also Cohen, "Grand Tour," pp. 251–52, as well as Terence N. Bowers, "Rites of Passage: Inventions of Self and Community in Eighteenth-Century British Travel Literature" (Ph.D. diss., University of Chicago, 1994).

29. Victor Turner, "Betwixt and Between: The Liminal Period in *Rites de Passage*," in *The Forest of Symbols: Aspects of Ndembu Ritual* (Ithaca and London, 1967), p. 95.

30. Arnold van Gennep, *The Rites of Passage* (Chicago, 1960), p. 192.

31. Turner, "Betwixt and Between," p. 95.

32. Ibid., p. 100.

33. Ibid.

34. Ibid., pp. 102, 108.

35. See Igor Kopytoff, "The Cultural Biography of Things: Commoditization as Process," in *The Social Life of Things: Commodities in Cultural Perspective*, ed. Arjun Appadurai (Cambridge, 1986), pp. 64–91.

36. *The Letters of Lady Mary Wortley Montagu*, ed. Robert Halsband (Oxford, 1966), ii.177 (to Lady Pomfret, March 1740).

37. Samuel Johnson, *A Dictionary of the English Language*, 4th ed. (London, 1773).

38. *Gertleman's Magazine* 1 (1731), p. 321 (abridging a letter from the *London Journal*, 7 Aug. 1731).

39. Robert Molesworth, *An Account of Denmark* (London, 1694), A2v–A3r.

40. Ibid., C2v–C3r.

41. Ibid., C6v–C7r.

42. Ibid., A4v–A5r.

43. A. D. McKillop, *The Background of Thomson's "Liberty,"* Rice Institute Monographs in English, vol. 38, no. 2 (Houston, 1951), p. 12.

44. James Thomson, *"Liberty," "The Castle of Indolence," and Other Poems*, ed. James Sambrook (Oxford, 1986), p. 89 ("The Contents of Part IV").

45. Ibid., ll. 259, 294–96, 305–06. William Levine notes that in *Liberty*, Thomson "makes Venice a 'type' of Britain, which will later fulfill the destiny of commercial superiority at sea" ("Collins, Thomson, and the Whig Progress of Liberty," *Studies in English Literature* 34 [1994], p. 556).

46. James Sambrook in Thomson, *"Liberty", and Other Poems*, p. 38.

47. *James Thomson (1700–1748): Letters and Documents*, ed. A. D. McKillop (Lawrence, Kans., 1958), p. 81.

48. H. J. Müllenbrock, "The Political Implications of the Grand Tour," *Trema* 9 (1984), p. 9.

49. Ibid., p. 10.

50. See R. W. Ketton-Cremer, *The Early Life and Diaries of William Windham* (London, 1930), pp. 22–23.

51. *Correspondence of Thomas Gray*, ed. Paget Toynbee and Leonard Whibley, rev. H. W. Starr, 3 vols. (Oxford, 1971), i.130.

52. *The Correspondence of James Boswell and John Johnston of Grange*, ed. Ralph S. Walker (New York, 1966), pp. 157–58.

53. See George B. Parks, "Travel as Education," in Richard Foster Jones et al., *The Seventeenth Century* (Stanford, 1951), pp. 264–90.

54. The first guidebook to emphasize the visual is *The Painter's Voyage of Italy* (1679), a translation by William Lodge of Giacomo Barri's Italian original (1671).

55. Fritz Saxl and Rudolph Wittkower, *British Art and the Mediterranean* (Oxford, 1948), p. 57.

56. Lawrence E. Klein, *Shaftesbury and the Culture of Politeness* (Cambridge, 1994), p. 21.

57. Such as James Harris, *Three Treatises*, 1744 (see Clive T. Probyn, *The Sociable Humanist* [Oxford, 1991]).

58. For the transmission of Shaftesbury's thought, see James McCosh, *The Scottish Philosophy* (London, 1875); Paul B. Wood, *The Aberdeen Enlightenment: The Arts Curriculum in the Eighteenth Century* (Aberdeen, 1993); and Isabel Rivers, *Reason, Grace, and Sentiment*, vol. 2 (forthcoming).

59. Klein, *Shaftsbury*, pp. 207–08.

60. I am grateful to Isabel Rivers for clarifying Shaftesbury's thought and rhetoric and for showing me in typescript the relevant sections of *Reason, Grace, and Sentiment*, vol. 2. See also Rivers, "Shaftesburian Enthusiasm and the Evangelical Revival," in *Revival and Religion since 1700: Essays for John Walsh*, ed. Jane Garnett and Colin Matthew (London, 1993), p. 30.

61. Frederick A. Pottle, *James Boswell: The Earlier Years* (London, 1966), pp. 199–200.

62. *Boswell on the Grand Tour: Italy, Corsica, and France*, ed. Frank Brady and Frederick A. Pottle (New York, 1955), pp. 5–6.

63. I take the term "instrument of social reproduction" from Porter, *Haunted Journeys*, p. 35.

64. Jacob, "Concerning Travel, and Education," in *Works*, pp. 117–21.

65. See Black, *Grand Tour*, pp. 190–95.

66. Colley, *Britons*, p. 156.

67. Francis Osborne, *Advice to a Son* (Oxford, 1656), p. 84. Cf. the testimony in Henri Misson, *Memoirs and Observations in his Travels over England* (London, 1719), p. 24: "The *English* say, both the Word and Thing [sodomy] came to them from *Italy*."

68. John Dryden, *Four Comedies*, ed. L. A. Beaurline and Fredson Bowers (Chicago, 1967), p. 221 (act 2, scene 1).

69. As Robert Ness notes, "Italian opera was, until the end of the eighteenth century, synonymous with the castrati. . . . In their epicene appeal, they usurped the position of 'legitimate' humans" ("*The Dunciad* and Italian Opera," *Eighteenth-Century Studies* 20 [1986–87], pp. 185, 187). See also Pat Rogers, "The Critique of Opera in Pope's *Dunciad*," *Musical Quarterly* 59 (1973), pp. 15–30; Thomas McGeary, "'Warbling Eunuchs': Opera, Gender, and Sexuality on the London Stage, 1705–1742," *Restoration and Eighteenth Century Theatre Research* 7 (1992), pp. 1–22.

70. John Dennis, "An Essay upon Publick Spirit" (1711), in

*The Critical Works of John Dennis*, ed. Edward Niles Hooker (Baltimore, 1943), ii.396.

71. *Memoires de Casanova*, ed. Robert Abirached (Paris, 1959), ii.801–02. I owe this reference to Nicholas Clapton.

72. Cf. Jill Campbell's provocative observation: "Pope locates Hervey within a new kind of governmental body, one made up of men linked suspiciously, physically, together in a network of diffuse and feminized masculinity" ("Politics and Sexuality in Portraits of John, Lord Hervey," *Word and Image* 6 [1990], p. 285).

73. Henry Fielding, *The Adventures of Joseph Andrews*, ed. Martin Battestin (Oxford, 1967), p. 312 and p. xxiii, n. 2.

74. *Walpole's Correspondence*, xxxviii.306.

75. Ibid., 470.

76. Aileen Ribeiro, *Dress in Eighteenth-Century Europe* (New York, 1985), p. 142.

77. *Oxford Magazine* 4 (June 1770), p. 228.

78. See *Catalogue of Prints and Drawings in the British Museum, Political and Personal Satires* (London, 1883), iv.720 (no. 4536).

79. Robert Hitchcock, *The Macaroni* (London, 1773), pp. 1–2.

80. Porter, *Haunted Journeys*, p. 51. See also Peter Stallybrass and Allon White, *The Politics and Poetics of Transgression* (Ithaca and London, 1986).

## Notes to Chapter 2

1. *Correspondence of Thomas Gray*, ed. Paget Toynbee and Leonard Whibley, rev. H. W. Starr, 3 vols. (Oxford, 1971), i.128–29. All subsequent references appear parenthetically in the text.

2. "From dusty shops neglected authors come, / Martyrs of pies, and relics of the bum" (Dryden, "Mac Flecknoe, or a Satire Upon the True-Blue-Protestant Poet, T.S.," ll. 100–01).

3. Gilbert Burnet, *History of His Own Time*, 6 vols. (Oxford, 1833), iii.22.

4. Gilbert Burnet, *Some Letters . . .* , 2nd ed. (Rotterdam, 1687). All subsequent references appear parenthetically in the text.

5. "Si quis in caelum ascendisset naturamque mundi et pulchritudinem siderum perspexisset, insuavem illam admirationem ei fore, quae iucundissima fuisset, si aliquem cui narraret habuisset": Cicero, *De Amicitia* xxiii.88 (trans. W. A. Falconer, Loeb Classical Library [1953], pp. 194–95). All quotations from Joseph Addison, *Remarks on Several Parts of Italy, etc.* are taken from the first edition (London, 1705); references appear parenthetically in the text.

6. Peter Smithers, *The Life of Joseph Addison*, 2nd ed. (Oxford, 1968), p. 65.

7. "Poetick fields encompass me around, / And still I seem to tread on Classic ground" (Joseph Addison, *A Letter from Italy* [London, 1703], ll. 11–12).

8. *Horace Walpole's Correspondence*, ed. W. S. Lewis et al., 48 vols. (New Haven, 1937-83), xiii.231 (to Richard West, 2 Oct. 1740).

9. "But the plentiful travel literature of the eighteenth century contains many passages in praise of Addison's book. And it deservedly became the indispensable companion of every young man upon the grand tour"

(Smithers, *Life of Addison*, p. 105). For the most engaging of parodies, see Horace Walpole's letter "in the style of Addison's *Travels*" (*Correspondence of Thomas Gray*, i.29–33).

10. Joseph Warton, "To a Gentleman upon his Travels thro' Italy," Ode V in *Odes on Various Subjects* (London, 1746), pp. 22–23.

11. *The Letters of Joseph Addison*, ed. Walter Graham (Oxford, 1941), p. 21 (to John Hough from Rome, 2 July 1701).

12. I owe this reference to D. F. McKenzie; see *Bibliography and the Sociology of Texts* (British Library, The Panizzi Lectures 1985), p. 50.

13. Samuel Johnson, *Lives of the Poets*, ed. G. B. Hill, 3 vols. (Oxford, 1905), iii.176.

14. *Boswell's Life of Johnson*, ed. G. B. Hill, rev. L. F. Powell, 6 vols. (Oxford, 1937–60), ii.346.

15. See Johnson, *Lives of the Poets*, ii.87.

16. Addison's tacit insistence on balancing *utile* and *dulce*, objectivity and subjectivity, helps to form the century's principal aesthetic for travel-writing: see Charles L. Batten, *Pleasurable Instruction* (Berkeley, 1978).

17. See Richard Wendorf, *The Elements of Life: Biography and Portrait-Painting in Stuart and Georgian England* (Oxford, 1990), p. 149.

18. Jonathan Richardson, Sr. and Jr., *An Account of Some of the Statues, Bas-reliefs, Drawings and Pictures in Italy, etc. with Remarks* (London, 1722), pref., A13r. Subsequent references appear parenthetically in the text.

19. I quote from Samuel Johnson's tribute to Addison: "His prose is the model of the middle style; on grave subjects not formal, on light occasions not groveling; pure without scrupulosity, and exact without apparent elaboration. . . . It was apparently his principal endeavour to avoid all harshness and severity of diction" (*Lives of the Poets*, ii.149).

20. Francis Haskell and Nicholas Penny, *Taste and the Antique: The Lure of Classical Sculpture, 1500–1900* (New Haven and London, 1981), p. 61.

21. Morris R. Brownell describes the Richardsons' *Account* as "a book which became the Baedeker of the grand tourist" (*Alexander Pope and the Arts of Georgian England* [Oxford, 1978], p. 30).

22. Richardson, *An Account*, pref., A4r; Lawrence Lipking, *The Ordering of the Arts in Eighteenth-Century England* (Princeton, 1970), p. 109.

23. Carol Gibson-Wood, *Studies in the Theory of Connoisseurship from Vasari to Morelli* (New York and London, 1988), p. 107.

24. Jonathan Richardson, Sr. and Jr., *Two Discourses* (London, 1719), ii.8.

25. Gibson-Wood, *Theory of Connoisseurship*, p. 103.

26. Lipking, *Ordering of the Arts*, p. 115.

27. Patricia Meyer Spacks, "Splendid Falsehoods: English Accounts of Rome, 1760–1798," *Prose Studies* 3 (1980), p. 206.

28. Samuel Johnson, *A Dictionary of the English Language*, 4th ed. (London, 1773), def. 3.

29. John Breval, *Remarks on Several Parts of Europe* (London, 1726), pref., A1v.

30. *The Spectator*, ed. Donald F. Bond, 5 vols., Oxford, 1965, iii.369.

31. Soame Jenyns, *The Modern Fine Gentleman* (London, 1746), ll. 1–12.

32. Thomas Sheridan, *British Education*, pp. 32–33.
33. Linda Colley, *Britons: Forging the Nation, 1707–1837* (New Haven and London, 1992), p. 101.
34. See ibid., pp. 102–03.
35. See Plato, *Gorgias*, trans. W. C. Helmbold (Indianapolis, 1952), p. 26 (Steph. 465).
36. For the polemical context, see A. W. Evans, *Warburton and the Warburtonians* (London, 1932); R. L. Brett, *The Third Earl of Shaftesbury* (London and New York, 1951).
37. Richard Hurd, *Dialogues* (London, 1764), p. 10. All future references appear parenthetically in the text.
38. By the terms of the Treaty of Paris, Great Britain acquired the province of Canada and supremacy in India. The Cape of Good Hope immediately became of crucial strategic importance: as the directors of the East India Company were later to declare, whoever "shall possess the Cape, the same may govern India" (quoted in Vincent T. Harlow, *The Founding of the Second British Empire, 1763–1793*, 2 vols. [London, 1952], i.108).
39. See Annette Kolodny, *The Lay of the Land: Metaphor as Experience and History in American Life and Letters* (Chapel Hill, N.C., 1975).
40. The classic statement of this equation occurs in Dryden's address "To the Reader," prefixed to *Absalom and Achitophel*: "The true end of *Satyre*, is the amendment of Vices by correction. And he who writes Honestly, is no more an Enemy to the Offendour, than the Physician to the Patient, when he prescribes harsh Remedies to an inveterate Disease" (*The Poems and Fables of John Dryden*, ed. James Kinsley [Oxford, 1962], p. 189).
41. T. Smollett, *Travels through France and Italy*, ed. Frank Felsenstein (Oxford, 1981), p. 60. All future references appear parenthetically in the text.
42. In his "The Satiric Persona of Smollett's *Travels*," Scott Rice identifies "a Juvenalian attack upon luxury" (*Studies in Scottish Literature* 10 [1972], p. 35).
43. In Chapter 3 of "Rites of Passage: Inventions of Self and Community in Eighteenth-Century British Travel Literature" (Ph.D. diss., University of Chicago, 1994), Terence N. Bowers comments perceptively on Smollett's preoccupation with dirt and links it to his social and political agenda.
44. Laurence Sterne, *A Sentimental Journey through France and Italy*, ed. Gardner D. Stout (Berkeley and Los Angeles, 1967), pp. 116, 219. All future references appear parenthetically in the text.
45. *The Whitefoord Papers*, ed. W. A. S. Hewins (Oxford, 1898), p. 228.
46. Laurence Sterne, *The Life and Opinions of Tristram Shandy, Gentleman*, ed. Melvyn New and Joan New (Gainesville, Fla., 1978), p. 26. All future references appear parenthetically in the text.
47. *Letters of Laurence Sterne*, ed. Lewis Perry Curtis (Oxford, 1935), p. 231.
48. In his commentary, Gardner Stout collects the evidence without committing himself on either point (Sterne, *Sentimental Journey*, pp. 326–27).
49. *The Sermons of Mr. Yorick* (London, 1766), iii.152. All future references appear parenthetically in the text.
50. I owe this point to Gardner Stout (Sterne, *Sentimental Journey*, pp. 335–36).
51. See John 13:36, 16:5.

**Notes to Chapter 3**

1. *The Letters of Samuel Johnson*, ed. Bruce Redford, 5 vols. (Oxford, 1992–94), ii.78 (to Hester Thrale, 15–21 September 1773).
2. *Boswell's Life of Johnson*, ed. G. B. Hill, rev. L. F. Powell, 6 vols. (Oxford, 1934–50), iii.36.
3. Franco Gaeta, "Alcune Considerazioni sul Mito di Venezia," *Bibliothèque d'humanisme et renaissance* 23 (1961), p. 60. David C. McPherson draws attention to Gaeta's categories in *Shakespeare, Jonson, and the Myth of Venice* (Newark, 1990).
4. This brief account draws upon the following: Zera S. Fink, *The Classical Republicans* (Evanston, Ill., 1945); William J. Bouwsma, *Venice and the Defence of Republican Liberty* (Berkeley, 1968); Bouwsma, "Venice and the Political Education of Europe," in *Renaissance Venice*, ed. J. R. Hale (London, 1973), pp. 445–66; Brian Pullan, "The Significance of Venice," *Bulletin of the John Rylands Library* 56 (1974), pp. 443–62; J. G. A. Pocock, *The Machiavellian Moment* (Princeton, 1975); *The Political Works of James Harrington*, ed. Pocock (Cambridge, 1977); Pocock, *Virtue, Commerce, and History* (Cambridge, 1985).
5. Gasparo Contarini, *The Commonwealth and Government of Venice*, trans. Lewes Lewkenor (London, 1599), p. 5.
6. Logan Pearsall Smith, *The Life and Letters of Sir Henry Wotton*, 2 vols. (Oxford, 1907), i.85–106.
7. James Howell, *S.P.Q.V.* (London, 1651), pp. 1, 5.
8. J. R. Hale, *England and the Italian Renaissance* (London, 1954), pp. 40–41.
9. Contarini, *Commonwealth and Government*, p. 42.
10. Ibid., p. 35.
11. James Thomson, *"Liberty," "The Castle of Indoleuce," and Other Poems*, ed. James Sambrook (Oxford, 1986), pt. 4, ll. 813–16.
12. *The Poems and Letters of Andrew Marvell*, ed. H. M. Margoliouth, rev. Pierre Legouis with E. E. Duncan-Jones (Oxford, 1971), p. 198. The poem is thought to date from the 1670s. Margoliouth doubts the ascription to Marvell, and George Lord gives it to John Ayloffe (Commentary in *Poems and Letters*, pp. 400–01).
13. *Coryat's Crudities* (London, 1611), p. 158.
14. James Howell, *Instructions and Directions for Forren Travell* (London, 1650), p. 56.
15. James Howell, *Epistolae Ho-Elianae*, 3rd ed. (London, 1655), i.44–45.
16. *The Poetical Works of William Wordsworth*, ed. Ernest de Selincourt and Helen Darbishire, 5 vols. (Oxford, 1940–49), iii.111–12.
17. Samuel Johnson, *A Dictionary of the English Language*, 4th ed. (London, 1773).
18. Michael Levey, *Painting in Eighteenth-Century Venice*, 3rd ed. (New Haven and London, 1994), pp. 1–2.
19. Joseph Spence, British Library Egerton MS 2235, fol. 38v.
20. Francis Drake, Magdalen College, Oxford, MS 247, iii.13–15.
21. Thomas Watkins, *Travels through Switzerland, Italy, Sicily . . . in the Years 1787, 1788, 1789*, 2nd ed. (London, 1794), ii.112.
22. See Chapter 2, p. ••.
23. Drake, MS ii.145.
24. Edward Wright, *Some Observations Made in Travelling*

*through France, Italy, etc.* (London, 1730), p. 94.

25. Peter Beckford, *Familiar Letters from Italy* (Salisbury, 1805), p. 430.

26. Drake, MS ii.141–42.

27. William Bromley, *Remarks in the Grand Tour of France and Italy* (London, 1691, 2nd ed. 1705), p. 64.

28. Beckford, *Familiar Letters*, p. 433.

29. John Moore, *A View of Society and Manners in Italy* (London, 1781), p. 58.

30. Brinsley Ford Archive, Paul Mellon Centre for Studies in British Art (s.v. "Baldwyn").

31. *The Correspondence of James Boswell with John Johnston of Grange*, ed. Ralph S. Walker (New York and Toronto, 1966), p. 174.

32. Thomas Nugent, *The Grand Tour*, 3rd ed., 3 vols. (London, 1778), iii.88.

33. British Library Add. MS 19,941, fol. 37v.

34. Martin Folkes, Bodleian MS Eng. misc. c.444, p. 12.

35. Joseph Spence, British Library Egerton MS 2235, fol. 37r.

36. Drake, MS iii.7.

37. Maximilian Misson, *A New Voyage to Italy*, 4th ed., 4 vols. (London, 1714), i.270.

38. George Mercer, Bodleian MS Top. Gen. e.98, p. 11.

39. Sir Thomas Twisden's journal of his continental travels, 1693, Bodleian MS Eng misc. c.206, p. 26.

40. Lord Palmerston's journal entry for 8 June 1794, quoted in Brian Connell, *Portrait of a Whig Peer* (London, 1957), p. 301.

41. Edward Muir, *Civic Ritual in Renaissance Venice* (Princeton, 1981), pp. 119–34.

42. Pompeo G. Molmenti, *La storia di Venezia nella vita privata*, 3 vols. (Trieste, 1973), iii.223 (reprint of 7th ed. 1927–29).

43. Muir, *Civic Ritual* p. 133 n. 76; Wright, *Some Observations*, pp. 81–82.

44. British Library Add. MS 61,479, fol. 176v.

45. *Horace Walpole's Correspondence*, ed. W. S. Lewis et al., 48 vols. (New Haven, 1937–83), xxiii.296 (13 Apr. 1771).

46. *The Complete Letters of Lady Mary Wortley Montagu*, ed. Robert Halsband, 3 vols. (Oxford, 1966), ii.196.

47. *Henry, Elizabeth and George*, ed. Lord Herbert (London, 1939), pp. 164, 174–75.

48. British Library Add. MS 19,939, fol. 15r.

49. Drake, MS ii.164.

50. Moore, *Society and Manners*, pp. 23–25.

51. *Correspondence of Thomas Gray*, ed. Paget Toynbee and Leonard Whibley, rev. H. W. Starr (Oxford, 1935, 1971), i.128–29 (to West, Apr. 1741).

52. Beckford, *Familiar Letters*, ii.429–30.

53. Bodleian MS Eng. misc. c.444, p. 46.

54. Goethe, *Italian Journey*, trans. W. H. Auden and Elizabeth Mayer (San Francisco, 1982), p. 72.

55. Consider Edward Wright's representative description: "The *Bucentaur* has forty-two Oars, four Men to an Oar; there is a Seat at the upper end for the *Doge*, others on each side for the *Council of Ten*: below is a double Row of Benches for the *Senate*" (*Some Observations*, pp. 81–82).

56. Muir, *Civic Ritual*, p. 124.

57. *Walpole's Correspondence*, xxiv.112 (5 June 1775).

58. Paul J. Korshin, *Typologies in England, 1650–1820* (Princeton, 1982).

59. *The Poems of Gray, Collins and Goldsmith*, ed. Roger Lonsdale (London, 1969), pp. 445–46.

60. Dennis Porter, *Haunted Journeys: Desire and Transgression in European Travel Writing* (Princeton, 1991), p. 48.

61. James S. Ackerman, *The Villa: Form and Ideology of Country Houses* (Princeton, 1990), p. 157. The fundamental work on the connections between Whig principles and neo-Palladian practices is Rudolph Wittkower, *Palladio and Palladianism* (London, 1974). Wittkower's conclusions are confirmed and supplemented by Francis Haskell, who observes of the first generation of Whig oligarchs: "It is not surprising that their sons should have looked back admiringly to sixteenth-century Venice and its leading architect Palladio as the embodiments of their own ambitions and tastes" (*Patrons and Painters: A Study in the Relations between Italian Art and Society in the Age of the Baroque* [New Haven and London, 1980], p. 278). However, it has been suggested of late that such Whig patrons and designers as Lord Burlington were actually closet Jacobites; see in particular three essays by Jane Clark: "The Mysterious Mr Buck: Patronage and Politics, 1688–1745," *Apollo* 129 (1989), pp. 317–22; "For Kings and Senates Fit," *Georgian Group Journal* (1989), pp. 55–63; "Palladianism and the Divine Right of Kings: Jacobite Iconography," *Apollo* 135 (1992), pp. 224–28. Nevertheless, the putative evidence for Stuart sympathies is unpersuasive, for reasons lucidly explained by Giles Worsley: "The search for masonic and Jacobite explanations behind Palladian architecture rapidly dissolves into a game of mirrors in which it is impossible to tell what is fact and what is disinformation" (*Classical Architecture in Britain* [New Haven and London, 1995], p. 112).

62. Francis Russell, "The International Taste for Venetian Art: England," in *The Glory of Venice: Art in the Eighteenth Century*, ed. Jane Martineau and Andrew Robison (New Haven and London, 1994), p. 57. See also Brian Allen, "Venetian Painters in England in the Earlier Eighteenth Century," in *Canaletto and England*, ed. Michael Liversidge and Jane Farrington (Birmingham, 1993), pp. 30–37.

63. "English Villas and Venetian Decorators," *Journal of the Royal Institute of British Architects* 61 (1954), pp. 171–77.

64. This reading of the Kimbolton Staircase draws upon the following sources: Edward Croft-Murray, "Giovanni Antonio Pellegrini at Kimbolton," *Apollo* 70 (1959), pp. 119–24; Nikolaus Pevsner, *Bedfordshire and the County of Huntingdon and Peterborough*, Buildings of England (Harmondsworth, 1968), p. 280; Croft-Murray, *Decorative Painting in England, 1537–1837* (London, 1970), ii.13–15, 255; George Knox, *Antonio Pellegrini 1675–1741* (Oxford, 1995); *Kimbolton Castle: A Guide* (n.d.).

65. Edgar Wind, "Julian the Apostate at Hampton Court," in *Hume and the Heroic Portrait*, ed. Jaynie Anderson (Oxford, 1986), pp. 53–63. See also Haskell, *Patrons and Painters*, pp. 195–96.

66. Croft-Murray, *Decorative Painting*, ii.255.

67. Kenneth Woodbridge, "William Kent as Landscape-Gardener: A Re-Appraisal," *Apollo* 100 (1974), pp. 130, 137 n. 18.

68. *Descriptions of Lord Cobham's Gardens at Stowe, 1700–1750*, ed. G. B. Clarke (Buckinghamshire Record Society, 1990), pp. 62, 126. The original Latin is adapted from Catullus.

69. *Descriptions of Stowe*, p. 68.

70. Sleter had worked for the Duke of Chandos at Canons (1719); he went on to decorate the staircase and salon at

Moor Park. See Croft-Murray, *Decorative Painting*, ii.19, 279.

71. All quotations are taken from *The Faerie Queene*, ed. Thomas P. Roche, Jr. (New Haven and London, 1981).

72. *Descriptions of Stowe*, pp. 39, 68, 163; personal communication from Mr. Peter Inskip, RIBA, May 1994.

73. G. B. Clarke, "Grecian Taste and Gothic Virtue: Lord Cobham's Gardening Programme and its Iconography," *Apollo* 97 (1973), p. 570.

74. A similar kind of succession myth also informs Kent's work for Queen Caroline in Richmond Park: see Judith Colton, "Merlin's Cave and Queen Caroline: Garden Art as Political Propaganda," *Eighteenth-Century Studies* 10 (1976–77), pp. 1–20.

75. As John Dixon Hunt has observed, "Spenser was what Kenelm Digby had called the 'English Virgil', and if Kent was as sensitive as has been suggested to the theme of the progress of the arts he must have seen Spenser's major poem as a vital stage in poetic development from Virgil through Ariosto and Tasso . . . to the eighteenth century" (*William Kent: Landscape Garden Designer* [London, 1987], p. 66).

76. See Colton, "Merlin's Cave," p. 14 and n. 49.

77. See Michael I. Wilson, *William Kent* (London, 1984), pp. 150, 211.

78. Giles Worsley, *Classical Architecture*, pp. 228–29.

79. The identification of the statue is confirmed by inventories at Kedleston (personal communication from Mr. Leslie Harris, April 1995).

80. *The Greek Anthology*, trans. W. R. Paton, 5 vols. (Loeb Classical Library, 1925), iii.339 (ix.608). I am grateful to Jonathan Dancy for transcribing the inscription, and to Leofranc Holford-Strevens for tracking it to its source.

81. Anthony Blunt, "A Neo-Palladian Programme Executed by Visentini and Zuccarelli for Consul Smith," *Burlington Magazine* 100 (1958), pp. 283–84.

82. While I agree with Andrew Graham-Dixon's penetrating account of Canaletto's London as "Venice *redivivus*," I take exception to his claim that the painter "strands" the viewer "between fantasy and reality" in a space that is "neither entirely Italian nor entirely English." On the contrary, the viewer is firmly anchored in place and time: Canaletto insists upon the quiddity of mid-Georgian London, a London that also *implies* or *evokes* its Italian counterpart. See Graham-Dixon, "A Tale of Two Cities," *The Independent* (London), 16 Nov. 1993, p. 25.

83. John Harris, "The Neo-Palladians and Mid-century Landscape," in *Glory of Venice* (see above, n. 62), p. 251.

84. David Buttery, *Canaletto and Warwick Castle* (Chichester, 1992), pp. 22–23.

85. Katherine Baetjer and J. G. Links, *Canaletto* (New York, 1989), p. 256.

## Notes to Chapter 4

1. E. P. Thompson, "Patrician Society, Plebeian Culture," *Journal of Social History* 7 (1974), pp. 389–90.

2. Because Carriera's career was ending just as Batoni's (as portraitist) was beginning, there exist only a few examples of Grand Tourists who sat to both; these include Francis Whithed and John Chute (Anthony M. Clark, *Pompeo Batoni*, ed. Edgar Peters Bowron [Oxford, 1985], p. 236; Bernardina Sani, *Rosalba Carriera* [Turin, 1988], p. 321). However, over a span of some twenty years (from the mid-1720s to the mid-1740s) travelers were able to commission both "Roman" oils and "Venetian" pastels. Even before the development of the Batoni-esque formula, Tourists had themselves painted by Carriera and by an artist in Rome, witness Thomas Coke's commissions of 1714 (Andrew W. Moore, *Norfolk and the Grand Tour* [Norwich, 1985], pp. 34, 37).

3. *James Thomson (1700–1748): Letters and Documents*, ed. A. D. McKillop (Lawrence, Kans., 1958), p. 82.

4. "Rome est une vaste scénographie. Elle a pour decor ses ruines grandioses" (Aimee Vitzthum, "Rome dans les relations de voyages au XVIIIè siècle," *Trema* 9, [1984], p. 57).

5. See the subsection called "A Portraiture of Display" in Andrew Wilton's introduction to *The Swagger Portrait* (London, 1992), pp. 19, 22.

6. Ibid., pp. 17, 19.

7. "Pastel, which could be used readily to create effects of delicacy and softness, brilliance, immediacy and exuberance of touch, texture, and colour, was a medium ideally suited for paintings now destined [according to a rococo aesthetic] to provide sensual pleasure" (Thea Burns, "Rosalba Carriera and the Early History of Pastel Painting," in *The Institute of Paper Conservation: Conference Papers Manchester 1992*, ed. Sheila Fairbrass [Manchester, 1992], p. 37). See p. 102, for a discussion of English responses to the pastel medium as such.

8. For a telling contrast between Giorgione's approach to portraiture on the one hand and Titian's on the other, see John Pope-Hennessy, *The Portrait in the Renaissance* (New York, 1966), pp. 135–36.

9. On the whole Raphael Mengs, Batoni's chief rival in the 1750s, avoided this formula. Only three full-length portraits of British sitters have been documented; moreover, Mengs had a strong preference in both half-lengths and full-lengths for relatively unostentatious setting and dress. As Steffi Roettgen points out, "Mengs's portraits cannot be regarded as aristocratic status symbols" (*Anton Raphael Mengs, 1723–1779, and His British Patrons* [London, 1993], p. 22). The fact that Grand Tourists tended to sit to both Mengs and Batoni suggests that they were valued for their contrasting approach to portraiture (see Francis Russell, "Mengs and the Milordi," *Country Life* [10 June 1993], p. 112).

10. Brinsley Ford, "A Portrait Group by Gavin Hamilton, with Some Notes on Portraits of Englishmen in Rome," *Burlington Magazine* 97 (1955), p. 372.

11. Frank R. DiFederico, *Francesco Trevisani: Eighteenth-Century Painter in Rome* (Washington, D.C., 1977), p. 24.

12. The best short account of the pre-Batoni stages of Roman Grand Tour portraiture is to be found in Bowron's introduction to Clark, *Batoni*, p. 30.

13. Ibid., p. 265.

14. Francis Russell, "Portraits on the Grand Tour," *Country Life* (7 June 1973), p. 1610.

15. Andrew Wilton makes a similar point in his analysis of Batoni's *George Gordon, Lord Haddo:* "The distant view of buildings is intended to suggest the sitter's familiarity with the Campagna and its towns and villages, standing

in for the view of a country seat which might occupy an analogous position in a portrait painted at home" (*Swagger Portrait*, p. 122).

16. Francis Haskell and Nicholas Penny, *Taste and the Antique: The Lure of Classical Sculpture, 1500–1900* (New Haven and London, 1981), pp. 148–50.

17. Iain Pears, *The Discovery of Painting* (New Haven and London, 1988), p. 36.

18. "The true and liberal ground of imitation is an open field; where, though he who precedes has had the advantage of starting before you, you may always propose to overtake him: it is enough however to pursue his course; you need not tread in his footsteps; and you certainly have a right to outstrip him if you can" (Joshua Reynolds, *Discourses on Art*, ed. Robert R. Wark [New Haven and London, 1975], p. 101 [Discourse VI]).

19. "Most of these [classical references] are no doubt intended merely to emphasize, for the sitter's family and descendents, that he was once in Rome" (John Steegman, "Some English Portraits by Pompeo Batoni," *Burlington Magazine* 88 [March 1946], p. 56).

20. Wilton, *Swagger Portrait*, p. 120. According to Clark/Bowron, the head of the statue has been repositioned to achieve this effect (*Batoni*, p. 333).

21. This handling of the relationship between sitter and statue has a parallel in Batoni's *William Gordon* (National Trust for Scotland, Fyvie Castle), in which a statue of Rome, personified as a young woman and painted à la Watteau, offers a globe to the swashbuckling sitter, who takes phallic possession with his drawn sword.

22. *The Poetical Works of George Keate, Esq.* (London, 1781), pp. 16–17, 28–29.

23. George Lyttelton, "An Epistle to Mr. Pope, From Rome, 1730," in *Poems by . . . Lord Lyttleton* (Glasgow, 1777), pp. 38, 40.

24. "The artist may wish to capture a distinct and significant moment in a subject's life, similar to the 'break-through' stage that is associated with crucial episodes in biography and autobiography" (Richard Wendorf, *The Elements of Life: Biography and Portrait-Painting in Stuart and Georgian England* [Oxford, 1990], p. 15).

25. Hugh Honour, "Pompeo Batoni at Lucca," *Burlington Magazine* 109 (Sept. 1967), pp. 549–50.

26. e.g. *Rosalba Carriera: Lettere, Diari, Frammenti*, ed. Bernardina Sani (Florence, 1985), p. 329.

27. Martin Folkes's Journal (1733), Bodleian MS Eng. misc. c.444, p. 22.

28. See Sani, *Rosalba Carriera*, pp. 309–10 (though Sani herself does not make the connection to the Knole pastel).

29. *Carriera: Lettere*, pp. 13–14, 79 n. 2.

30. "Più difficile spiegare la predilezione degli inglesi per i ritratti a pastello della veneziana, ma è possibile che essi piacessero perchè erano ben lontani dalla severa pompa del ritratto di apparato e offrivano delle immagini seducenti anche se rispettose del vero, adatte ad un'aristocrazia che volesse dare di se un'immagine nuova" (*Carriere: Lettere*, pp. 13–14).

31. Evelyn Newby, "The Hoares of Bath," *Bath History* 1 (1986), p. 101.

32. *Carriera: Lettere*, p. 390. Cf. Carriera's statement to Pierre Jean Mariette, 4 Apr. 1727: "Li signori Inglesi mi tengono occupata ne' ritratti di pastelle. Di questi ne ho diversi a finire" (p. 467).

33. Much of the information in this paragraph is taken from F. J. B. Watson, "The Nazari—A Forgotten Family of Venetian Portrait Painters," *Burlington Magazine* 91 (1949), pp. 75–79.

34. Brinsley Ford calls *Samuel Egerton* "the only eighteenth-century portrait of an Englishman with a Venetian background" ("The Grand Tour," *Apollo* 114 [Dec. 1981], p. 400).

35. The church in the background is mistakenly identified as *Il Redentore* in *Italian Art in Britain* (London, 1960).

36. "L'Egerton imitò ben presto il suo superiore [Consul Smith] facendosi eseguire questo ritratto da inviare a Londra nella casa di famiglia" (Fernando Noris, *Bartolomeo Nazari* [Bergamo, 1982], p. 231).

37. Edward Wright, *Some Observations Made in Travelling through France, Italy, etc.* (London, 1730), p. 86.

38. Joseph Spence's travel notebook for 1731–32 (British Library Egerton MS 2235, fol. 39r–v).

39. Sani, *Rosalba Carriera*, p. 311.

40. Burns, "Rosalba Carriera," p. 37. Burns is quoting from Thomas E. Crow, *Painters and Public Life in Eighteenth-Century Paris* (New Haven and London, 1985), p. 64.

41. Sani, *Rosalba Carriera*, p. 29; Donald Posner, *Antoine Watteau* (London, 1984), p. 116.

42. Michael Levey, *Painting in XVIII Century Venice* (London, 1959), p. 144; Horace Walpole, *Anecdotes of Painting in England*, 3rd ed. (London, 1786), iv.195–96.

43. *Carriera: Lettere*, p. 508 and n. 1.

44. Sani, *Rosalba Carriera*, p. 313.

45. *The Glory of Venice: Art in the Eighteenth Century*, ed. Jane Martineau and Andrew Robison (New Haven and London, 1994), p. 57.

46. George Vertue, *Notebooks III* (The Walpole Society, 1933–34), xxii.109–10.

47. Walpole, *Anecdotes*, iv.195–96.

48. Ibid., iv.128.

49. *The European Magazine* (Feb. 1797), pp. 84–85; excerpted in Edward Mead Johnson, *Francis Cotes* (London, 1976), p. 45.

50. Evelyn Newby, *William Hoare of Bath* (Bath, 1990), p. 10.

51. Daniel Defoe, *A Tour thro' the Whole Island of Great Britain*, 2nd ed. (London, 1738), ii.241.

52. Johnson, *Cotes*, p. 3.

53. Marcia Pointon, *Hanging the Head: Portraiture and Social Formation in Eighteenth-Century England* (New Haven and London, 1993), p. 22.

## Notes to Chapter 5

1. *Byron's Letters and Journals*, ed. Leslie A. Marchand, 12 vols. (Cambridge, Mass. 1973–82), i.210. Subsequent references appear parenthetically in the text. For an account of links and affinities, see André Parreaux, "Beckford et Byron," *Études Anglaises* 8 (1955), pp. 11–31, 113–32; also Brian Fothergill, *Beckford of Fonthill* (London and Boston, 1979), pp. 302–05.

2. William Beckford, *Dreams, Waking Thoughts, and Incidents*, ed. Robert J. Gemmet (Cranbury, N.J., 1971), p. 53. All subsequent references appear parenthetically in the text.

3. Though Beckford himself took the decision, he appears

to have acted under intense family pressure to quiet rumors about his unorthodox behavior. All but a handful of copies were destroyed; these Beckford kept at Fonthill, where he favored select guests with readings and, in a few cases, a gift of the book itself. See ibid., pp. 24–28.

4. Lewis Melville, *The Life and Letters of William Beckford of Fonthill* (London, 1910), p. 109.

5. Ibid., p. 93.

6. See Beckford, *Dreams*, pp. 33–34.

7. My account of De Loutherbourg and the *Eidophysikon* is drawn from three sources: Sybil Rosenfeld, "The *Eidophysikon* Illustrated," *Theatre Notebook* 18 (1963–64), pp. 52–54; Richard D. Altick, *The Shows of London* (Cambridge, Mass., 1978), pp. 120–25; the entry in *A Biographical Dictionary of Actors, Actresses . . . and Other Stage Personnel in London, 1660–1800*, ed. Philip Highfill et al., 16 vols. (Carbondale, Ill., 1973–93), iv.300–14.

8. *The Morning Chronicle* (London), 17 Feb. 1776, quoted in *Biographical Dictionary*, iv.305.

9. See Altick, *Shows of London*, pp. 121–22; Boyd Alexander, *England's Wealthiest Son* (London, 1962), pp. 83–84; James Lees-Milne, *William Beckford* (Tisbury, Wilts., 1976), p. 24.

10. Holograph note, 9 Dec. 1838, quoted in J. W. Oliver, *The Life of William Beckford* (London, 1932), pp. 90–91.

11. Melville, *Life of Beckford*, pp. 108–09.

12. The *OED* defines "show box" as "a box in which objects of curiosity are exhibited; esp. a box containing a peep-show."

13. Altick, *Shows of London*, p. 56.

14. For a fascinating account of the operations and connotations of the "show box," see two short stories by Nathaniel Hawthorne: "Fancy's Show Box" and "Ethan Brand." According to Henry James, writing in 1881, "Venice scarcely exists any more as a city at all . . . she exists only as a battered peep-show and bazaar" ("Venice," in *Collected Travel Writings: The Continent*, The Library of America [New York, 1993], p. 292).

15. Brian Fothergill wittily describes the contessa as "not quite an adventuress, but not quite anything else"; as he goes on to say, "she was hardly the most suitable companion for a young man on the Grand Tour" (*Beckford of Fonthill*, p. 84).

16. See ibid., pp. 85–86.

17. Lord Byron, *The Complete Poetical Works*, ed. Jerome J. McGann, 7 vols. (Oxford, 1980–93), ii.124. All subsequent quotations from Canto IV are taken from this edition; references appear parenthetically in the text.

18. Edward Gibbon, *Memoirs of My Life*, ed. Georges A. Bonnard (New York, 1966), p. 134.

19. For example, the note to line 642 reads: "The fall looks so much like 'the hell of waters' that Addison thought [it] the descent alluded to by the gulf in which Alecto plunged into the infernal regions. . . . The traveller is strongly recommended to trace the Velino, at least as high as the little lake, called *Pie di Lup*" (Canto IV, 1st ed., 1818, p. 184).

20. See, in particular, the notes to lines 484 and 532, and Hobhouse's commentary on the decline of Venice after 1797: "to those who wish to recover their independence, any masters must be an object of detestation; and it may be safely foretold that this unprofitable aversion [to Austrian rule] will not have been corrected before

Venice shall have sunk into the slime of her choked canals" (1818, p. 126). According to McGann, Hobhouse made explicit a republican ideology that Byron chose either to imply or to subordinate to more general considerations (in Byron, *Works*, ii.317–18). See below, n. 23.

21. See Andrew Rutherford, "The Influence of Hobhouse on *Childe Harold's Pilgrimage*, Canto IV," *Review of English Studies*, n.s., 12 (1961), pp. 391–97.

22. See Nicholas Purcell, "The City of Rome," in *The Legacy of Rome*, ed. Richard Jenkyns (Oxford, 1992), pp. 443–45. James Buzard has suggested that, "in addition to prompting new habits of remembrance and reference, the new Byronic associations of the Continental tour also gave rise to new varieties of travellers' texts, which in time supplanted their classicist precursors" (*The Beaten Track: European Tourism, Literature, and the Ways to Culture, 1800–1918* [Oxford, 1993], p. 118).

23. For the most perceptive analysis of Canto IV's political import, see Jerome J. McGann, *Fiery Dust: Byron's Poetic Development* (Chicago, 1968), pp. 129–32. McGann concludes that the "Italian *risorgimento* and the great artists of Italy's past and present are only mirrors in which we perceive the struggle of the poet of *Childe Harold's Pilgrimage* to offer a general redemptive vision to mankind at large" (p. 131).

24. Joseph Addison, *Remarks on Several Parts of Italy, etc.* (London, 1705), p. 372.

25. "Since I am got among the Poets, I shall end this Chapter with Two or Three Passages out of 'em, that I have omitted inserting in their proper Places" (ibid., p. 171).

26. Cf. John Chetwode Eustace, A *Classical Tour through Italy* (1812), 3rd ed. (London, 1819), pp. 439–41. I join Andrew Rutherford in suspecting that "Byron may have refreshed his memory by glancing at the guide-book as he wrote this canto" ("Influence of Hobhouse," p. 394).

27. John Pemble, *Venice Rediscovered* (Oxford, 1995), p. 113.

28. Lina Padoan Urban, "La festa della sensa nelle arti e nell'iconografia," *Studi veneziani* 10 (1968), pp. 291–341.

29. *Childe Harold's Pilgrimage*, Canto IV, 1st ed., 1818, pp. 117–18.

30. Tony Tanner, *Venice Desired* (Cambridge, Mass., 1992), p. 20.

31. For an especially acute analysis of *Beppo* in relation to Canto IV, see Jerome J. McGann, "'Mixed Company': Byron's *Beppo* and the Italian Medley," in *Shelley and His Circle*, vol. 7, ed. Donald H. Reiman (Cambridge, Mass., 1986), pp. 234–57.

32. Byron, *Works*, iv.135. All quotations from *Beppo* are taken from this edition; subsequent references appear parenthetically in the text.

33. Byron's Augustanism and the effect of Italy upon his poetic career are analyzed by Michael G. Cooke, "Byron, Pope, and the Grand Tour," and by Donald H. Reiman, "Byron in Italy: The Return of Augustus." Both essays appear in *Byron: Augustan and Romantic*, ed. Andrew Rutherford (New York, 1990), pp. 165–98.

34. As McGann notes, this second epigraph comes from the Shakespearean edition of Samuel Ayscough; "dissoluteness" should be "licentiousness" (Byron, *Works*, iv.485).

35. Denis Cosgrove, "The Myth and the Stones of Venice: an Historical Geography of a Symbolic Landscape," *Journal of Historical Geography* 8 (1982), p. 155.

# INDEX

# Index

# Photographic Acknowledgments